Realism and Social Vision in COURBET & PROUDHON

Realism and Social Vision in COURBET & PROUDHON

by James Henry Rubin

PRINCETON UNIVERSITY PRESS

PRINCETON, NEW JERSEY

Publication of this book has been aided by a grant from
The Andrew W. Mellon Foundation

This book has been composed in Linotype Caledonia

Clothbound editions of Princeton University Press books
are printed on acid-free paper, and binding materials are
chosen for strength and durability

Illustrations printed by The Meriden Gravure Company,
Meriden, Connecticut

Printed in the United States of America by Princeton
University Press, Princeton, New Jersey

Library of Congress Cataloging in Publication Data

Rubin, James Henry.
Realism and social vision in Courbet and Proudhon.

(Princeton essays on the arts ; 10)
Bibliography: p.
Includes index.
1. Courbet, Gustave, 1819-1877.
2. Realism in art—France.
3. Proudhon, Pierre-Joseph, 1809-1865—Influence.
4. France—Social conditions—19th century—Pictorial works.
5. Courbet, Gustave, 1819-1877, Painter's studio.
6. Art and society—France.
I. Title.
ND553.C9R82 759.4 80-17559
ISBN 0-691-03960-7
ISBN 0-691-00327-9 (pbk.)

The Princeton Essays on the Arts is a series of short-length books in the fine arts and aesthetics and includes inter-disciplinary essays as well as original contributions in a single field. Works in the series draw in substance upon the visual arts, music, literature, aesthetics, drama, film, and other theatrical arts, and are illustrated as appropri-ate. The series includes the following volumes, published simultaneously in hardcover and paperback editions:

For Meyer Schapiro

CONTENTS

ix

LIST OF ILLUSTRATIONS

UNLESS otherwise noted, all figures represent paintings in oil on canvas and are by Gustave Courbet.

PHOTOGRAPH CREDITS

PREFACE AND ACKNOWLEDGMENTS

THE need for a scholarly essay on Courbet and Proudhon has long been apparent. Although I had for some time been working with art and utopianism, the idea of undertaking such a project myself did not arise until I gave a seminar on Realism at Princeton University in spring 1977. To the members of that seminar must go my first thanks for the stimulation they provided and for demonstrating that ultimately there is never conflict between teaching and research. I also had the good fortune to treat some of the material contained in this essay in a course called Politics and Cultural Expression, which I taught with Jerrold E. Seigel of the Department of History, Princeton University, in the spring of 1978. This course was part of Princeton's European Cultural Studies Program, which is headed and inspired by Carl E. Schorske. I hope this study represents the kind of interdisciplinary exploration that the program has tried so hard to encourage.

I have benefited greatly from conversations with Albert Boime, Frank Paul Bowman, Timothy J. Clark, Klaus Herding, Thomas D. Kaufmann, Jerrold Lanes, Robert McVaugh, Linda Nochlin, Carol Ockman, Meyer Schapiro, Jerrold E. Seigel, William Sewell, Jack Spector, Gabriele Sprigath, and many others. Before I began writing, I discussed with Professor Seigel at least two key ideas—the concept of work and the concept of man. Subsequent conversations with Professor Schapiro helped enormously to clarify and strengthen these and other points and to place my argument in perspective. Professor Herding was especially generous in sharing his work on Proudhon's aesthetics. Professors Seigel, Schapiro, and Nochlin and Professor George Mauner were kind enough to read drafts of the manuscript at different stages in its development; their comments and suggestions, both major and minor, were invaluable in helping me to give it final form.

I wish to thank Aaron Lemonick, Dean of the Faculty, Princeton University, for authorizing the absences from campus that permitted me to finish research during the Courbet exhibition of 1977-1978 in Paris and to attend the Courbet Colloquium in

Frankfurt in March 1979, and I am deeply grateful to Klaus Herding and Klaus Gallwitz for their interest in my participation in the latter. Preparation of the lecture I gave there on a small part of the material presented here represented the final step in refining my point of view. (The lecture is to be published with the acts of the Colloquium.) Finally, I wish gratefully to acknowledge that the Spears Fund of the Department of Art and Archeology, and the Princeton University Committee on Research in the Humanities and Social Sciences provided some of the financial support for this project.

<div align="right">J.H.R.</div>

Stony Brook
December 1979

"Tell me now, Citizen Master Painter, what brought you to do your *Stonebreakers?*"

"But," answered the Citizen Master Painter, "I found the motif picturesque and suitable for me."

"What? Nothing more? . . . I cannot accept that such a subject be treated without a preconceived idea. Perhaps you thought of the sufferings of the people in representing two members of the great family of manual laborers exercising a profession so difficult and so poorly remunerated?"

"You are right, Citizen Philosopher, I must have thought of that."

From that time on it was not unusual to hear Courbet say: "One would think I paint for the pleasure of it, and without ever having meditated my subject. . . . Wrong, my friends! There is always in my painting a humanistic philosophical idea more or less hidden. . . . It is up to you to find it."

—Account of a conversation between Courbet and Proudhon
in the early 1850s, from
Alexandre Schanne, *Souvenirs de Schaunard,*
Paris, 1892, p. 301.

What neither gymnastics, politics, music, philosophy, nor all combined have been able to do, *Work* will accomplish. Just as in ancient times beauty was brought by the gods, in the distant future beauty will be revealed by the worker, by the veritable *ascetic*; and it is in the innumerable forms of industry that beauty will find diverse forms of expression, each one original and true. Then, finally, . . . laborious mankind, more beautiful and more free than the Greeks had ever been, with no nobles or slaves, with no magistrates or priests, will form all together on the cultivated Earth a family of heroes, sages, and artists. (Note: In art there are really only two periods: the religious or idolatrous epoch, to which Greece gave the highest expression; and the industrial or humanitarian epoch, which has just barely begun. . . . For our swiftest regeneration I would like to burn all the museums, cathedrals, palaces, salons, and boudoirs, including all of their furnishings, both ancient and modern. Then forbid artists to practice their art for fifty years. The past forgotten, we might be able to accomplish something.)

—Pierre-Joseph Proudhon, *Philosophie du progrès*, Paris, 1853 (see appendix IV).

There is already in Courbet's great *Enterrement* a trace of the double attitude of Champfleury to the events of 1848 and 1849. During a period of revolutionary violence and momentous political change, Courbet assembles the community about the grave. He was to say that "the only possible history is contemporary history," but here the history of man is like natural history and assumes a timeless and anonymous character, except in the costumes which show the historical succession of generations. The funeral custom replaces the occasion, the cause and effect of an individual death. The community at the grave absorbs the individual. The anti-romantic conception implies too the tranquil resigned spirit of reconciliation, that Champfleury considered the "supreme goal of art," and found only incompletely realized in Rethel's Dance of Death, a work that names Death as the only victor of the barricades. Thus the consciousness of the community, awakened by the revolution of 1848, appears for the first time in a monumental painting, in all its richness of allusion, already retrospective and inert.

—Meyer Schapiro, "Courbet and Popular Imagery,"
Journal of the Warburg and Courtauld Institutes,
IV, 1941, pp. 190-191.

Realism and Social Vision in COURBET & PROUDHON

Note to the Reader

A fold-out color reproduction of Gustave Courbet's *The Studio of the Painter* has been included as the last plate in the book.

I

INTRODUCTION: COURBET AS A WORKER-PAINTER

THE relationship between the painting of Gustave Courbet (1819-1877) and the social theory of his close friend, the radical anarchist philosopher Pierre-Joseph Proudhon (1809-1865), although it has never before been extensively treated by scholars, was a crucial subject for those who knew and wrote about Courbet during his lifetime. Only with the advent of the ostensibly neutral attitudes of the succeeding generation of painters and critics were the once-potent ideological implications of Courbet's Realism lost: somehow subversive of the pure naturalist aesthetic of Impressionism, the association of Proudhon's sometimes complicated and sometimes naive theories with Realism was either laughed away by them or gingerly set aside. In addition, the appearance in 1865 of Proudhon's treatise on art, *Du principe de l'art et de sa destination sociale*, immediately diverted attention from those aspects of his writings that in the 1850s had been the real basis for his relations with Courbet. Indeed, as noted by Jules-Antoine Castagnary, who was a friend of Courbet and a follower of Proudhon, any discussion of art during that earlier period would automatically have involved "argumentation and conclusion, not only for Aesthetics, but for Religion, Philosophy, Morals, Politics, and the rest."[1] Such interconnected perceptions were characteristic of the times; and thus the enormous impact of mid-nineteenth-century utopian reformers both on Courbet's painting and on his ambitions as an artist must be accepted as an obvious reality. Nevertheless, the question of what there was inherent in Courbet's art that could lead to the more limited vision of his later followers still remains. The varied aspects of this complex problem, then, including this last one, are the subject of this book.

3

Courbet shared with Proudhon not only ideas, but a basic attitude toward men and their interrelations, an attitude grounded in the similar character and Franc-Comtois origins of the two men. I should stress that however obscure Proudhon seems today as an art theorist and, especially for art historians, as a social theorist, he was more notorious in the 1850s than any other radical thinker; he was far more of a public figure than even Courbet himself. I wish to emphasize at the outset that this essay concerns Proudhon's attitudes toward Courbet as well as aspects of his influence on Courbet; hence, some of Proudhon's writings need exposition here at length. (One can only regret their prolixity and repetitiousness: such was Proudhon's inimitable prose style.) And although my attempts to link Courbet to them may sometimes appear too exclusive, I believe such a risk is necessary in order to re-establish some balance after a century of neglect.

Yet it goes with little saying that neither Courbet nor Proudhon can conceivably have been isolated from the impact of other vastly influential social writings of the day. The theories of labor, of social development, of egalitarianism, and the call for social leadership of the arts propounded by men such as Louis Blanc, Etienne Cabet, Auguste Comte, Victor Considerant, Charles Fourier, Pierre Leroux, Théophile Thoré, Henri de Saint-Simon, and others in the 1830s and 1840s enchanted ambitious young men like Courbet and influenced Proudhon. And it is precisely this background, which made Courbet all the more susceptible to social thinking, that gives the painter's attraction to Proudhon its telling significance. For while much of the social theory of the 1830s and 1840s was assimilated by Proudhon and was available through Proudhon, who often said what others had said before, his ostensible contribution was to recast such ideas in more practical formulations. Although he shared the faith in the imminent fulfillment of humanity in a new social future that animated so many mid-nineteenth-century thinkers, Proudhon offered a critique of utopian spiritualism that was appropriate to the disillusionment with their unrealistic schemes that followed 1848. He owed his success to his insistence on concrete proposals, proposals that would nonetheless preserve some of the values of the social and rural past from which utopian dreams had often been drawn. The specific experience of Proudhon, as is well known, was that of the relatively recently

4

annexed and still independent-spirited Franche-Comté—hence one important element of Proudhon's appeal for Courbet. So while some aspects of the ideas of other writers do need to be discussed in relation to Proudhon, it will easily become apparent that Courbet's attitudes had many strongly Proudhonian associations.[2]

As we see Courbet and Proudhon develop, however, especially beyond 1855, we shall witness a divergence. While their similarity as fiercely independent and egocentric personalities may have made the differences that emerged between them in the early 1860s inevitable—and a pattern of convergence and divergence had characterized Courbet's relations with other influential friends, such as Baudelaire and Champfleury, as well—we shall discover latent distinctions to have existed at the very time that Courbet and Proudhon seemed most closely associated. At the deepest level within his art, Courbet's combination of radicalism and conservatism, however it resembled Proudhon's similar combination, eventually distanced him from Proudhon. Seeing himself both as an example of positivist consciousness and as a romantic social prophet, the painter had clearly been attracted by certain non-Proudhonian ideas that led him to an increasingly different concept of the role of the artist in society. For our purposes, nevertheless, the eventual disagreement between Courbet and Proudhon is as informative as their meeting of minds: both illuminate the cultural conditions of artistic production in the mid-nineteenth century. Those conditions were determined by a contradiction between, on the one hand, the ideal of artistic creativity as unfettered subjective expression, and, on the other, the reality of concrete economic and social structures that invariably governed artistic success and survival in Paris. Both weighed heavily on Courbet. The terminology and political persona available to him in Proudhon's thought offer us the key to understanding his attempt to transcend them.

———

Courbet's most important painting, *L'Atelier du Peintre, Allégorie réelle déterminant une phase de sept années de ma vie artistique* (figs. 1 and 2 and fold-out plate at the end of this book) was the monumental centerpiece of the Realism pavilion Courbet set up to rival the art exhibits of the 1855 Exposition Universelle. This overtly programmatic and autobiographical

pictorial treatise had no equal as the self-conscious expression of an artist's ideas, and any attempt to deal with Courbet's intentions—and with how they might compare to Proudhon's—must come directly to grips with it. Yet since even today no satisfactory comprehensive explanation of this formidable and central document has emerged, a major part of my endeavor will concentrate on discovering its meaning.

Although few paintings have been so much studied—and one can hardly avoid building on the previous insights of many other scholars[3]—what I propose that is so far untried is a close analysis of *The Studio* and of related events and documents in the light of the philosophy of Courbet's friend, Proudhon (fig. 3).[4] *The Studio* in fact encompassed all aspects of the past, present, and future of their association: while, as we shall see, it alluded directly to a history of social development derived from Proudhon's social theory, it showed Courbet as the hero of that development. Thus, it represented what for Proudhon would become a problematic interpretation of his own ideas. Without reducing the content of the allegory to a narrow literal meaning, this approach will make *The Studio* generally coherent in the details of its structure and its cast of characters. It will resolve its many contradictions as part of a conscious dialectic, and it will also give real substance and specific dimension to what has always been recognized in a general way as Courbet's profound declaration of artistic freedom—a gesture that has become a touchstone for modern art. It will locate this act and the concomitant artistic developments of the so-called avant-garde in their all-important context of the social dream of the 1850s.

Two concepts fundamental to *The Studio* relate directly to the concerns of this essay. They are, first, the notion of "real allegory" proposed by the title, and, second, what might be said to emerge from the center of the picture as a definition of Realism as pure landscape painting. Both terms—real allegory and Realism—clearly had special meaning for Courbet in 1855. Two rather down-to-earth questions may serve as a fresh introduction to them.

To take the first, why did Courbet show himself at work at the easel? Courbet's self-portraits, of which there are so many that they alone form an important category within his oeuvre[5]—and *The Studio* is above all a self-portrait—had up to this point always de-emphasized his role as the artist-craftsman in favor of

an often dandified image of himself as a Bohemian, a lover, or some other romantic type. Even in *The Meeting* (fig. 17), the role of which in Courbet's development toward *The Studio* will have to be considered, the persona of *Man with Pipe* (fig. 4) and *The Violoncellist* (fig. 5) was reincarnated as "the apostle of Realism," a guise still well removed from that of the painter in the manual act of art production shown in *The Studio*. And in *Man with Leather Belt* (fig. 6), in which a few instruments of craft do in fact appear—so that one may assume Courbet is in some kind of studio setting—the tools were laid aside while the creator, however self-conscious he appears to us, lost himself in *rêverie*.

It has generally been assumed that the most telling context in which to place *The Studio* is in juxtaposition to its antecedents in a long history of pictures of artists in their workshops. Such images were often the occasion for pictorial statements of theory about picture-making and the role of the artist in society, and Courbet's *Studio of the Painter* is no less such a statement than is Velázquez's *Las Meninas*, to which the Courbet is often compared. But with this illustrious lineage as a given point of departure for almost any nineteenth-century scene of the artist in his studio, Courbet's decision to turn to such a genre must still be compared to its immediate antecedents within his own art, particularly since these antecedents show him so preoccupied with a very different image of himself. We must explore the possibility that Courbet's departure from the role of romantic dreamer and his new persona as the artist-craftsman are not merely the result of his choice of a new image type: they may have intrinsic value as something deliberately appropriated for his own purposes. This is especially likely because in the context of 1855 the frank choice of the *atelier*, the place of manual labor (which ought perhaps to be translated as "workshop" rather than "studio"), could not be without ramification as the locale for a "real allegory."[6] Anyone who has an acquaintance with French political thought in the middle of the nineteenth century will recognize the importance of the term "atelier" as particularly current and charged.

For the art historian, of course, "atelier" automatically calls up the image of the painter's studio; and the French term has become a standard word in the art historical vocabulary of English-speaking countries. But for the general historian and for the

broad public to whom Courbet's socio-political statements, pictorial and verbal, were addressed, atelier could well mean more. It meant *any workshop*, including not only that of the painter, but of any master craftsman, artisan, or even group of factory workers. This is not in any way to discard the many insights afforded us by viewing *The Studio* as part of a long tradition of artist's workshop imagery, even though such an approach has still not completely unraveled the picture's mystery.[7] Rather, I am arguing for a new inclusiveness in our understanding of Courbet's use of the concept of atelier which takes the idea of the atelier beyond its art historical limitation so that Courbet's painter's workshop is viewed as a paradigm for all workshops. After all, the problem of the atelier, its internal organization and its relationship to the larger whole of an increasingly stratified society, was a central and divisive issue for socio-economic thinkers of the period, while at the same time such theorists made the artist a vanguard figure in their imagined march toward social justice. Courbet's *Studio* must take its meaning from the intersection of both ideas.

Second, why, in a picture of such momentous portent as *The Studio*, has Courbet shown himself with a landscape on his easel? Further: why, when he had intended to populate the landscape with a somewhat vulgar interpretation of the Miller and the Ass (the miller was to be shown pinching a woman's rear), did Courbet ultimately put aside the joke and opt for a pure landscape, for a picture that in contemporary terms was virtually subjectless? Why may he have painted the subject out?[8] Even if the choice was made at the last minute because he was pressed for time, Courbet obviously accepted pure landscape as sufficient for his purposes; but perhaps on consideration of the exalted position the picture was to have, he finally saw it as a better vehicle for his aims. In other words, his choice should not be seen simply as congruent with his production of 1855 and later, but as announcing it. Before 1855, landscape had played a relatively minor role in his oeuvre, all the more so as his art had increasingly become a form of public statement. Out of some sixty-odd works submitted to the Salons through 1853, a maximum of only fifteen were pure landscapes, and only two of them measured more than a square meter, which is the approximate size of the one seen in *The Studio*. There were about twenty-five portraits and self-portraits, and that number does not in-

clude his many quasi-autobiographical pictures, such as *The Village Maidens* (fig. 11) or the large "historical" paintings that included portraiture.[9] In *The Studio*, however, landscape has become so much the wondrous product of the painter's vision and craft that the little Franc-Comtois peasant boy standing in front of the picture marvels at its authentic reproduction—at the complete illusion of a scene from his native region.

Surely, combined with the fact of Courbet's new persona—one that acknowledged his painting as a physical activity, as a form of work—the presence of a pure landscape of nearly identifiable topography at the center of an allegorical commentary on the artistic function cannot be insignificant. What is more, it was totally unexpected in the context of the still dominant romantic image of the artist as an inspired poetic genius, whose art was held to be the product of pure imaginative impulse as opposed merely to copying external nature. Such a myth, because it expressed the notion of the artist's privileged access to the ideal, conferred on him an elevated social status far above that of the artisan. Courbet's Realism, as he himself declared in 1861, was "the negation of the ideal";[10] and here he may be said to have shown himself as a "worker-painter" at the top of the social hierarchy.

For Courbet, of course, such a man stood morally and socially above others precisely *because* of his experience as an artisan. And no one who has noticed Courbet's central position in *The Studio*, his self-confident bearing and his gentlemanly dress, would be foolish enough to claim that he has returned from his bohemian images to the lowly status of craftsman, or that he has rejected the romantic claims for the nobility of the artist's role. Nor can it be for the simple reason that the scene purports to show his own workshop that Courbet felt so conspicuously entitled to his central role among friends and associates who were, after all, philosophers, critics, and historical figures over whom the artist had no clear general claim to superiority. Even in the utopias of romantic socialism, all these men together formed the vanguard of social progress; all were men of high culture. Hence, there must be some special context in which the status of the manual laborer—and by this I mean more the artisanal than the industrial or proletarianized laborer —as distinguished from all the other professions represented in *The Studio*, became, if not superior within society, at least cen-

9

tral to society. In other words, there must be a context in which the apparently conflicting notions I have claimed for Courbet's position in *The Studio* are resolved. That context, it will be guessed, is the philosophy of Proudhon, whether the philosopher realized it or not. For if in theory the artist was no more than coequal to the writer or politician as an intellectual, he nonetheless had a peculiar advantage over them, namely, that the physical nature of his craft and the subject matter of his images continually reaffirmed his link to the common, the specific, and the material essence of reality. Who was better equipped than the painter to "translate the customs, the ideas, the appearance" of his epoch, to quote Courbet's Realist Manifesto, or, to paraphrase Proudhon, to reproduce the "phenomenality" of things?

Courbet's conception of the worker-artist arose within two principal contexts—the literary-aesthetic milieu of a still "romantic" Realism of the late 1840s and early 1850s, and the intense socio-economic discussions of the same years. This ambiance is personified by a specific set of Courbet's intellectual associates who in addition to Proudhon include primarily Champfleury, Baudelaire, and the art patron Alfred Bruyas, whose collection now occupies a major portion of the Musée Fabre at Montpellier. Although Courbet's relations with these men and others have been studied before, no coherent theory of how their influences or mutual sympathies operated has yet been succesfully proposed. Even the seminal hypothesis of Linda Nochlin that *The Studio* was a Fourierist allegory has been unable to illuminate the picture fully, although her idea was based on the more or less Fourierist leaning of some of the figures depicted in *The Studio*, especially of Bruyas.

The term worker-artist, used first by Champfleury to describe the seventeenth-century Le Nain brothers, painters whom he saw as naive provincial realists, then in 1857 by Castagnary to describe Courbet, contains a preliminary indication of the nature of this intellectual environment.[11] The idea derived from the interest of the 1830s and 1840s in popular folk art and rustic poetry, which saw the emergence of a new type of contemporary literary figure—the worker-poet. The socialist rhymes and working-class prose of the worker-poets were undoubtedly welcomed as antidotes to the fantasies and the pretensions of romanticism as well as to the conventions of academicism, but the assumption

of the worker-poet's moral and aesthetic superiority was still based on a romantic notion of sincerity—a key word for early Realists—by which was meant authentically naive inspiration born of true proximity to nature. The worker-poet idea thus evoked a context of disappearing artisanship and its romanticized values rather than face the increasingly pressing problem of the integration of the worker into the industrialized future. Marx saw the latter as the essential and unavoidable issue, and for those who believe history to have proved him right, the relationship between work and art suggested by the idea of the worker-artist and elaborated by Courbet and Proudhon represents a conservative and historically ingenuous response to modern developments. While it will be important to understand why in its own time and for France their views were considered radical, it would be amiss not to view the overall relationship between Courbet and Proudhon, including its internal tensions and inconsistencies, in this light.[12]

Thus the most talked-about but perhaps least studied influence of all—Proudhon—was embedded at every level of *The Studio*'s conception and of Courbet's activity of the 1850s. One critic's quip that "M. Courbet is the Proudhon of painting," was truer than possibly he or anyone else since then has realized.[13] With *The Studio* as our starting point, we shall be able to anticipate the limitations as well as measure the extent of the relationship that bound Courbet and Proudhon together in their broader role as social prophets. Their interdependence, then their ultimate divergence, are keys to understanding not just one picture, nor just Courbet or Proudhon individually, but the revolution in consciousness their Realism was meant to effect and the historical content of their success and failure.

My theme, then, is not that Courbet's art simplistically or systematically embodies Proudhon's doctrine. It does both more and less. I believe that the parameters of "Courbetism"—as both a unique and personal development and as typical of its times— can only be measured accurately within the environment created by Proudhon. Proudhon's furtive appearance in *The Studio* may serve to underscore this point. While his presence testifies of course to his importance for Courbet, his less than central position suggests Courbet's need to keep his distance. Only after Proudhon's death did the painter loudly proclaim himself a disciple. Hence, treatment of Proudhon in *The Studio* may be an

11

accurate reflection of Courbet's ambivalent feeling, during Proudhon's lifetime, about what was indeed his deep-seated, if not always immediate, indebtedness to the philosopher's thought. When Courbet sat down to write a letter or to create a pictorial expression of ideology, the terms that were in the air around him, the terms he appropriated in spite of himself, were inevitably Proudhonian.

Finally, Proudhonian anarchism could be construed to make Courbet's still romantically egocentric personal and artistic self-fulfillment an act of social commitment as well. Paralleling Proudhon, Courbet recast essentially romantic aspirations on a new materialist base. He was neither wholly positivist (that is, neutrally submissive to naturalist and political facts), nor was he Marxian (a revolutionary critic of man's relation to those facts). Rather, Courbet sought practical means to achieve what remained at heart a utopian effort at transcendence.

II

PROUDHON'S CONCEPT OF LIBERTY

THE circumstances that led to the creation of *The Studio* included Courbet's contact with Alfred Bruyas, a banker's son from Montpellier. The precise chronology of their relationship has been reconstructed by Alan Bowness and Benedict Nicolson, based mainly on Courbet's letters to Bruyas.[1] Some of its events need to be reviewed in order to forge specific links between what might be called Bruyas' resolution of Courbet's "economic problem" of 1853 and the aspects of Proudhon's thought most relevant to Courbet at the time. We shall find that the relations Courbet attempted to establish with his patrons followed Proudhon's notion of direct, precapitalist, "mutualist," exchanges between producer and consumer. A commercial system based on such a principle, although ostensibly a throwback, was in Proudhon's view the key to creating a society based on liberty and social justice.

Although there is no evidence that Courbet suffered any serious economic hardship during the early 1850s, the circumstances that drew Courbet and Bruyas together were nonetheless principally material and practical. They even freely admitted they needed each other; each held the "solution"—a ubiquitous word in their correspondence—to the goal of the other. For his part, Bruyas, as far as one can make out from his writings, sought a modern art, one that approached nature directly, with simplicity and sincerity; he rejected art based on cold calculation or on sterile imitation of tradition. He sought to promote artistic change through the example of his enlightened patronage and the dissemination of his critical principles. He published increasingly more ambitious and voluminous—as well as confusing, indeed sometimes seemingly delirious—commentaries on the works in his collection.[2] His vainglorious narcissism lacked ful-

fillment only because he himself was meek and sickly, until in Courbet he found a complementary personality.[3] Bruyas must have believed that Courbet might eventually become the vehicle for his ideas, as well as the key to what he clairvoyantly hoped would be his fame as a patron.

The boisterous, independent Courbet, on the other hand, came in an even more concrete way to require the support of Bruyas. Bruyas had already acquired *The Bathers* (fig. 13) and *The Sleeping Spinner* (fig. 14) at the Salon of 1853, probably not long after its opening, since by 18 June of 1853 Courbet was writing to the collector back in Montpellier.[4] Soon after, by about October, Bruyas was becoming almost the only buyer of Courbet's major pictures. Under the Second Republic, the sizable *After-Dinner at Ornans* (fig. 7) had been purchased by the government; but by the time of the 1851 trilogy consisting of *The Stonebreakers* (fig. 8), *The Burial at Ornans* (fig. 9), and *The Peasants of Flagey Returning from the Fair* (fig. 10), such support had evaporated. Moreover, as Courbet recounted in a famous letter to his new patron (appendix I), the painter by now had burned his bridges and had no hope of future official patronage. Courbet told Bruyas of his meeting with the Intendant des Beaux-Arts, Comte Alfred-Emilien de Nieuwerkerke, a meeting during which Nieuwerkerke had attempted to persuade the painter to soften his political radicalism and then had had the audacity to bait the proposition with an offer of direct patronage for the Universal Exhibition of 1855. It was Nieuwerkerke's imposition of even further conditions that triggered Courbet's fury: Courbet would have had not only to submit a sketch, but also to present his finished picture for approval by a jury of artists and other representatives chosen by both sides.[5] The very adversary relationship that Courbet's political opposition underlined and that Nieuwerkerke was trying to overcome was thus reaffirmed by the government's own conditions. They constituted a form of blackmail that perfectly exemplified the alienated status of individuals vis-à-vis the state, a blackmail based on economic dependence.

Courbet's practical response to this situation was to challenge the government with a rival exhibition that was at first to feature Bruyas' collection as well as Courbet's own work. Bruyas eventually withdrew, but Courbet's exhibition, as is well known, actually succeeded.[6] For our purposes, however, Courbet's verbal

reply to the government's representative is every bit as important as the fact of his one-man exhibition, for, as we shall see, it was laced with the vocabulary of Proudhonian political philosophy. Courbet wrote to Bruyas that:

> I immediately answered that I understood absolutely nothing of all that he [Nieuwerkerke] had just told me, mainly because he claimed to represent a Government and I felt myself in no way included in his Government, that I was a Government, too, and I challenged his to find something it might do for mine that I might find acceptable.
>
> I added that I considered his Government to be the equivalent of any private person, and that if my pictures pleased him, he was free to purchase them. I said I would ask only one thing of him: that he grant art its freedom in his exhibition, and that he not use his 300,000 francs to support 3,000 artists against me.
>
> I added that I was the only judge of my painting, that I was not only a painter but a man, that I had been painting not in order to make art for art's sake, but to accomplish my intellectual freedom [conquérir ma liberté intéllectuelle] and that I had succeded through the study of tradition in freeing myself from it; and that I alone, of all my contemporaries among French artists, had the ability to express and to translate in an original manner both my personality and my social environment.[7]

The last paragraph of this passage outlines the terms that Courbet would use in the Realist Manifesto, which of course was written to accompany *The Studio* and the rival exhibition. The antigovernmentalism of the paragraphs that precede it demonstrate how closely linked were the principles of Realism to Proudhon's anarchism. Courbet's obsession with artistic freedom, his repetition of the word *liberté* or *libre*, reflect a common preoccupation of his times. But its association with his critique of governmental authority made his concept of liberty peculiarly Proudhonian, for Proudhon, especially after 1848, took up a philosophical discussion of liberty, claiming for it a dialectically antithetical relationship to the state. Already in his famous "Premier Mémoire," *Qu'est-ce que la propriété?* (1840), he held that as society advanced in its intellectual development, the authority of men over other men would necessarily diminish.

15

He arrived at the aphoristic conclusion, "Just as man seeks justice in equality, society seeks order in anarchy."[8] Already establishing a first basis for his opposition to all forms of government whatever their class orientation, he in this same year attacked even communistic systems for their requirement that all property be held by the state, and that man thus yield his sovereignty to a community.[9] Indeed Proudhon's antigovernmentalism was so all-inclusive that, despite his and the communists' common opposition to the present regime, he often felt compelled to underline his position by giving a prominent place to attacks on the communitarian and other utopian proposals of romantic socialism: "Our greatest enemy, socialists, is utopia!" he proclaimed in 1846.[10]

During and after 1848, Proudhon became even more isolated and bitter, and his polemics became more specific. In *Les Confessions d'un révolutionnaire* (1849), he compared government of men by men to exploitation of men by men.[11] In the epilogue to his *Idée générale de la révolution au XIXe siècle* (1851), he included the long passage that begins, "To be governed is to be kept under scrutiny, spied upon, directed, legislated, regulated. . . ." It was in this famous treatise that he defined the process of revolution, begun in 1789, as an evolutionary development toward the total dissolution of government.[12] The failure of democracy in 1848 provoked his sarcasm: "Like monarchy, democracy is no more than a symbol of sovereignty; it in no way responds to the questions raised by the concept of sovereignty." "Democracy is none other than the tyranny of the majority, the most execrable tyranny of all." "Democracy affirming the sovereignty of the people is like theology kneeling before the altar: neither can prove the existence of the Christ it adores, even less can it bring it forth." Then, reviving the theme that utopianism was anathema, he attacked Louis Blanc for suggesting that production be centrally organized in government-financed "ateliers sociaux."[13] He also rejected most other types of workers' associations, a form of post-1848 panacea that was most insistently and repeatedly proposed in a newspaper that bore the significative title, *L'Atelier*.[14] All such proposals were flawed by their presumption that a fundamentally social problem was susceptible to political solutions.

Against this background, one can begin to understand the peculiar concept of liberty that Proudhon arrived at in the early

1850s. (Later we shall consider how Proudhon reformulated the problem of the atelier and its role in an anarchist society.)

It is this profound anti-governmentalist and anti-mystical sentiment called liberty . . . that has recently called forth a universal repugnance for all utopias of political organization or social religion [foi sociale] that have been proposed in place of ancient ones. . . . Man no longer wants to be *organized,* to be *mechanized.* His tendency is toward disorganization . . . everywhere that he feels the weight of fatalism or machinism. This is the work, the function of liberty . . .

From this results the negative character that liberty normally affects. . . . Liberty is the external naysayer [contradicteur], who stands up against any idea or force that seeks to dominate; it is the indomitable insurgent, whose only faith is in himself.[15]

Courbet, in his response to Nieuwerkerke, could be the personification of this peculiar insurgent liberty. And one can understand the grounds on which Courbet rejected Nieuwerkerke's ostensibly liberal offer to allow him to participate in constituting a jury to which he would submit his project: however democratic it appeared, it still infringed on the artist's right to be the sovereign judge of his own work. It was a form of abdication to a community.

From 1848 on, when Courbet became Proudhon's constant companion,[16] the philosopher was more and more concerned with practical solutions to what was commonly called the "problème social." For example, the bitter attack on the incompetence and hypocrisy of democratic government was contained in a short piece called *Solution du problème social,* which prefaced Proudhon's famous proposal for a reorganization of the system of credit and the foundation of a People's Bank. His emphasis on economics was a concrete answer to the naive and nostalgic harmonism of Fourier, now converted into social religion by men like Victor Considerant. Considerant had become one of Proudhon's frequent targets. While the term *Solution* was one of those ubiquitous expressions of faith in progress that underlay the entire period up to about 1850, here it may also be a direct response to the idealistic content of writings such as Considerant's *La Solution, ou le gouvernement direct du peuple.* For even if Proudhon, too, preferred the virtues of a rural society and

had learned much from Fourier, he considered the phalangist communities of Fourierism a threat to the individualism he identified as a basic human trait, and rejected the socio-religious theories he called "foi sociale" as reactionary fatalism. If Courbet was a follower of Proudhon, he could not in the 1850s have been a Fourierist.

Proudhon's own theory of socio-economic organization was first expounded in 1851 in the *Idèe générale de la révolution* under the term "reciprocity." In a subsequent work, the four-volume *De la justice dans la révolution* (1858), in which the concept of liberty held an even more central position, he gave it its better-known name—mutualism. The inherently opposed interests of the individual and the state were to be resolved by "the mutualist principle of law [le principe mutuelliste du droit]." This principle was the means to a just society among reasonable creatures. "There will have to be a meshing of liberties, voluntary transaction, reciprocal engagement. . . . Thanks to this principle, individuals . . . will become specialized according to their talents, their industries, their functions; they will develop and multiply their own activity and their liberty to a degree hitherto unknown."[17] Here was the theory that already underlay the pamphlet on the *Solution du problème social* and the founding of the People's Bank. The early version of it was printed in a paragraph that itself carried the title, "Solution," and I believe that closely related concepts formed the basis for Courbet's attitude to Bruyas' patronage.

One can quote from Proudhon's later writings to find terms even closer to those of Courbet's letter of 1853. The mutualist system was

> that of the defenders of individual liberty. According to them, society must be thought of not as a hierarchical system of functions and faculties, but as a system of free forces balancing each other; . . . They say therefore that the State is simply the product of the freely consented union formed by equal, independent subjects, *all of whom alike are lawmakers* [my italics]. Thus, the State represents only group interests, and any debate between Power and the citizen is really only a debate between citizens. . . . Its law . . . is service for service, product for product, loan for loan [etc.]. . . . In this system, the laborer is no longer a serf of the State, swamped by the ocean of the community. He is a free man,

truly *his own master* [my italics], who acts on his own initiative and is personally responsible. He knows that he will obtain just and sufficient payment for his products and services, and that his fellow citizens will give him absolute loyalty and complete guarantees for all the consumer goods he might need. The State or government is no longer sovereign. Authority is no longer the antithesis of liberty . . . in short, groups and individuals, corporate bodies and persons—are all equal before the law.[18]

Courbet's refusal to treat with Nieuwerkerke or with the government as anything other than an equal, as if he were a government, or to reverse the terms, as if the government were a private citizen, is clearly founded on this anarchist principle of mutualism. The only form of economic exchange between the two acceptable to Courbet was that which respected his integrity, not merely as an artist—and thus as the only legitimate judge of his own work—but as a man, as an independent, unalienated entity, endowed with a full set of rights, including those of exploiting his talents to his satisfaction and of receiving a just compensation for their product. Even Courbet's one request of Nieuwerkerke, that he "grant art its freedom in his exhibition," can be taken in this quasi-economic context. That is, Courbet charged Nieuwerkerke not to interfere in the free economy of the Salon. This, too, was reminiscent of Proudhon, whose goal as a political economist was the establishment of conditions under which there might be direct exchange between producer and consumer.

The condition to which Courbet aspired was precisely, as Proudhon wrote, that of being *his own master*. This was recognized by Bruyas, who consistently and repeatedly referred to Courbet with the painter's own term—*maître-peintre*—a term Bruyas used for no other artist at any other time. With its derivation from the old tradition of the guilds, which had been destroyed in a well-intentioned liberal gesture under the First Republic, this expression was a professional designation that clearly located Courbet as an independent craftsman within the productive process. Lacking reference to a specific hierarchy, the term fell into disuse by the great romantic masters of the first half of the nineteenth century, who in any case undoubtedly preferred the heavily spiritualized notion of *l'artiste*, as it had begun to emerge in social theory and in literature.[19] Hence, *maître-peintre* had for Courbet the antidotal effect of recalling

19

an earlier, craft-oriented tradition, while at the same time preserving and asserting the rights of the worker-individual. Worker-artist was Courbet's answer to utopia's artist-priest.

The depth of Courbet's meeting of minds with Proudhon, as exhibited by his clear ability to use Proudhonian terms and to act on the principles they embodied, lends credibility to the image of Courbet, in the words of T. J. Clark, as self-consciously both "rustic and theoretician."[20] However much it was a vainglorious attempt to rival the government, the artist's one-man exhibition must also be seen as a Proudhonian effort to address the public directly. This two-sided view of Courbet's action as both narcissistic and doctrinaire suggests how his high intelligence was channeled, not into original thinking, but into an intense receptivity to what the ideas of others might hold for him. The result was a brash combination of blatant economic opportunism, serious philosophy, and farce: the Realism Pavilion exploited notoriety in order to attract business; *The Studio* explained, as we shall see, the social role of art; and the whole served to *épater* the bourgeois. (The original idea of the Miller and the Ass certainly had this as at least part of its purpose.) While I shall argue that in its general structure *The Studio* expresses a coherent ideology, it should never be forgotten that the many internal inconsistencies of its hasty and additive composition reveal the appropriated nature of Courbet's ideas and the (possibly confused) multiplicity of his intentions. So in this sense, despite so many aspects of deep congruence with Proudhon, the painting will always remain pure Courbet.

III

BRUYAS AND DIALECTICAL
AUTOBIOGRAPHY

COURBET wrote to Bruyas in May 1854, shortly before depart-
ing for Montpellier, that after literally having painted his spir-
itual autobiography through self-portraiture, he was now ready
to make one more self-portrait—that of "a man sure of his prin-
ciple, that is, a free man." In the same letter, Courbet congratu-
lated himself and Bruyas for having found each other. But his
ecstatic words were for the validation of his own vision that his
"inevitable" encounter with Bruyas offered. After all, he wrote,
"It is not we who met each other, but our solutions."[1]

After making such statements, and following his exercise of
principle in the affair with Nieuwerkerke, it is highly improbable
that Courbet could have seen his own and Bruyas' solutions as
incompatible; indeed earlier in the letter he spoke of "our solu-
tion." What he meant, however—and this will become clearer
when we turn to a discussion of *The Studio*—was not an iden-
tity of ideas between him and Bruyas, but that there existed a
principle of mutual cooperation between artist and patron. Cour-
bet conceded to Bruyas a degree of intelligence, courage, and,
especially, financial success that he could not possibly match.
Yet the key to their cooperation was precisely that which had
been lacking in the government's proposal—a mutually self-re-
specting agreement. It is doubtful that either Bruyas or Courbet
modified a single one of their fundamental ideas for each other;
and as we shall see later, they were in one very important way
basically opposed. Yet each could, through pursuit of his own
talent and ambition, aid in the attainment of the goal of the
other. Courbet could have spiritual independence any day he
liked; but without financial independence his Proudhonian lib-
erty would never reach its full potential. Bruyas, without Cour-

bet, could never have the impact on contemporary art and society that he in his way coveted. His books and commentaries were one thing, but a concrete example in a major artistic statement was impossible without the association of the most clearly outspoken artist of the day.

The one last projected self-portrait to which Courbet referred actually became two. For before *The Studio*, and immediately following the visit to Montpellier, Courbet commemorated his encounter with Bruyas in *The Meeting* (*Bonjour, Monsieur Courbet*) (fig. 17). In this image, as Linda Nochlin has brilliantly demonstrated, Courbet transformed a familiar motif from popular imagery—"Les bourgeois de la ville parlant au juif errant" (fig. 18)—into a contemporary homily.[2] The symbol of the wandering and persecuted outcast, so romanticized in the nineteenth century, became in this case the artist. Here he stood on equal footing with the two bourgeois, who have taken the identities of Courbet's patron, Bruyas, and a servant. The latter even show Courbet some deference, while the painter's expression of self-confidence emphasizes his freedom and independence. The motif of the Wandering Jew had been used earlier by Courbet in a now lost portrait of the itinerant disciple of Fourier, the demagogical and reputedly eccentric Jean Journet. So if Courbet can be said to have shown Journet as the apostle of social reform (the title of his lithograph of Journet was "L'Apôtre Jean Journet" [fig. 19]), then he can be said to have shown himself in *The Meeting* as the apostle of Realism, emphasizing, as Nochlin has shown, both his social and his sacerdotal role.[3]

Yet it is not often enough stressed that the "Realist" theme was inherent in the motif of the Wandering Jew per se. For Ahasverus was condemned to walk the land without rest because of his scorn for Christ on the road to Calvary; and although perpetual wandering was a punishment, through it he became the last survivor to have seen the Crucifixion, hence the only true remaining witness to his time. It was as such a witness, and not only to the truth of his own time but to the triumph of truth over time, that he was stopped and engaged in conversion by curious inhabitants of the present. In addition, as Jack Lindsay has suggested, Courbet's image of himself as a wanderer can be associated with the tradition of the traveling artisan, such as the journeymen or *compagnons* who went from town to town

practicing their skilled crafts.[4] Although such men were not *maîtres*, as Courbet claimed to be, their mobility paralleled his independent search for patronage. So did their leftward political leanings. Hence the special pose Courbet adopted for himself in *The Meeting* expressed the duality of his artistic principle— freedom and Realism. The latter was defined as painting of one's own times; both were already in *The Meeting* associated with the practice of the independent artisan. This special pose was epitomized by what Courbet termed his "Assyrian" profile, per- haps that of a nomadic primitive making a monumental art reflecting his own epoch; it was deliberately reused for the painter's image of himself in *The Studio*.[5] Thus Courbet can be seen incorporating the interconnected concepts of *The Meeting* into *The Studio*.

In his commentary on the works in his collection, Bruyas had associated the word "solution" with two earlier pictures by Cour- bet, first with *The Bathers* (fig. 13), then with the *Portrait of Alfred Bruyas* (fig. 15), in which Bruyas' hand rests on a volume (never published) entitled *L'Art moderne. Solution*.[6] Difficult as it is to follow the artistic theory contained in Bruyas' commen- tary, there are several main points that eventually emerge. First, by modern art he meant the budding school of Realism;[7] hence, in the title of the book Bruyas holds in figure 15, modern art was not meant to be understood as the problem, but rather as the solution to it. Indeed, at the end of a theoretical introduction to his *Salons de peinture* of 1853, which prefigured his much longer *Explication des ouvrages de peinture du Cabinet de M. Alfred Bruyas* of 1854, Bruyas wrote that what remained to be resolved was "the problem of the education and the justice of mankind."[8] The problem in need of a solution was the same for him as for all radical thinkers of the early 1850s—the social problem. Bruyas believed art was to be its means.

Although such words certainly find an echo in the ideas of Proudhon, they were hardly specific to Proudhon, and with an important exception we shall discuss later, Bruyas seems to have been much more under the spell of the quasi-religious brand of Saint-Simonianism that had merged with Fourierism after 1848.[9] For our purposes, it is only important that Bruyas' concept of the social significance of art was in general agreement with Courbet's or, for that matter, with Proudhon's. Bruyas demanded moral instruction from art, but he saw it as emerging only from

the sincere representation of the natural and the true, as opposed to the repetition of academic formulas. He wrote, "Art must find its humble solution everywhere"; that is, he believed that the subject matter of art, if it was to be an effective social tool, must be taken from everyday reality. These notions were announced on one of the several title pages to the 1854 *Explication*: in a statement labeled "Solution: Profession de foi," he equated the expression of truth with moral duty, with the accomplishment of good, and, in a final step, with the search for God. God, since He embodied the requisite qualities of truth and virtue, ultimately became the key to liberty.[10] On his previous page, Bruyas had quoted Lamartine's typically romantic explanation that "liberty is the divine ideal of man."[11]

Although neither Proudhon nor Courbet would ever have used Bruyas' vague religious language, after the word "Solution" in the title of his credo Bruyas placed a reference that pointed the reader to Courbet's *Bathers* (fig. 13). According to his own account, Bruyas had felt it his duty to acquire *The Bathers* for his *cabinet* as soon as he saw it at the Salon of 1853. He did so despite the ugliness of the forms it exposed, for he realized that this picture struck out in a new direction, one that made the ugliness of the comic mode flattering by comparison.[12] For a commentary on the picture, Bruyas appropriated Théophile Gautier's appreciation, which he placed under the heading, "Leur Verité" (referring of course to that of *The Bathers*). Gautier had come very close to recognizing the grotesqueness of the picture as satire: he was surprised by the main figure's "conventional, nearly academic gesture"; and, after observing "the silly smile of her froglike mouth," he asked, "Is she serious or making fun?" Courbet himself later referred to the picture as his one essay in the field of irony.[13] Bruyas considered the significance of *The Bathers* to arise less from its forms themselves than from the subject's radical departure from convention as a gesture of artistic freedom. "Il est en liberté!" he exclaimed of Courbet; and he quoted another passage from Théophile Gautier, this one written in 1848, which attributed the proliferation of anticlassical and antiacademic individualism in art to the "sincerity of free man."[14] The use of irony or satire on such a large scale was in itself a challenge to the classical notion of what was a suitable genre for high art.

Bruyas' discovery of Courbet at the Salon of 1853 was prob-

ably aided by his intimate friend, a Fourierist from near Mont-pellier and a far more articulate connoisseur of art, François Sabatier (fig. 16). Sabatier's clarity of thought and his comments on certain aspects of his friend's collection shed badly needed light on Bruyas' role as a source for some of the formal even more than the theoretical aspects of Courbet's *Studio*. Sabatier's unique effort at art criticism, which he signed as Sabatier-Ungher, was a highly intelligent review of the Salon of 1851, published by the Fourierist Librairie Phalanstérienne.[15] This predated any of Bruyas' writings, and it is not unthinkable that Sabatier's ex-ample helped to guide the slightly younger Bruyas' taste after 1851.[16]

Moreover, when for the first time in his works (1854) Bruyas mentioned Courbet's *Burial at Ornans* (fig. 9), it was in terms entirely congruent with the first chapter of Sabatier's *Salon*. Like Sabatier, Bruyas saw *The Burial at Ornans* as the exposition of a new artistic principle, one that was now liberated from the "retrospective" principle of imitation of the Greek and historical past.[17] Bruyas' definition of Courbet's purpose as "to show that sentiment still makes the heart beat under the mean costumes [habits mesquins] of our age" clearly summarized passages on *The Burial* by Sabatier, specifically reflecting the importance Sabatier had given to modern dress as well as Sabatier's own word—"mesquin"—characterizing it.[18] Finally, it should be noted that a letter from Sabatier to Bruyas dated 1854 referred back to Sabatier's *Salon* and made clear that almost the sole subject of recent discussion between him and Bruyas had been Courbet. The letter ended with the salutation, "Tout à vous pour nos communes sympathies."[19]

Beyond obvious superficial coincidences, then, there existed a profound identity between the two men's views of art. Indeed, the theory adopted by Bruyas had already found cogent and complete expression in the opening pages of Sabatier's *Salon*:

> Art, even if its sole object were beauty alone, would still be as serious an endeavor as economics or politics. Each is a pathway to happiness. . . .
>
> From the general standpoint, then, art is linked to the so-cial question; moreover, its connection is a double one, that is, both historical and practical.
>
> Art is the expression of the moral and intellectual devel-

opment of nations. Everything can be found in nature; the present is always *pregnant* with the future [*gros* de l'avenir]; and we who see in all contemporary facts a prefiguration of the future, we can and must find in art the symptoms of the event we are awaiting—the birth of the new world.[20]

Sabatier's view of art as helping to reveal the future course of society in its evolution toward *bonheur*—a view that was widespread among advanced thinkers of the 1840s—helps to explain the ambitions that Bruyas attached to his role as art patron.[21] For Bruyas not only defined the purpose of his collection as "a serious search for truth [sérieuses recherches de la vérité]," but he seems to have organized this search as a spiritual journey, like that of mankind, in which the element of time was important as a measure of progress. The basis of his collection was thus allegorical: he called it the "Odyssey of painting," and he himself became a prophet.[22]

At the very beginning of his *Explication*, Bruyas subtitled his brochure a "Catalogue of Heaven and Hell," or "liberty in goodness [la liberté dans le bien]."[23] These terms suggested that the viewer was confronted with a choice, like that of Hercules at the crossroads. Since it is not at all clear from either the order of Bruyas' catalogue entries or from the nature of the art in his collection that his *cabinet* actually embodied this choice, the works he acquired may simply have been meant to reflect the results of choice, that is, the resolution—the solution—of the human dilemma. This concept was important enough to Bruyas that he commissioned his friend, the painter Octave Tassaert, to do a picture representing Heaven and Hell, entitled *France Hesitating between Good and Evil Sentiments* (fig. 21). Apparently Bruyas felt that all levels of society—the individual, the political, and the artistic—were faced with a momentous decision; despite its unlikely semi-erotic forms, the picture was even dedicated to Louis Napoleon.[24] This retrograde vision suggests the limits to Bruyas' practical notion of the contribution of art to social progress in 1850.

Choice was but one aspect of the more generic concept of dialectical opposition that permeated Bruyas' thought. Indeed, he appears to have conceived his gallery as a spiritual autobiography, in which progress toward his "solution" was revealed through a series of representations of opposing personalities,

either his own or others. Sabatier's letter of 1854 made clear how programmatic Bruyas' intentions may have been:

> At your house, the point was to set up a philosophical and psychological history. Your gallery of portraits is something more than a reunion of different individualities expressed in their mutual opposition. They are different moments of the same individual, the genesis of a single and unique personality, the history of its intellectual development in its successive phases.[25]

Hence, the organizing principle of the gallery was the resolution of opposition through dialectic in order to reveal the process of becoming an individual personality—Bruyas' own. As we shall see, the principle underlying Courbet's *Studio* was identical.[26]

The specific stages of the quest for truth that Bruyas' gallery represented were suggested by the schematic diagram on one of the title pages of the 1854 *Explication* (fig. 23). Bruyas saw himself as having moved from his beginnings with the beauties of nature toward a "solution" that he called "the humble atelier." The former was recalled by his association with Alexandre Cabanel, which dated from 1846; the latter, by Octave Tassaert, who had executed Bruyas' commission, probably of 1852, to portray the collector in the artist's own atelier (fig. 22). Both terms of the dialectic were thus autobiographical, and in his comments on Tassaert's *Atelier*, where he was both the central and dominant figure, Bruyas reminded the reader that most of the pictures he owned were the result of his own ideas and agreement with the artists who executed them.[27]

On his title page, between the two poles of his dialectical journey from "Début" to "Solution," Bruyas placed the words "religion" and "conviction," as if it were by means of both that his progress had been accomplished. All of this was located under the Saint-Simonian banners of "Amour" and "Travail," thus forming a familiar utopian trinity. At the center, just below all of the foregoing, Bruyas placed the word "Liberté!" as if it were the final result of the dialectical combination of the preceding terms. And directly under the word "Liberté!" he placed the name of Courbet and the date 1853. On a page of his *Salons de peinture* of 1853, Bruyas had reproduced exactly the same design, but, of course, without the name of Courbet. Such designs, with their use of typography to stress hierarchical arrangements,

27

were a trademark of Saint-Simonian propaganda. And one of the most remarkable features of Saint-Simonian doctrine was the central role of the artist as a kind of secular priest leading the rest of humanity to ultimate fulfillment. It is evident, then, that in the letter to Bruyas in which he spoke of the meeting of their solutions, Courbet was speaking just as much for Bruyas as for himself.[28]

The relevance for Courbet of Bruyas' schemata, divided as it was into two halves with Courbet representing the concept of liberty at its center, is obvious, for *The Studio* is divided in a similar manner. The relationship is confirmed by Bruyas' use, at the very top of his title page above the words "(Cabinet Bruyas)," of a phrase that sums up the whole of his design as a "Phase d'une éducation d'artiste de la grande famille."[29] Despite its ambiguity, this statement finds a clear echo in Courbet's title: *Une Allégorie réelle déterminant une phase de sept années de ma vie artistique.* Indeed, in some comments on *The Studio*, one critic who is said to have been familiar with Courbet's ideas at first hand wrote, "The painting is more or less called *l'Education du Peintre.*"[30] Finally, it can be suggested that the two poles of Bruyas' original dialectic—"Début" and "Solution"—with the reference of the first to nature and of the second to the physical activity of the workshop, contain avant la lettre two other key concepts underlying Courbet's painting. For as we shall see Proudhon to have theorized, it was precisely the encounter between nature on the one hand and man's need to work on the other that occasioned the production of art.[31]

Yet one cannot leave the subject of Bruyas' influence on Courbet without being struck by the common bond of narcissism that united the two. In this respect their association anticipated Courbet's later divergence from Proudhon; for Saint-Simon's romantic concept of the artist as an independent and unrivaled social prophet, the principal notion on which Bruyas' activities had been based and certainly a factor in Courbet's, was incompatible with Proudhon's version of the origins of art.

IV

POLITICAL ECONOMY AND THE
ORIGINS OF ART

COURBET and Bruyas thus undoubtedly shared the belief that
art could be a social force, as well as many other secondary ideas.
There can be no doubt that the expository form used to convey
the attitudes we shall see embodied in *The Studio* derived sig-
nificantly from Bruyas' autobiographical and dialectical obses-
sions. But it seems unlikely that Bruyas would have envisaged
his place in Courbet's *Studio* as so subordinate to that of the
painter (Courbet's attempt to reassure him that he held a mag-
nificent position was transparent exaggeration), and it is even
less likely that Bruyas, a transcendental eclectic at heart, would
have fully accepted Courbet's very concrete notion of Realism.[1]
Following Proudhon, Courbet believed in particular that art
developed in a natural process from the productive, hence both
economic and creative, activity of man as a working but rational
animal. This concept, stressing the popular origins of art, was
one of the principal ideas his allegory served to express.

Such differences as these, and they will later become even
more striking, may help to explain the intrusion of a new and
somewhat foreign element in Bruyas' *Explication* of 1854. This
was contained in the entry for the catalogue no. 79, a now un-
traceable bronze statue with the attributes of a worker, entitled
Le Métier ennobli, or *L'Homme et son sentiment*. The image was
accompanied by an overthrown cannon and was set on a lion-
skin, the latter interpreted by Bruyas as a symbol of strength and
rectitude. This curious *objet*, which had not appeared in the ear-
lier Bruyas Salons but which was now at its center, defining its
"dernière partie," that is, its final and resolved phase, repre-
sented, to quote Bruyas, "the worker, free in his career." It was

29

given an exceptionally long commentary in which there were several references both to Courbet, and, for virtually the first and only time in Bruyas' writings, to Proudhon. However ambiguous Bruyas continued to be, there was no mistaking the link between his description of the statute of *Le Métier ennobli* and Proudhon's notion of the nobility of work.[2]

Immediately before his description of the statue, Bruyas had written, "Let us be men above all: God alone is our judge. Thus, through his rectitude, the slave will break his chains." On the face of it, such rhetoric is not especially Proudhonian, but the phrase "let us be men" recalls Courbet's assertion in his letter of around October 1854 that he "was not only a painter but a man," a theme he repeated in the Realist Manifesto of the following year. The term, "a man," was in fact a loaded one, which we shall have to explore further on. Suffice it to say for the moment that Proudhon's philosophy had made a great deal out of the idea that the defining characteristic of man was that he engaged in work. If not subjected to external restraints, man's work would become the key to his liberation (a secularized version of salvation). Bruyas' reminder that God alone, hence not other men, was the judge of one's actions was to his mind a corollary to the notion of manhood, for it asserted the independence of individual activity. From this it followed that the chains of slavery could be broken. Bruyas' association of this process with artistic endeavor—hence, its value for Courbet, indeed, most likely its source in Courbet—was suggested by another title page of the *Explication*, on which the phrase "Le Métier ennobli, ou l'Homme et son sentiment" was placed under the single word, "PEINTURE."[3]

Since Courbet's *Studio* is in other ways prefigured in Bruyas' writings, it hardly seems unreasonable to propose that Courbet's depiction of his artistic activity as a manual *métier* was now deliberate and that it had Proudhonian implications. But in order fully to understand the profound ramifications of this new self-image not only for Courbet's conception of the artist but for the notion of Realism, we must study Proudhon in greater detail. Proudhon's theory of work, closer to Hegel's than was Marx's, was contained in a passage from the 1846 *Système des contradictions économiques, ou Philosophie de la misère* (see appendix III):

Work is the first attribute, the essential characteristic of man.

Man is a worker, that is to say, a creator and a poet: he projects ideas and signs; while remaking nature, he produces from her stores, he lives from her substance: that explains the popular saying: To live from one's work. . . .

Man, God's rival, like God but in a different way, works; he speaks, he sings, he writes, he tells, he calculates, . . . carves and paints images, celebrates the memorable acts of his existence, . . . provokes his thinking through religion, philosophy, and art. In order to subsist, he puts all of nature to work; he appropriates and assimilates nature.[4]

Proudhon wrote that "Man alone works because he is able to conceive his work. . . . Work is the projection of his mind." But he added, soberly emphasizing the fatally physical nature of man, "To work is to spend life, to devote oneself, to die."[5] Elsewhere he observed: "[Work] occurs [in the confrontation] between the spiritual force of man and inert substance; it is . . . a communion between man and nature."[6]

This profound concept of work as a manual yet noble, as a private yet useful and universally necessary activity, almost as a ritual in which man spends himself in a physical dialogue with the stuff of nature, derived from Hegel's view of labor as a process of mediation between the objective and subjective worlds. While man infused nature with his own self, he appropriated nature to himself; the synthesis embodied in the product was the condition for human fulfillment. Proudhon's description had as one of its goals a demystification of the myth that man was condemned to work by the Fall. Rather, man worked from inner necessity for material satisfaction, and the value of the product thus depended on labor as the expression of man's physicality. Any alienation of its value from the producer, whether the result of communist or of capitalist appropriations, was a profound injustice. Such injustices were perpetrated especially through religious and utopian myths, which degraded the physical nature of man and preferred to see him yearning toward a perfect spiritual archetype, and which thus diminished the value of his physical product by linking it to what they defined as a transitory stage in his existence. No externally imposed ideal or

31

system of socio-economic organization could respect the right of each human being to dispose of his product as he ought to be able to do, that is, through exchanges that eliminated intermediaries and procured to the individual the enjoyment of its full value. All such systems were the result of suppositions extrinsic to the essence of man. Proudhon summed up the practical results of this position in the motto of his newspaper, *Le Représentant du peuple*: "What is the producer? Nothing. What should be? Everything!"[7]

Some of the sources and parallels for Proudhon's notion of man reveal the profound shift in nineteenth-century thought embodied in Courbet's art. By defining man as an essentially economic and self-centered being, though that is not to say malicious or destructive, Proudhon opposed both the notion of man's essence as social—as in Rousseau, whom Proudhon fiercely attacked—and the notion of man's essential spirituality. Proudhon's critique of the latter concept is of particular interest, for it had strong connections with the thought of a group of Germans who were in Paris in the mid-1840s, and whom Proudhon knew well. These men, the so-called radical young Hegelians, included Karl Marx, who later attacked Proudhon's *Philosophie de la misère* for its supposedly petty bourgeois opposition to collectivism, but whose *Economic and Philosophic Manuscripts of 1844* made an even stronger claim than Proudhon for manual labor to be the basic determinant of value.[8] Two other men, however, Arnold Ruge and Karl Grün, had a greater effect on Proudhon's development. Before meeting them, the main influences to which Proudhon had been susceptible were those of the utopian Charles Fourier and the positivist Auguste Comte. The latter's concept of a scientific "social physics" must have been particularly appealing. In Proudhon's book of 1843, *De la création de l'ordre dans l'humanité*, in which the influence of these earlier writers is most clearly evident, Proudhon's attempts at dialectical reasoning indicate that he had also at least a passing notion of the ideas of Hegel.[9] As a result of his encounters between 1844 and 1846 with the young Hegelians, who were of course much better versed in Hegel's thought than he, Proudhon was subsequently encouraged to confront Hegel directly on the question of transcendence.[10] Grün and his friends were harsh critics of the Hegelian idea of the Absolute, Grün himself having at the time been influenced by the deeply positivist ideas of Ludwig Feuer-

bach. Grün expounded these ideas to Proudhon: he is said to have proclaimed, paraphrasing Feuerbach, that "anthropology is metaphysics in action." To this, Proudhon is supposed to have replied, "As for me, I am going to show that political economy is metaphysics in action."[11]

This exchange is revealing, because Feuerbach's criticism of Hegel, which Proudhon must have been relieved to hear, involved the basic concept of man. In the *Grundsätze der Philosophie der Zukunft* (1843), Feuerbach had attacked Hegel's spiritualism—his concept that reality is determined by idea—as merely a rationalized extension of the theological doctrine that God created nature. For Feuerbach, neither Hegel nor theology properly recognized the essentially sensuous-corporeal nature of man. Naturally, Proudhon, as a reader of Comte, shared this notion of man as a positive and finite reality grounded in phenomena, and would have regarded man's existence as essentially terminated rather than liberated by death—the latter a decidedly spiritualist belief. To recognize work as man's means to survival was to recognize his mortality as well (as in Courbet's *Burial*), and vice versa. Feuerbach's philosophy of the future was to be "anthropological," that is, not only man-centered, but determined by this positive empiricism. Proudhon's answer to Grün was thus in no way a refutation of Feuerbach's ideas—indeed Grün himself called Proudhon "le Feuerbach français"—but rather an extension of them viewed through his own more economically oriented interests. He believed, so to speak, that the sensuous-corporeal plane of man's activity was that of economics. Man's relation to his peers, which Arnold Ruge had recognized to be the subject of politics and history, thus for Proudhon combined with economics, seen as the medium of human relationships, to generate the science of political economy.[12]

Proudhon's social aims were to be achieved by changing human consciousness. For he recognized that the resignation to mechanization and fatalism encouraged by religion and by government was made possible by the submissiveness of man's mind to their myths. When he wrote "Dieu, c'est le mal," Proudhon meant that by persuading man of the existence of eternal and universal powers beyond his reach, religion deprived him of his capacity for *self*-fulfillment, hence of liberty. What Proudhon called the "authoritarian" principle underlying religion had its translation in any and in every political system, not only in mon-

archy, but even in the supposedly "contractual" system of democracy, in which the citizen ceded individual sovereignty to an elected body.[13] Proudhon held that anarchy (that is, an-archy, the absence of authority) was the only possible condition for social progress, since it was the only condition that respected the positivist premise of the physical and inevitably economic nature of man. Political economy thus literally became, to recall the words cited earlier, "metaphysics in action."

Returning now to Courbet, one can see first of all how his claim to economic freedom was totally congruent with his claim to be a man. One can also understand how his response to Nieuwerkerke had been predetermined by his "mutualist" entente with Bruyas. Later, in the letter of May 1854 to Bruyas in which he depicted himself as sure of his principles, Courbet reiterated the economic theme:

> Yes, my dear friend, I hope in my life to achieve a unique miracle. I hope to live from my art during my entire lifetime without departing even a single inch from my principles, without having even for an instant lied to my conscience, without even ever having made a picture as tiny as my hand in order to please anyone, nor to get it sold.
>
> I have always told my friends . . . : "There is nothing to fear. Even if I have to travel all over the world, I am sure to find men who will understand me; if I only find five or six, they will allow me to live, they will save me."[14]

Even these last lines have a Proudhonian aspect, for as both producer and seller, that is, lacking an intermediary, Courbet would himself have to seek out men to purchase his art. His establishment of links with German patrons as early as 1854 and, from 1862 to 1863, of an independent atelier in Saintonge attest to his attempt to free himself from the traditional Salon and government-oriented pattern of the French art market. He thus set the stage for subsequent secessionist movements, such as those of Van Gogh and Gauguin and of the Nabis.[15]

It is important in this context that Courbet drew little distinction between his painting and any other more ordinary material item of commerce. And in *The Studio* Courbet may have followed Proudhon's philosophy to the letter in this respect, for not only has he shown himself in the physical act of production, but he has located the scene in his workshop in order to emphasize

all the physical, economic, and even industrial, or at least ar-
tisanal, overtones of that location, with its clutter of props and
canvases. Through a peculiar inflection of style, too, Courbet
emphasized the materiality of the object he showed himself cre-
ating. Compared to his large works of previous years, it is re-
markable how conventionally smooth and traditionally modeled
most of the figures in his painting of *The Studio* appeared, their
surfaces so thin that the aging process has now begun to cause
them to fade. This difference from the artist's earlier style was
noticed by Théophile Silvestre, who wrote in 1856 that "with the
exception of the nude model and the artist at his easel, the paint-
ing was pallid, flaccid, and blurred compared to the powerful
technique of the best parts of the *After-Dinner* and *The Bur-
ial.*"[16] The landscape on Courbet's easel was also painted with
the freedom and vigor of the earlier works: one can still see how
the rocks and foliage are heavily impastoed. The colors of the
landscape are also brighter than in the rest of *The Studio*, and
the proximity of the palette held in the painter's hand provokes
a constant comparison between the materiality of the paint as
signifier on the canvas of the landscape and its actuality as coarse
substance on the palette itself, stressing the analogy between the
two (fig. 2). Indeed, X-rays have shown that Courbet changed
the palette's shape from round to rectangular.[17] Whereas his
heavy-handedness had been evidence of his artistic presence
and originality in earlier pictures, this feature was eliminated
from most parts of *The Studio* so that it might be concentrated
in the physical object on the painter's easel. Hence, Delacroix's
comment that the painted landscape, which represented the
countryside of Courbet's native province, was what appeared
most "real" in *The Studio*—despite the fact that it was being cre-
ated in the artist's Paris workshop—was not really so paradoxical
as it might seem.[18] Baudelaire himself called Courbet a "puissant
ouvrier," and a caricature of *The Studio* (fig. 24) shows Courbet
wielding a heavy brush like those used to paint wooden build-
ings.[19] The physical "objectness" of the easel painting as Courbet
treated it thus corresponded uncannily to its reality as a factor
in the politico-economic existence of the artist as a Hegelian
man, fulfilling himself through material production and subject
to economic forces.

Along with Courbet's actual engagement in manual labor, the
physicality of his landscape painting contrasted strongly with

the prevalent romantic image of the artist as a demigod who survived solely by imagination as if he were above the needs of ordinary men. Courbet showed this aspect of the romantic notion of artistic freedom to be a chimera. His demythification of creative activity, however, far from being an end in itself, was meant to reveal all the more clearly the true solution to the problem of artistic freedom. Here again we return to Proudhon, for who else but Proudhon could have declared that "the atelier will make government disappear" or that "the constitutive element of society is the atelier"?[20] It was, in other words, only at the center of the workshop (as the basic social unit) that every man as a *maître*, as an independent worker who owned his means of production and who "monopolized" the disposition of his own product, to use another of Proudhon's terms, could attain liberty. Because of the physical and economic nature of man, then, artistic and intellectual freedom were economic matters. And because the artist had to contend with both the aesthetic and the economic restraints of governmental institutions, they were political matters.

Courbet's entente with Bruyas, which we saw the artist view as much in economic terms as in any other, removed these restraints for him. But beyond the personal significance of Courbet's attainment of freedom, he used his own accomplishment as a Proudhonian model for society as a whole. In 1872 he made such a claim for his art outright, professing to have been "constantly preoccupied with the social question and with the philosophies associated with it," and to have followed "a path parallel to that of my comrade, Proudhon."[21] In 1855, the public appears to have seen Proudhonian doctrine in Courbet's oeuvre, for in that year the caricaturist Cham showed Courbet and Proudhon, both with brushes in hand, in front of a huge canvas (fig. 25).[22] Moreover, in his letter to Champfleury describing *The Studio* in detail, Courbet took time to mention how pleased he would have been to get Proudhon, "who is of our way of seeing," to pose.[23] The jump from the personal to the general level of meaning, then, was dependent on references to Proudhon for clarification. For Courbet's unqualified exclamations, such as "I am achieving liberty, I am saving the independence of Art," were impossible to accept at face value; unsupported, they were, on the contrary, responsible for the slightly comical notion that circulated during his lifetime of an intoxicated Courbet attempting to save the

world.[24] Despite his overstatements, Courbet intended his own artistic liberation—achieved by recognizing his own individuality in relation to tradition, that is, by casting off preconceptions extrinsic to himself—as a model for what could be attained by all mankind. Hence, whether or not Courbet referred to him directly, as he only sometimes did, Proudhon, for whom concreteness and freedom were interdependent, provided the most important key to a claim that in most other contexts would have been absurd. It was only with the later naturalism of Castagnary and Zola that it became important to play down the importance of Proudhon for Courbet in order to appropriate the artist as a predecessor for the ostensibly more neutral, less overtly ideological aesthetic of the 1870s. Otherwise, it is hardly conceivable that an understanding of the crucial significance of Proudhon for Courbet would have been lost. Consciously or not, in the later generation formalism became a strategy for submerging threatening content.[25]

V

THE STUDIO OF THE PAINTER AS HISTORY OF THE WORLD

NO one mistakes Courbet's *Studio* for a realistic representation of an artist's workshop as it would have looked while he was painting. Indeed, even Courbet's immediate romantic predecessors in the theme of the artist's studio presented a more realistic image than his. The difference between them is that while preserving the physical surroundings of the studio as it might actually have appeared, the romantics, whom I have exemplified by Géricault and Delacroix (figs. 26 and 27), showed the artist in an idealized state of dreaming or brooding, as Courbet had shown himself in *Man with Leather Belt* (fig. 6).[1] In *The Studio* Courbet changed this emphasis, now preserving the image of the artist at work while he populated his surroundings with such evident complexity that the painting must be read as a text.

Given its programmatic structure, it is hardly remarkable that Courbet made several attempts to explain *The Studio*—to Bruyas in December 1854, to Champfleury in much greater detail at about the same time, and presumably a bit later to Théophile Silvestre, whose book of 1856 is a source of further information.[2] To another friend Courbet wrote that it would take so long for him to explain the picture's subject that he would prefer to let him guess at it when he saw it. He did offer one hint, however, repeating a version of a phrase he had used to both Bruyas and Champfleury before: "It is the moral and physical history of my atelier."[3] Courbet's most simplified explanation of the picture thus stressed the physical nature of workshop activity as well as its moral significance, alluding through this shorthand to the dialectic he was creating on canvas between Realism and allegory, and to the duality of man.

38

The key document for *The Studio* is of course the description sent to Champfleury (appendix II). Part of it needs to be quoted at length here as a basis for examining the painting in greater detail:

[*The Studio* is] perhaps even larger than *The Burial*, which will show that I am not dead yet, and nor is Realism, since Realism is a fact of life [puisque réalisme il y a]. It is the moral and physical history of my workshop, first stage [première partie]; there are those who serve me, who support me in my idea, who participate in my action. There are those who live on life and who live on death. It is society at its top, bottom, and middle. In a word, it is my way of seeing society in its interests and its passions. It is the world come to be painted at my place. You see that the picture has no title. I shall try to give you a more exact idea of it through a dry description. The scene takes place in my atelier in Paris. The painting is divided into two parts. I am in the middle, painting. To the right are all the shareholders [les actionnaires], that is to say, [my] friends, [my fellow] workers, and amateurs from the art world. To the left is the other world of the trivial life, the people, misery, poverty, wealth, the exploited, the exploiters, people who live on death. . . . I will list the characters beginning at the extreme left. At the edge is a Jew I saw in England making his way through the febrile activity of the London streets, religiously carrying a money-box on his right arm; while covering it with his left hand he seemed to be saying, "It is I who am on the right track." . . . Behind him is a priest with a triumphant look and a bloated red face. In front of them is a poor withered old man, a republican veteran of '93 . . . , a man of ninety years, holding his ammunition bag [possibly used for begging], dressed in old white linencloth made out of patches and a visored cap. He looks down at the romantic cast-offs at his feet (he is pitied by the Jew). Next come a hunter, a reaper, a strong-man, a buffoon, a textile peddler, a workman's wife, a worker, an undertaker, a death's-head on a newspaper, an Irishwoman suckling a child, an artist's dummy. The Irishwoman is another English product. I encountered this woman in a London street; her only clothing was a black straw hat, a torn green sheet, and a frayed

black shawl under which she was carrying on her arm a naked baby. The cloth peddler presides over all of this: he displays his finery to everyone, and all show the greatest interest, each in his own way. Behind him, lying in the foreground, are a guitar and a plumed hat.

Second part. Then comes the canvas on my easel with me painting it seen from the Assyrian side of my head. Behind my chair is a nude female model. She is leaning on the back of my chair to watch me paint for a moment; her clothes are on the floor in front of the picture and there is a white cat near my chair. Following this woman come Promayet with his violin. . . . Then behind him are Bruyas, Cuenot, Buchon, Proudhon (I would like to have the philosopher Proudhon who is of our way of seeing; I would be pleased if he would pose. If you see him, ask if I can count on him). Then it is your turn toward the foreground of the composition. You are seated on a stool, legs crossed and a hat on your lap. Next to you and closer to the foreground is a woman of the world and her husband, both luxuriously dressed. Then toward the extreme right, sitting on the edge of a table, is Baudelaire reading a large book.[4]

In the letter to Bruyas of December 1854, Courbet included the following helpful remark: "I will call this 'First series,' for I hope to put [all of] society through my atelier, to make known and to win agreement for [faire connaître et aimer] my propensities and my repulsions."[5] In addition to description, the principal ideas contained in these statements are, first, that the picture presented an analysis of society and, second, that the purpose of displaying this analysis was to win acceptance for it. The letters helped to make the painter's social aims explicit.

It will be no surprise to find that even in the fine points of his "analysis," Courbet was frequently indebted to Proudhon. For example, the part of society shown at the left of *The Studio* —those who make up the trivial life, those who live on death— are those whom Proudhon attacked. (Associated with them are the "romantic cast-offs [des défroques romantiques].") Many of the figures represent various forms of commercial exploitation or victimization. Whether or not Courbet actually traveled to England, where he claimed to have seen the old Jew and the poor Irishwoman suckling her child in the streets of London, is

less important than his clear allusion to the results, already evident in Britain, of industrialization and urbanization. These processes were only beginning to take place in France. With the support of the financial resources of the Second Empire, this situation was likely further to undermine the traditions of artisanry and worker independence that had animated French industry in its early and primarily rural stage.[6] The earlier phase embodied precisely the values that Proudhon's theories attempted to preserve and to which Courbet may well have been alluding in his *Sleeping Spinner* (fig. 14) and his *Grain Sifters* (fig. 20). Moreover, whether the Jew of *The Studio* is actually a portrait of Achille Fould, a Jewish banker with Saint-Simonian ideas who became Minister of Finances, or whether the priest is actually the ultra-royalist Catholic journalist, Louis Veuillot, as Hélène Toussaint would have us believe, is immaterial.[7] Courbet may simply have sought appropriate physiognomies for the general characteristics he wished to symbolize. The Jew stood inevitably for capital and finance—certain prominent Saint-Simonians were Jewish, too—while the priest stood for the more traditional Catholic bourgeoisie, or perhaps for the neo-Catholicism of the late followers of Lamennais. Both are presented much as the rural population would have perceived them: the Jew is a moneylender; the priest resembles the curé in *The Burial*. In this respect once again, Courbet's vision, tainted by provincial anti-Semitism and anticlericalism, resembles Proudhon's.[8]

Lazare Carnot may well have been the model for the Republican of '93, but more important again is the allusion to the persistence of old-fashioned revolutionary republicanism—Carnot's son Hippolyte had been a member of the government of 1848. The identity of the undertaker is doubtful; but clearly he is dressed as a bourgeois, and he is one who literally "lives on death," or on the spiritualization of it endemic to romantic ideologies. One wonders if this figure was meant to allude through contrast to his earlier painting, *The Burial at Ornans*, in which the rites of death were rudely de-spiritualized.[9] The hunter seated near the foreground with his dog, a figure unmentioned by Courbet to Champfleury despite his prominence, was referred to by Silvestre in 1856 as a poacher [un braconnier]. Hélène Toussaint proposes, correctly it seems, that Courbet represented Louis Napoleon here. Thus, the figure might characterize as poaching the political theft and deception associated with

Louis's election, his coup d'état, and the establishment of the Second Empire. What is more, Klaus Herding has convincingly shown that Louis's special place in *The Studio* reflects Courbet's attempt to enlist his support for the artistic regeneration of society, as I mentioned Bruyas had done in dedicating Tassaert's *Heaven and Hell* to him. Courbet's activity as a worker-artist would embody all that Napoleon III and his ministers had hoped to accomplish through the industrial and artistic Exposition Universelle of 1855, which Courbet's Realism rivaled—that is, cultural and political unity and social progress.[10]

According to Toussaint and to the subsequent work of Michel Cadot, the four male figures in the back row of *The Studio*, from left to right after the Republican of '93, are Garibaldi, Lajos Kossuth, Thaddeus Kosciuszko, and Michael Bakunin.[11] The first three represent Italian, Hungarian, and Polish insurrectionary movements that were based principally on nationalist ideologies. In 1852, the three movements formed a pact that looked toward what they hoped would be liberal French aid. The fourth figure, Bakunin, was a Russian anarchist who, although intimately associated with Proudhon's ideas (Courbet identified him as a worker), had a penchant for insurrection and conspiracy that Proudhon abhorred. From 1848 until his imprisonment in Russia in 1851, Bakunin was constantly promoting Slavic nationalism.[12] Proudhon's relationship to Bakunin is thus a key to understanding this group of figures and its relation to the French characters Courbet showed. For whether in the Crimea, in Poland, Hungary, or Italy, Proudhon violently opposed nationalist movements. In the "Avant Propos" to the *Philosophie du progrès* of 1853, he overtly attacked such movements as engendered by the imperialist intentions of bourgeois capitalism. They would result in fragmentation, which would in turn allow the more powerful and reactionary economic interests to dominate. This seemed to be the basis of Napoleon III's foreign policy at the time. As had quickly become clear in Poland, Italy, and Russia, attention and energy were too often diverted from badly needed economic reforms and social progress.[13] In more generic terms, nationalism was just another authoritarian principle, and it was thus to be opposed as another means of subverting individual liberty.

Expanding the lesson of Proudhon's opposition to the ideas of these men to apply to all the figures on the left-hand side of *The*

Studio, each becomes, in its own particular way, an incarnation of one aspect of the stultifying "principe d'autorité." There is even an indication in Proudhon's writings that he could consider individual national figures—including one of those used by Courbet: Carnot—as having acquired such symbolic roles. In his *Solution du problème social*, Proudhon wrote: "You, citizens Crémieux, Marie, Bethmont, Carnot, Marrast, you symbolize under diverse forms nationalism, patriotism, and the republican ideal. But you remain inescapably within the negative."[14] By "negative," Proudhon meant the opposite of his own positivist-derived principles. That is, these men represented preconceptions based on arbitrary authority rather than the reasoned observation of real phenomena. Indeed, the figures on the left side of *The Studio* could be called ideological romantics, and hence their association with "romantic cast-offs" was anything but coincidental. This was the common denominator provided by what might be called Proudhon's "Realist" political thought. Radical or reactionary, Saint-Simonist or Republican of '93 (there had recently been a Jacobinist revival movement), financier or worker, all of those to the left of *The Studio* were part of, that is, they either believed in or were victimized by, political systems, political solutions, or political action. Proudhon and his co-believer Courbet refused any such externally imposed structures, no matter whether their authority was of the right or of the left. The principle of their solution was, as we shall see, cultural; it was neither political nor violent. Courbet's artistic activity was to be its foundation and its model.

Before turning to the dialectically opposed right-hand side of *The Studio*, it is important to see how Proudhon quite literally may have provided the matrix for transposing Courbet's personal history into world history. In the "Avant Propos" to the *Philosophie du progrès*, Proudhon had made an appeal to all elements of society:

> Royalists and democrats, bourgeois and proletarians, French, Germans and Slavs must all together seek the underlying principles by which they are governed. . . . Humanity . . . must write its own history before its facts are known; it must determine its route in advance [a priori]! Are we to be governed by science or fatality?
>
> . . . Here is the situation: it is to face through reflection

43

the necessity of things; it is to recommence our social and intellectual education; and since a point of view [parti] based on the very nature of the human spirit cannot fail [ne peut périr], it is to give to democracy the idea and standard that have been lacking.[15]

That idea, Proudhon held, though rather vaguely, was the notion of inevitable progress.

Each of the diverse factions mentioned by Proudhon was represented in Courbet's *Studio*. And through the dynamic relationships he set up between them, the painter proposed an illustrated version of an "historical analysis" such as Proudhon had called for in the hope of determining just what the future "route" of mankind would be. To the right, Courbet showed those, like Proudhon, who had confronted the situation of disarray depicted at the left. The painter's own central position, in a resolved or synthetic state, associated him more closely with those to the right than with those to the left, as if he was the first from the right-hand group to have arrived at the "solution" they all sought—the others, such as Baudelaire, having diverged from or not yet found the true path.

Courbet called the figures to the right shareholders (les actionnaires)—again an economic term, and one that implied that each figure had in some way invested in or at least contributed to his enterprise. In the letter to Champfleury, Courbet was vague about the nature of this contribution, except in the case of Proudhon, to whom he had attributed the same way of seeing as himself; presumably Champfleury understood the rest well enough already. The phrase, "those who serve me, who support me in my idea, who participate in my action," seems to specify no more than that there was practical as well as moral and intellectual support involved. Thanks to the letter of December 1854 to Bruyas, we learn in addition that some members of the group were present because they were "artists who share [qui sont dans] Realist ideas."[16] Since no other painters were included, and putting aside momentarily the possibility that Courbet may have meant to include all the figures to the right as Realist artists—just as all those to the left were romantics, and using "artist" in a broader sense we shall soon consider—Courbet must certainly have been referring at least to the Realist poet Max Buchon, to Champfleury himself, and to Baudelaire.

The latter two are the seated figures, Baudelaire being withdrawn to the far right.

In the back row, from left to right, the male figures are Promayet, Bruyas, Proudhon, Cuenot (half hidden), and Buchon. Alphonse Promayet and Urbain Cuenot are the least familiar: like Buchon, they were long-time friends of Courbet, and in a way they illustrate the kinds of support he received. Promayet was a violinist who had taught Courbet's sisters and later struggled unsuccessfully to make a career in Paris. (Thus, he might be included among the Realist artists.) He liked country folksongs, and his politics were leftish; he surely supported Courbet in his "idea." Cuenot, on the other hand, was a prosperous, rugged, and extroverted individual who hunted and drank with Courbet, sat for him as a model, helped him financially during the early part of his career, and yet who was under arrest in 1851 as a threat to the maintenance of order.[17] He may well have been in political sympathy with the painter, who exhibited his portrait for the third time in 1852.[18] To provide material and financial support was also the role of Bruyas, as we have seen, although it was far from limited to that; indeed, he combined both the practical and intellectual modes of participation to a much greater extent than Cuenot. The same can be said for the Sabatiers, although it is difficult to be entirely sure that they are really the models for the couple of rich art lovers standing in front of Baudelaire.[19] In their case once again, individual identity is less important than the roles to which they allude, whereas each of the other figures had contributed more significantly as an individual with particular ideas.

Of the literary figures, Buchon is the most outwardly close to Courbet. His poems and songs, with titles such as "The Pig" or "Cheese Soup," reflected the odors and tastes of the countryside just as Courbet's paintings reflected its colors and its textures.[20] Like Courbet, he had become radicalized by the events and circumstances of the late 1840s. He appears more or less to have directed his advertisement for *The Burial* to "the people," and his interpretation of the picture may reveal overtones of class conflict, as T. J. Clark has suggested.[21] In a group of essays on Realism, Buchon declared, "To be understood by the people, one must be one of the people. They are competent in literature, just as they are in politics and religion."[22] In a letter of 1850, Courbet expressed an identical idea.[23] When Buchon was sought

45

by the police, the Courbet family hid him before he eventually escaped to Switzerland. Courbet's fears that the same might happen to him can hardly have been unfounded.

Champfleury and Baudelaire have the most complicated relationship to Courbet's "idea," and this complexity is surely expressed by their unusual postures and locations in *The Studio*. It is unnecessary to do much more than summarize Meyer Schapiro's perceptive treatment of Champfleury's increasingly estranged attitude toward Courbet's developing politicization.[24] Suffice it to say that Champfleury heightened Courbet's sensitivity to key aesthetic characteristics of popular and folk art, such as that of the Le Nains or popular prints. By adopting their primitive robustness, even their crudeness and their lack of conventional composition, as formal emblems of his own naiveté, Courbet sought to identify the source of Realist art as both spontaneous and popular. Champfleury had been the principal proponent of this basis of Realism, a role to which Courbet alluded by representing a child drawing at Champfleury's feet; Champfleury, perhaps echoing the popular writings of Rodolphe Töpffer, as Schapiro has suggested, habitually compared folk art to the art of children.[25]

Although Courbet was surely further attracted to popular works because of the radical implications of using the art forms of the lower classes, Champfleury himself eventually preferred to see only their conservative lessons in traditional morality. Courbet even understood the radical overtones of the theme of the child better than Champfleury; for in adopting the motif from Rembrandt's *La Petite tombe* (fig. 28), Courbet made a deliberate reversal of Rembrandt's moral comment.[26] The boy's lack of interest in or awareness of the teachings of Rembrandt's Christ was a positive quality for Courbet because of its anti-authoritarian overtones. Courbet's boy studies nature directly, as Proudhon recommended, without academic intermediaries, and he thus echoed Proudhon's phrase, "the veritable school is in the workshop."[27]

Although Courbet eventually assimilated and transformed Champfleury's early and highly romantic version of Realism into what emerged as a single-minded social as well as artistic idea, he thus owed to Champfleury a fundamental aspect of the aesthetic that gave this idea its visual form. It is unlikely, however, that Courbet in 1848 and 1849 could so completely have per-

ceived the relevance for his social aims of the Realism of folk art and sincerity—the latter a trademark of Champfleury's terminology—had he not at the same time been affected by the theories of Baudelaire, to whom in 1849 he was sufficiently close that the poet was writing the painter's catalogue entries for the Salon of that year.[28] In fact, despite Baudelaire's position at the farthest distance from the center of *The Studio* (suggesting how far from each other the painter and the poet had diverged), Courbet still included him in his picture, even though he was under no obligation to do so. What is more, when Baudelaire asked that Courbet paint out the portrait of his mistress, Jeanne Duval, Courbet quickly acceded to the request. He even singled out Baudelaire's importance in his letter to Champfleury with the following words: "I have done a very bad job explaining all of this to you, for I've done it backwards. I should have begun with Baudelaire."[29] Thus, if Baudelaire was the starting point for the autobiographical odyssey Courbet represented in *The Studio*, the painter must have believed that however far away he may have traveled, Baudelaire was still essential for a comprehension of his itinerary. Even more important, Baudelaire was essential for understanding the general, one might say the avant-la-lettre, historical dimension to Courbet's autobiography and the all-important outcome his painting proposed for the social evolution of mankind.

VI

BAUDELAIRE AND THE MORALITY
OF REALIST ART

THE autobiographical phrase, "seven years of my artistic life,"
points us back to 1848, when, as he wrote to his parents, Courbet
felt himself "on the point of success because I have all around
me very influential people in the press and in the arts who are
enthusiastic about my work." With them, he hoped "to consti-
tute a new school, of which I shall be the representative in
painting."[1] Courbet can only have been referring to his friend-
ship with Champfleury and Baudelaire, and his words further
imply that as a member of this founding group of Realists he
had some form of theory on which to base his ambitions. The
three men must have been linked together by a shared preoc-
cupation with naiveté, the primitive, and childhood—themes
adumbrated in Baudelaire's *Salon of 1846*, even though not fully
elaborated until the *Painter of Modern Life* (1863). In 1846,
Baudelaire had found these qualities in the art of the inspired
individual as exemplified in the painting of Delacroix, and he
had identified them with romanticism. But even then, his con-
cept of artistic expression was inseparable from his attitude
toward a modern life deeply embedded in the material world.
The effort of romantic art to transcend everyday reality, offering
a refuge in the more perfect fantasy of the ideal, was one form
of response to and commentary on modern existence, as Baude-
laire saw.

Realism, while appropriating the romantic premise that art
must be of its time, on the contrary refused to treat reality
as escapable. Yet in other respects Courbet's translation of "both
my personality and my social environment" was in complete ac-

cord with Baudelaire's requirement that the artist combine "a sincere expression of his [own] temperament," that is, romantic individualism, with an art that reflected its own epoch.[2] Champfleury's appreciation of *The Burial* (fig. 9) is evidence that in the early 1850s a Realist style based on the aesthetics of Dutch and Spanish painting, on the Le Nains, and on popular images satisfied these criteria: he first quoted from the end of Baudelaire's *Salon of 1846* the passage on the contemporary black frock-coat as an expression of both the political and poetical beauty of the public soul; he then concluded, "The painter from Ornans has understood completely the ideas of a rare and curious book (the *Salon of 1846* by M. Baudelaire)."[3]

Courbet and Baudelaire together, however, outdistanced their friend Champfleury in the realm of politics. For even though, unlike Baudelaire and like Champfleury (but like Proudhon, too), Courbet had abstained from the fighting of 1848, he must have understood that all great art, as Baudelaire had said of criticism, was "partial, passionate, and political."[4] He certainly agreed with Baudelaire's anti-*l'art pour l'art* statement in a commentary on their mutual friend, the revolutionary Lyonnais songwriter Pierre Dupont, that "art was inseparable from morality and utility."[5] And even though Baudelaire might be seen as arguing these points as the result of certain "Realist" premises of romanticism, he appears to have done so on a new basis that, in contrast to Champfleury, made him sound like a follower of Proudhon. Baudelaire had met Proudhon in 1848 after writing to him as "a passionate friend," and Courbet is presumed to have known the philosopher at this time.[6] The Proudhon of 1848, however, was much less the Proudhon of the later *Du principe de l'art et de sa destination sociale* (1865) than he was the Proudhon of the *Philosophie de la misère* (1846). In the earlier work, the philosopher had drawn specific parallels between work and art that not only offered a rationale for the popular origins of art, but redefined the romantic notion of its moral superiority on more apparently scientific grounds than the argument of naiveté. Baudelaire copied a passage from this book in which such a demonstration was the central issue; surely Courbet read at least the same section, if not much more. The community of thought that the three men shared at this time, more than anything else, became the seminal influence on Courbet's career.

And if this is true, Courbet's remark to Champfleury that he should have begun his discussion of *The Studio* with Baudelaire was fully justified.

The all-important pages by Proudhon (see appendix III) began with the observation that "the same force, the same vital principle" that gave value to work was also the principle that ruled the drives of love. The philosopher pointed out that the similarly physical motivations underlying both were responsible for man's attentions so often being divided between the two, a condition that produced the notion that sex and work are incompatible.[7] A dialectical argument resolved this apparent love-work antithesis: it made art into aesthetic labor, and by thus bridging the rift between culture and society it could freshly reveal the high moral significance of art. It is worth following carefully and at length:

> In work, as in love, the heart is moved by the desire for possession, while reason, on the contrary, resists. This antagonism between the physical and the moral aspects of man . . . is the pivot of the social mechanism. Man in his development progresses incessantly from fatality to liberty, from instinct to reason, from the material to the spiritual. It is thanks to this progression that he is little by little freed from the slavery of the senses, just as he is from the oppression of painful and repugnant work. . . .
>
> It is according to this progression that work becomes divided into specialties which are naturally determined in each worker. But this specialization or determination must not be considered as opposed to the collective enterprise. . . . [Rather,] every specialty is a summit from which the worker may dominate and contemplate the entirety of the social edifice, making himself its center and its monitor.
>
> Art, that is to say, the search for the beautiful, for the perfection of the true, in one's person, in one's wife and children, in one's ideas, discourse, actions, and products: such is the final stage in the evolution of the worker, the phase that is destined gloriously to close the circle of nature. *Aesthetics*, and above aesthetics, *Morality*, these are the keystones of the economic edifice.
>
> The whole of human practice, the progress of civilization, the tendencies of society all bear witness to this law. All that

man does, all that he loves and hates, all that affects and interests him becomes for him the subject of art. He composes it, polishes it, harmonizes it until, through the spiritualizing quality [le prestige] of work, he has, so to speak, eliminated from it its materiality.[8]

The conceptual jump between the second and third paragraphs of this passage needs some explanation. Proudhon cleverly redirected the familiar evolutionary schemata of utopian socialism toward more positive and practical ends by redefining its basis in more empirical terms. First, he saw a progression toward greater craftsmanly skill as the result of natural human drives; that is, increased specialization was the natural consequence of the expression of individual talent. It was, therefore, a normal part of, rather than a threat to the evolutionary process, which in its final stage reached the perfection and beauty associated with art. Art itself was viewed as the result of man's will to reason and to liberty; it represented victory in the individual's encounter with the stuff of the world, for it involved the imposition of his rational will on the material of nature, hence the most perfect fulfillment of and liberation from his physical needs. This life-long enterprise was then proof of man's moral worth, so that the link between aesthetics and morality became in effect the keystone to his economic activity. Since Proudhon saw the highest form of social evolution as that which would take its inherent structure from man's natural inclinations (and hence must be based on the rational observation of them), it could be concluded that a society in which all workers had become artists would eventually replace political forms of organization. It is especially important to note that this stage corresponded to the resolution of what Proudhon called the antagonism between moral and physical man. It was to such a resolution that Courbet alluded when he stressed *The Studio*'s role as "moral and physical" history. Proudhon's description of this process as "determination" (a Hegelian term) explains the presence of this unusual word in *The Studio*'s explicative title ("déterminant une phase . . ."). It alludes to the natural identity between the moral example of high art and its origin as a physical *métier*.

As T. J. Clark has shown, these ideas were of profound interest to Baudelaire, who copied out the second-to-last paragraph of the passage cited above in 1848.[9] Although he was more con-

51

cerned with individual fulfillment, and soon dispensed with the relation between art and social progress that had been most important for Proudhon, Baudelaire made the link between man's physical experience in the material world and his art the philosophical core of the *Painter of Modern Life,* which he composed in the late 1850s.[10] Proudhon had redefined the ideal of romantic spontaneity in terrestrial terms. Of course, it must be stressed that Baudelaire soon assimilated the philosopher's writings to his own antipopular obsessions; and he continued to use spiritualist language for his conclusions. But Baudelaire was obviously predisposed to accept Proudhon's pseudo-scientific argument, if for no other reason than through readings in Stendhal, who had earlier related the ideal to contemporary tastes.[11] The point is that in 1848 Baudelaire found in Proudhon a *moral* basis for expanding the artistic role of modern life that he had already proposed at the end of his *Salon of 1846.* And the beauty of the theory he discovered was its apparently empirical rationale. The moral significance of popular art was derived from the same source that had given art its crucial function in Proudhon's social edifice— its relation to man's natural drive to satisfy his needs. By demonstrating how the unrestricted fulfillment of those needs lifted man above nature, ultimately resulting in a just society for all men, Proudhon made Baudelaire's predisposition a moral stance.

Proudhon explained further:

All actions, movements, discourse, thought, products, and manners of mankind bear this artistic character. But this art itself is none other than the practice of activities that reveal it; hence, it is work that leads to its development. It does so in such a way that the more human industry approaches the ideal, the more it raises itself above sensation as well. That which constitutes the attraction and dignity of work is to create by thought, to free oneself from all mechanistic activity, to eliminate the material from the self. . . .

. . . But art, born of work, is necessarily founded on its utility and corresponds to a need; considered in its own right, art is but the means, however exquisite, to satisfy this need. What constitutes the morality of art, hence that which preserves the attractiveness of work, awakens emulation of it, excites its drive, and assures its glory, is therefore its value. . . .

Every worker must become an artist in the specialty he has chosen. . . .

From the idealization of work . . . the result is what is universally called VIRTUE, which is a force (or value) that is properly human—as opposed to PASSION, which is an attribute of man when he is considered merely as the being of fate, as the being made by God.

Human virtue, as opposed to divine force, resides in liberation from nature through the ideal: it is freedom and love in all spheres of activity and knowledge. . . .

It is through virtue (the meaning of this word deriving from the previous discussion) that man, freeing himself from authority [fatalité], gradually assumes full possession of himself.[12]

If the production of art as the sign of man's liberation from nature was the ultimate stage in the development of work, then it was clearly the sign of human virtue. And Proudhon's emphasis on the human aspects of virtue, as opposed to those divine qualities assigned to it by religious or other authority, has brought us full circle, back to the concept of man. Art has taken on a necessary role in the self-fulfillment of the individual; through this role it has become the center of the social (Proudhon said economic) edifice.

Although Baudelaire stopped with the individual, it was this concept, which he shared with Courbet in 1848, that made their relationship to Proudhon the catalyst for Courbet's social conception of art and his abandonment of bohemian dandyism in favor of his Franc-Comtois roots. Even when a more socially alienated Baudelaire soon afterward refused to take Courbet's universalizing ideas seriously, he revealed his understanding of the interconnections that had produced them. His remark, "Courbet saving the world," had been preceded by the notation: "Analysis of nature, of Courbet's talent, and of morality."[13] In other words, he linked together and in the same order the concepts treated by Proudhon in the *Philosophie de la misère*—nature as a positive realm, art as a development from man's physical encounter with nature, and proof of man's moral character through the results of this encounter. Even while dismissing what he considered Courbet's ludicrously ambitious social aims, Baudelaire had intended to use this logical progression to explain them.

The link between Courbet's own attainment of freedom and his ambition for social transformation was thus not a leap made through the painter's singular egocentrism—though Proudhon's theory surely appealed to him partly on this basis. Courbet's personal evolution, through the development of his manual labor into art, was an example of morality for the rest of mankind to follow: *The Studio* was both historical and moral. Whatever the sources for Proudhon's ideas—in the Realist notion of art as spontaneous popular expression, in Fourier's utopian communities founded on satisfaction of the passions, in post-Hegelian dialectics of labor, in Comte's positivism, or Feuerbach's anthropocentrism—Courbet's painting of *The Studio* alluded to the stages of human development as they were suggested by Proudhon, the final stage being that of freedom expressed through art. Courbet used the allegorical structure suggested to him through contact with Bruyas to illustrate a Proudhonian history of man, and he might well have intended to characterize all the figures on the right-hand side of *The Studio* as Realist artists, as men whose work had developed into "art." This natural development, depicted in *The Studio*, both demonstrated the moral value of art and suggested a highly moral basis for a new social order. To paraphrase a statement cited earlier from Proudhon's *Philosophie du progrès*, Courbet literally wrote the history of humanity before its facts were known. In that history, art embodied the synthesis of the duality found in man himself.

Related theoretical histories of mankind or of human consciousness, based on a dialectical structure of opposed successive stages, had been a commonplace in utopian writings for the past fifty years. It is hardly surprising that Courbet, in his self-appointed role as social prophet, should allude to such schemes in the tripartite composition of his painting. Saint-Simon had seen an alternation between "critical" and "organic" phases in man's existence, with the final stage being an organic synthesis of characteristics from both. Pierre Leroux, in his *L'Humanité* of 1840, called the final stage "humanitarian"—a term Proudhon and Castagnary repeated once it had gained currency; in this stage, equality among all men would be attained. Auguste Comte described the progression of consciousness as moving from the theological, through the metaphysical, to a final positive stage sometime in the future. As we shall see shortly, this was probably included in Courbet's idea.[14] The principle underlying these the-

ories was an old-fashioned belief in progress. In the final stage of history, man would transcend the contradictions of his earlier development; he would recover the wholeness necessary to his well-being within an ordered society. In fact, most romantic socialism revealed its conservative nostalgia for order by adopting absolutist, frequently religious terms to describe how society would be organized during history's final stage.

In virtually all such doctrines, the artist had a leading role as a visionary or inspired priest of social revelation, a role which both reinforced and expanded the romantic conception of the artist. Courbet had attempted both to confront and to assimilate this concept by presenting himself as a worker-artist. Thus, the distinction between the romantic theorists and those, including Courbet and Proudhon, whom we may call Realists, had to do with the material basis the latter attempted to give their formulas. In the *Philosophie du progrès*, Proudhon reiterated the seminal theory contained in the *Système des contradictions* while detailing it more specifically as it related to art: the "asceticism" of work (a term used by Marx as well) was the only authentic basis for art, that is, the deliberate espousal of materiality, and resistance to the seductions of idolatry in art were keys to its leadership toward the future (see appendix IV). What Proudhon had in common with his predecessors, then, was the idea, still founded on a belief in progress, that art embodied a synthetic state corresponding to reconciliation and transcendence. In the *Philosophie du progrès*, he described it with the word apotheosis, redefined of course in materialist terms. This idealism of the Realists justified the concrete perceptions of the economically free and self-interested individual as the basis for a new society.

Proposing this model as a pragmatic alternative to the quasi-mystical illusions of the utopians, especially after their failures of 1848, Courbet and Proudhon appeared to offer practical means of facilitating social advancement. Their effort, while still naive, does not seem misdirected. However, it needs finally to be placed in historical perspective by recalling some of the criticisms of Proudhon made by Marx.

In his refutation of Proudhon, called *La Misère de la philosophie*, Marx showed how Proudhon's concept of work elided the central modern questions of proletarianization and division of labor. Proudhon's view of society was ahistorical; still based on

a romantic notion of progress, it failed in both its analysis and in its proposed solutions to consider the results of capitalism and industrialization. Rather, it nostalgically advanced a model founded on the presuppositions of rural experience, and it overtly constituted a defense of rural middle classes. Even if Proudhon was right in his belief that the cooperative traditions of his native countryside exemplified unalienated social and economic activity, he was no less naive in thinking that one set of communitarian conditions was any more valid for the future evolution of society than others, such as those proposed by Fourier and Considerant, whom he so often attacked (yet who also had Franc-Comtois roots). Proudhon's liberated worker was still essentially a provincial artisan of the petty bourgeoisie. And Proudhon's treatment of the division of labor as "specialization" ignored rather than resolved what Marx showed to be the real problem: the reduction of work to isolated mechanical tasks. Proudhon's contention that specialization still offered the satisfactions of artisanship was either unrealistic in the light of modern conditions, or simply failed to take them into account.[15]

Courbet's survey of society, which is reflected by the social and economic types he portrayed either in individual pictures or in *The Studio* (none of which contain any clearly industrial activity), reveals the same limited experience as Proudhon. Indeed, *The Studio's* furtive allusions to an industrial or urban future show it as a prospect to be feared and avoided rather than one on which to base a new social philosophy. Marx might have said not only that Courbet's views were as anachronistic as Proudhon's, but that he had fallen into the dangerous trap of Proudhonian thinking. That is, Courbet was deluded into believing that when clothed in empirical language and ostensibly based on historical examples, the principles of a disappearing past could be reintroduced for the future. If, as T. J. Clark has effectively argued, Courbet's self-image was rooted in a need to integrate certain bourgeois aspirations within antibourgeois and anti-Parisian dreams of social reform, Proudhon's appeal is clear.[16] His apparent fusion of moral utopia and practical observation wedded two chief romantic concerns of the 1830s and 1840s in a way that justified the leadership role of Courbet as a Franc-Comtois artisan. However fallacious such logic might have appeared to Marx, and perhaps to us, it represents an exemplary mid-nineteenth century answer to the persistent tension between

the claims of positivism and romanticism to resolve the so-called social problem. We shall see how this dualism was exhibited in *The Studio* itself and in Proudhon's responses to Courbet, for both reveal conflict between Courbet's romantic self-image and the naturalist thrust of the aesthetic the painter now propounded.

VII

REAL ALLEGORY AND REALISM

FAR more than most paintings of its time, especially other paintings by Courbet himself—as the passage from Schanne I have used as an epigraph suggests—*The Studio* is an image that deals directly and above all with ideas. Its presentation of a progression through time toward a singular goal (note that Courbet speaks of his idea and his action in the singular) evokes the literary function of allegory as a way of enhancing the discovery of a moral or historical truth by clothing it in an air of ritual. *The Studio*'s scenario of moral and social development that was (in Proudhon's philosophy) demonstrably necessary and therefore true was an appropriate subject for allegory. Thus, in the sense that it expresses verbal concepts through pictorial signs, *The Studio* is so clearly allegorical that this aspect of Courbet's title would be a far less controversial issue had the artist not denied in theory the possibility of ever painting what was not concrete, and claimed that his allegory was "real."[1]

The Studio's claim to be real as well as true was at least in part based on Proudhon's link between man's positive physicality and its necessary fulfillment in an anarchistic social ideal. In that context, "real allegory" meant simply the "Realist version" of philosophical, hence of social and historical truth. This explanation, however, covers only part of the complex resonances that were set into play by Courbet's disconcerting conjunction of the word "real" with the idea of allegory as a pictorial or literary mode.[2] One can only be sure that the juxtaposition of terms was deliberate and significant on several levels; Courbet loved to play on words and had used loaded terminology in his titles before. For example, *The Burial at Ornans*, the painting to which he later pointed as his declaration of principles, had been entitled "tableau historique."[3] By the same token, Courbet mentioned

to Champfleury that his painting of *The Studio* had no title. Since he made this remark just after stating that "it is the world come to be painted at my place," he might have been suggesting that in showing the world, or better, society as a whole, his new painting needed no title. Certainly if in terms of mode he wished to classify the picture as allegory, it would in this context have had to be "real" allegory, too. Society was shown standing for itself rather than being represented by arbitrary or conventional substitutes used as symbols. Courbet may have meant that no such substitutes needed designating by means of a title, since something that is real is self-evident without one.

One needs only to compare the necessity of titles for previous allegorical pictures of socio-political intention to understand this point. For example, Dominique Papety's Fourierist *The Dream of Happiness* of 1843 (fig. 29), with its lolling classical figures, could hardly have had contemporary overtones without its title and the word "harmonie" inscribed on the base of the large statue toward the picture's left; these words were catch-phrases for concepts in Fourier's theory of universal harmony.[4] Another good example is Thomas Couture's *Romans of the Decadence* of 1847 (fig. 30). Its effectiveness as a pictorial form of political discourse would have been severely diminished without the specificity of the word "decadence" in its title or the lines from Juvenal's *Satires* that accompanied its entry in the Salon catalogue.[5] Courbet preferred to construct allegory with elements from modern life itself.[6]

If Courbet was still referring to *The Burial* in 1854 as his declaration of principle, one must ask how a real allegory could continue the work of a "tableau historique"—how both could be based on the same principle. Perhaps an answer can be found in the term "tableau historique" itself, for it seems deliberately differentiated from the more usual appellation, "tableau d'histoire"—history painting. By "historical painting," Courbet surely meant painting of equal status to history painting, still generally considered the highest of the genres, but based on contemporary reality rather than on the past. This oft-repeated claim for the valid historical significance of the present and its right to appear in high art was once again relevant in 1850-1851. Courbet chose his terminology in order to stress the point. The real allegory, on the other hand, dealt not with a single point in time, but with a process of development over time, as we have

59

seen. Hence, Courbet's terms, the "top, bottom and middle" of society may refer to stages in social development, Courbet himself having been the first to reach the summit at its center. Sabatier had remarked in his defense of modern subjects that each moment in time was a stage in a process of becoming and that, since the present contained the seeds of the future, it was not only the right but the duty of the arts to investigate the present.[7] This principle explains both *The Burial* and *The Studio* equally well.

With *The Burial* there is no question that Courbet chose such a path, especially if he was already consciously proposing the view of man it represented as the basis for social progress. With *The Studio* he went a step further, for in it the investigation of the present was made to reveal the past and the future explicitly. The term "real allegory" on this level thus asserted the reality of what was not immediately apparent on the surface of the present—that is, the process of the future's coming into being. Its emergence began with the casting-off of all elements of authority; and since, at least in Courbet's view, the artist was the forerunner for the rest of society, authority meant especially the power of academicism and the preconceptions of the romanticism of *l'art pour l'art*. The props immediately to the left of Courbet's landscape in *The Studio*—the cast of a figure in a St. Bartholomew pose, the guitar, the dagger, and the plumed hat—refer to these discarded beliefs, whereas the studio model behind him and the child at Champfleury's feet drawing this model refer to the literal contact with nature that replaced them. Even the cat, an animal well known to be favored by Gautier, Baudelaire, and Champfleury as a symbol of quasi-erotic mystery alluding to the inspirational sources of the romantic artist, bends down in a gesture of double acquiescence to the new authority of Courbet and the naked model. Yet its posture is the totally natural and instinctive one of an animal ready for play.[8] Finally, in an obvious *vanitas* reference, the skull used as a paperweight on the *Journal des Débats* (to the left of the easel) was not only a response to this conservative newspaper's attacks on the Realists, but may, according to Théophile Silvestre, have been an attempt to transpose Proudhon's phrase, "Newspapers are the graveyards of ideas."[9] The authority of *ideas* was what Courbet rejected.

In 1861, Courbet saw the meaning of *The Burial*, although

not apparent on its surface, as identical to that of *The Studio*; he called it "the negation of the ideal" and the "burial of romanticism."[10] In this sense, the real allegory of 1855 made explicit the principle and consequences of the earlier treatment of the real as an artistic subject. Clearly Courbet, who was "sure of his principle" in 1853 and who claimed *The Burial*, begun in 1849, as its first declaration, had followed a single "idea," a coherent course of action since 1848. The difference between *The Burial* and *The Studio* is then principally related to their different modes as pictorial discourse, to different ways of expressing their single central preoccupation—the real. As an expression of social evolution, *The Studio* therefore belongs to the same category as Papety's *The Dream of Happiness*. Its figures are even similarly, and quite traditionally, arranged in the composition as a whole. But this parallel merely offers an additional reason to take *The Studio* as Courbet's activist and Proudhonian answer to images like Papety's wishful Fourierist golden age, just as Proudhon had so often cast his own writings as practicable responses to the naive utopias of Fourier and Considerant.[11]

Courbet may well have been aware of the modal divisions within his overall oeuvre between 1848 and 1855, for he seems to have viewed his paintings as belonging to series. We may recall that in the letter to Bruyas of December 1854 he called *The Studio* his "First series." He added: "For I hope to put [all of] society through my atelier."[12] In the letter to Champfleury, Courbet mentioned that he had "a picture of rural customs based on grain sifters that forms part of the same series as the Village Maidens."[13] This other series was clearly distinct from that represented by *The Studio*, and must have been defined by its rural subject matter. *The Studio*, on the other hand, being more overtly ideological, contained the whole of society and propounded a complete theory of social analysis. It could in fact stand not only as a "series" on its own, but as the "first" or highest of such series, since it made a complete disclosure of the principle from which the rest of his art, hence other series, had been generated. If this principle, which Courbet called his idea and his action, was to be taken in the singular, the "first series" then became indivisible—incapable of elaboration as a group of separate, however interrelated, parts. A third series within Courbet's

oeuvre might have been portraiture and self-portraiture; and a fourth might have been based on urban subjects, had Courbet finished the picture of *Firemen Running to a Fire* (fig. 12) and done more on related themes. A fifth would of course have to be reserved for landscape. Each group, seen from the retrospective view of 1855, could thus have stood as an elaboration of one of the many categories embraced by *The Studio*, even though all the pictures in each series were executed before it.

However, at this point it should be recalled that the word "series" was a philosophically loaded term, referring to a principle of organization that had found favor among utopian socialists, especially Fourier. The so-called "loix sérielles" were transcendent numerical principles that governed the world; Pythagorean in origin, in the mid-nineteenth century they became a basis on which universal harmony could be constructed. Even Proudhon, although he was no mystic, was strongly attracted for a time by the concept, which formed one of the key methodological approaches of his *De la création de l'ordre dans l'humanité, ou Principes d'organisation politique* (1843). In this, perhaps the most chaotic and diffuse of his treatises, Proudhon attempted to put the concept of series on a more empirical foundation than pure numerology, and he applied it to the more practical ends of political economics. His breakdown of areas of knowledge or activity into series was supposed to reveal classes of relationships at different levels such that categories appearing on one level to be contradictory would, on a higher level, reveal their greater unity. So-called "seriation" was an obviously crude and overcomplicated, if ostensibly scientific, form of dialectical reasoning.

Toward the end of his book, Proudhon wrote that "the problem of the creation of order in humanity" was one of applying philosophical logic "to coordinate and classify necessarily equal functions; to distribute the tools and the product of labor according to individual specialties and the laws of exchange." The determination of series was the key: "To organize society is to describe a series; for, even if the social series is immutable in its [overall] form, its organic units are vital, intelligent, and intelligible. To organize society is to make the synthesis of the material and the spiritual. . . ."[14] Serial ratiocination for Proudhon had come a long way from Fourier's arbitrariness, and represented a scientific brand of metaphysics that could reveal the

unimpeachable, quasi-mathematical laws underlying material relationships. "To discover a series," he wrote, "is to perceive unity in multiplicity, synthesis in division: it is not to create order on the basis of predisposition or a preconception of the mind; it is to place oneself in its very presence and to view its image through an act of intelligence." "*Raisonner*, c'est SERIER," he exclaimed.[15] Courbet, proclaiming the analytic purpose of his images of society, also used the notion of series to emphasize his scientific approach.

Even though it constituted a different mode from the works in Courbet's other series, and even if after the fact, the real allegory was able thus to establish the basis for the deeper significance of other pictures by partaking itself of a central aspect of their subjects. The series before 1855 had dealt mainly with different social types and *métiers*, themes that were of course basic to the choice of personnages for and the organization of *The Studio*.[16] At the same time, *The Studio* was itself a version of that theme, for the artist was a characteristic social type, and the practice of art was a *métier*—a status *The Studio* explicitly acknowledged. Courbet's claim that the artist's role in *The Studio* was to take the world as his subject made art a metaphor for all other occupations. Realist art was archetypal in the sense that it was the least specialized; it was the least selective because it recreated the whole of reality, refusing to make arbitrary choices within it. But it was precisely for this reason that it became the highest and most perfect of the occupations as well, for the process of its total recreation of the world served to reveal the philosophical nature of reality. Werner Hofmann put it succinctly: "*The Studio* is a glorification of the creative act through which the world knows its own meaning."[17] Moreover, the artist is simultaneously at the top, bottom, and middle of society; he expresses on all levels at once the individual activities of those in other roles. As Harry Levin has written: "Here the real allegory is that of the self-portraying artist, whose world is the studio and whose studio is the world, whose symbols are actualities and whose ideology is his art."[18]

VIII

THE SOCIAL QUESTION AND
LANDSCAPE

IF Courbet's principle is to have a single name, it must be the word "Realism." But this simple word had profound and multiple implications in 1855, and one ought perhaps first to clear the ground by citing a few aspects of what it did not mean for Courbet. First, Realism referred to a coherent school of artists only in the very loosest sense. In his so-called Realist Manifesto, Courbet claimed to accept the term merely because it was available —he knew of course that in a general way it was appropriate— and, as we shall see, he took pains to explain what it meant for him. The notion of a school was abhorrent to Courbet, and, as all the various defenders of the term from about 1855 to 1857 recognized, one of its fundamental tenets was in fact the absence of principle and the preservation of the individual artistic temperament. In 1857 both Edmond Duranty, editor of the short-lived journal entitled *Réalisme*, and Champfleury, who had just published a series of essays called *Le Réalisme*, spoke out against those who accused the Realists of exclusivity. Duranty insisted that no single member incarnated Realism, but that the school was made up of individuals each with his own brand of it.[1] Champfleury also refused the concept of a single Realism: the only principle he recognized, he said, using one of the Realists' favorite terms, was "sincerity in art."[2] Courbet himself, of course, despite the importance he attached to his own example for the evolution of a new society, warned those who approached him to be their teacher not to do what he or what anyone else did; to imitate another artist, he claimed, was a form of suicide.[3]

A second aspect of Realism rejected by the Realists had to do

with another aspect of imitation. Nature was never to be copied so closely that art became a mechanical process. For Courbet, total submission to reality would merely have been to substitute one form of authority for another, whereas above all, he saw self-realization through art as a means of preserving individuality. Champfleury's argument in an essay dated 1854 from *Le Réalisme* was slightly different. He maintained that even if he tried, man could never operate mechanically, like a daguerreotype: "Man's reproduction of nature will never become a *reproduction* or an *imitation*, but will always be an *interpretation*." For "no matter what man does to enslave himself to copying nature, he will always be caused by his particular temperament . . . to render nature according to the impression he receives."[4] For him Realism was automatically a matter of honesty and temperament and, as in romanticism, its link to morality was through this element of subjectivity. Indeed, this conservative aspect of its ideology was never so well exemplified as in 1857 by the chorus of protest, which included most Realists, against the amorality they perceived in the neutral aesthetic of Flaubert's *Madame Bovary*.

While Courbet might have agreed to some of Champfleury's theory, his view of the relationship of moral truth to concrete reality was different. Like Proudhon, Courbet repudiated the right of judgment by any external authority—we recall how he claimed to be the sole judge of his painting. In the letter to Champfleury on *The Studio* he further harped on this theme: "Those who wish to judge [*The Studio*] will have their work cut out for them. They will have to do the best they can. For there are people who wake up in the middle of the night screaming and shouting: I want to judge, I must judge!"[5] In Courbet's view, morality and truth were concepts that concerned the individual only. For in his liberated state, in his state of fulfilled manhood, the individual reappropriated for himself those roles of which external authority—religion and government in particular, as the creations of idealism—had deprived him. In Feuerbach's theory, man was the only god of man.[6] Morality and truth could exist solely as part of the reality of man. Since this reality was necessarily physical, morality and truth must be sought somehow within the very substance of matter. That is why the most noble and the only true role of art was to explore the materiality of

things. And that is why art, which was itself a material object produced by manual labor, could eventually become its own most significant subject matter.

The connection between this consequence and the role of art as the centerpiece of Proudhon's and Courbet's dream of social justice is crucial. In *Du principe de l'art*, Proudhon wrote:

> Liberty . . . does not consist in freeing ourselves from the laws of truth and justice; on the contrary, liberty grows as we approach the just and the true more and more closely. How could it be different for art, which I consider the proper and specific expression of liberty?[7]

In 1858, Proudhon had asserted that Realism was the precondition for the relationship between liberty and art:

> Art is liberty itself, recreating under its guise, and for its own glorification, the phenomenality of things, executing (pardon the word) variations on the concrete theme of nature.
>
> Art, like liberty, has as its subject man and things; as its object it has their reproduction, while at the same time it surpasses them; as its goal it has justice.[8]

If liberty was the recognition of and the fulfillment of the true nature of man, Realist art was its physical incarnation. In theory it could, by exploring its own laws, arrive at the laws of truth and justice.

This metaphysical justification of Realist style points up a fundamental disagreement between Courbet's Realism, or, to stay closer to Proudhon, his phenomenalism, and the still basically transcendentalist attitudes of others, particularly of Bruyas and Sabatier. Bruyas' constant references to the ultimate attainment of God totally contradict Courbet's and Proudhon's emphasis on man, for however much the process of Bruyas' dialectical journey might have taken him through the substance of the real —and on this he seems rather superficial—his ideal was still ontologically independent from its manifestation in phenomena. Bruyas' inclusion in an appendix to his *Explication* of a series of long quotations from the lectures of Victor Cousin, whose *Du beau, du vrai et du bien* had just been published separately in 1853, is more than a further clue to this traditionalist bias, for it appears almost to stand as an answer to Courbet's positivism and

Proudhon's atheism.[9] For Cousin, quoted by Bruyas, God resided behind all forms of beauty—physical, intellectual, and moral—and although a synthesis of the ideal and the natural would be necessary for visual representation, the goal of art was nonetheless to express the good through its symbolization in beautiful forms. To this theory, taken from Cousin, Bruyas gave the subtitle, "Solution Bruyas."

Sabatier seems to have made a similar distinction between this view and Realism explicit when he polemicized: "I want a serious and a profound art, and that is why I want it to be *true*, I do not say *real*."[10] The difference between the true and the real, which did not exist for Courbet, and which we shall see clearly defined by Proudhon as "critical idealism," can only have been based on Sabatier's belief in the moral superiority of noumenal concepts, such as those still proposed by Victor Cousin. Proudhon specifically rejected such a notion in his *Système des contradictions*, where he called the idea of "vrai" man no more than a "projection" as opposed to the "réel."[11] Thus, a clear parallel can be drawn between, on the one hand, Courbet's positivist Realism versus traditional forms of art, and on the other hand, the young Hegelians' critique of Hegel's version of idealism. The young Hegelians had argued that rather than freeing himself from tradition and using philosophy to criticize it, Hegel had merely assimilated tradition, substituting the more naturalized concept of Absolute for the concept of God. Courbet's study of the artistic past has to be viewed in this light; only by understanding tradition could one free oneself from its authority.

———

The social purpose of Courbet's Realism, as opposed to art that sought to display so-called a priori truths, was in the artist's interpretation of the Proudhonian point of view enhanced rather than diminished by its concrete positive emphasis. Although some of the limits of this interpretation became in part the subject of Proudhon's late *Du principe de l'art*, it appeared at present that the social good to be achieved through a confrontation with unadulterated reality was not unlike the liberating process realized through the study of tradition. This is probably why, of all Courbet's paintings, Proudhon seems to have best understood *The Stonebreakers* (fig. 8): he believed better knowledge of the facts of contemporary reality would lead man to self-improve-

ment. Anticipating the *Du principe de l'art,* he wrote in the *Philosophie du progrès* of 1853 (see appendix IV):

> Let the people, recognizing its misery, learn to blush at its cowardice and to despise tyrants; let the aristocracy, exposed in its fat and obscene nudity, receive on each limb the lashes of its parasitism, insolence, and corruption. Let the magistrate, the soldier, the merchant, the peasant—all conditions of society—seeing themselves each in turn in the epitome [l'idéalisme] of their dignity and their baseness, learn through both glory and shame to rectify their ideas, to correct their habits, and to perfect their institutions. And let each generation, recording on canvas or in marble the essence of its spirit, come down to posterity with no other indictment or apology than the works of artists.
>
> This is how art must participate in the movement of society, both provoking it and following it.[12]

This method of achieving social transformation through art was different from, although not unrelated to, art that attempted to represent the process of liberation itself, as in *The Studio.* But Proudhon was put off by the latter, first of all because of its ideological, as opposed to its descriptive intentions. He undoubtedly preferred history to allegory because history operated on consciousness through a narrative representation of positive reality whose moral intention could immediately be restated in verbal terms. He also objected to *The Studio* because for him Courbet's preoccupation with himself got in the way of any perception of the broader application of his principles. Even though *The Studio* was based on his own writings, Proudhon could not accept Courbet's assimilation of all social roles, including and perhaps especially that of social philosopher, to his own.

Most of Courbet's major subject pictures from 1848 to 1855 did in fact deal with the social theme precisely as Proudhon had advocated. That is, they used historical or descriptive as opposed to allegorical images of real man, representing him both in his physical activity and its limitations. They range from the dehumanized figures of *The Stonebreakers* to the charming sensuality of *The Sleeping Spinner* (fig. 14). (The latter is spent by her devotion to a task, as Werner Hofmann has suggested, that epitomizes man's—and the artist's—unalienated creative enterprise.)[13] Even *The Bathers* (fig. 13) might be part of the series

of rural *métiers*, if only because Courbet's ironic display of the woman's excess fat shows that she clearly suffered from the absence of a serious occupation. While the picture clearly restored to woman all the fleshy physicality that had been denied in idealist art, rendering her so provocative that Louis Napoleon irately struck the image with his riding crop, *The Bathers* may also have been a response to the ideas contained in the passage from Proudhon just cited, for Proudhon's lines had been composed during his imprisonment of 1851, when Courbet had been a frequent visitor. At least Courbet's sisters in *The Village Maidens* (fig. 11) were occupied by an act of charity, which for the artist surely alluded to the rural tradition of communal sharing on which Proudhon founded aspects of his anarchism.[14] *Firemen Running to a Fire* (fig. 12) also shows a dignified aspect of man's activity. *The Grain Sifters* (fig. 20), painted in 1854, has become more complicated, however, for while the gesture of the main figure suggests her strength and the nobility of her work—which is here again set in a rural domestic situation—it is unconscious; and the posture and expression of the woman to the left might even imply a degree of boredom or physical laxity. That is, Courbet's figures lack an ideological attitude toward their own activities.

Similar psychological complexities are inherent in all of Courbet's multi-figure compositions of this period—witness *The Peasants of Flagey* (fig. 10), *The Burial* (fig. 9), and *The Toilet of the Dead Woman*. All partake of a Proudhonian vision of humanity, as at least part of their significance. The latter two deal so matter-of-factly with man's phenomenality in their display of a ritualized community acceptance of his mortality, that they become in a sense positive pendants to the negative lesson of *The Stonebreakers*. The inertness of figures in *The Burial*, which Meyer Schapiro (see epigraph) has associated through popular imagery with the collective spirit of a community that survives beyond the death of individuals, is kind of Proudhonian response to the intoxication of the barricades of 1848, at which neither the pacifistic Proudhon nor Courbet fought. For whatever else it may be, *The Burial* remains ultimately and essentially an image of the matter-of-factness and the inevitability of death, as its deep-dug grave, projecting rudely into our space (we see only the head of the gaping hole in the picture) never lets us forget.[15]

These pictures implicitly suggest the values of rural society as

a source of radical renewal *cum* reconciliation in a divided France. For the society Courbet depicted was capable, however unconsciously, of recognizing, accepting, and assimilating the mortality, the imperfections, even the grotesque foibles of its constituents, as they are displayed in *The Burial* and *The Peasants of Flagey*. Such qualities were not only recognized by Proudhon, they were seen as the very essence of man's physical being. Of *The Peasants of Flagey* (fig. 10), the philosopher wrote:

> Here is rural France, with its indecisive mood and its positive spirit, its simple language, its gentle passions, its unemphatic style, its thoughts more down to earth than in the clouds, its mores as far removed from democracy as from demagoguery, its decided preference for the common ways, far distant from all idealist exaltation, happy when it can preserve its honest mediocrity under a temperate authority. . . . That which characterizes our people, what you will find in all classes of French society regardless of distinctions of wealth, age, or sex . . . is a moderate temperament, a unified character, evenness of habits, no ambition to rule and even less to rebellion, and the most profound antipathy for all that departs from the common, everyday direction [la route vulgaire].

Explaining why this vision infuriated a Parisian public, Proudhon continued:

> No doubt we are no longer today, in Paris especially, like those I have described in explaining Courbet's painting. Our political middle road has resulted in shameful destitution. The respect for mediocrity that characterized our fathers has given way to the impatience of industrialism and the greed of stockbroking; we have given up our Gallic common sense for a pretentious and sophistic terminology, and the eccentricity of our pleasures makes our old customs look insipid.[16]

Political structures, Proudhon would argue, must be based neither on such hypocritical pretensions nor on some impossible idealization of man; they must derive from his natural, unpretentious, positive character, fully grounded in time and place and fully engaged in a life determined by his physical existence. The same must be true for the artist. The principles of independence

in the fulfillment of this existence, and of cooperation, were fused in the ongoing ritual of rural life. Although they constituted elements of conservatism and continuity in the communities of the Jura, they had at least evolved naturally and thus corresponded to man's basic needs, no matter how mediocre they showed man ultimately to be. This was their value for Proudhon, who used them to challenge any centralized or arbitrary authority, including both that of the Parisian version of democracy and the class-oriented and other utopian proposals of the socialists and communists. By the same token, Courbet's art was highly inflammatory to a Parisian audience. On the aesthetic level, of course, its depiction of plain folk in their vulgar mediocrity was an overt parallel to Proudhon's political ideal. But the straightforward relation of his subjects to the rural conservative tradition—in which the community comes together spontaneously, embodying the natural coexistence of individuals as independent equals regardless of class differences—was a threat to the political ideologies of Paris, especially, it is ironic to note, to those of the Right.

The radicalization of Courbet and of the Jura peasantry may have been born of impatience with and resentment of the centralizing, proletarianizing, and appropriating tendencies of Parisian capitalism. But their responses, however radical they appeared to Paris, were rooted in their own experience of a rural life that combined individual liberty with collective cooperation based on pragmatism. Courbet himself and the subjects of his painting were clearly untouched by the myths, both aesthetic and political, that moved men of Paris. The evidence of this is to be found in Courbet's ostensibly crude style and in the apparent immovability, acquiescence, even indifference of his subjects to their world. The threat they posed was less one of defiance than of utter lack of susceptibility to political and ideological control. This very manner of their existence, as displayed by Courbet, embodied the myth of natural, unaffected, and unconscious rural oneness with self and nature.[17]

Before *The Studio*, Courbet's Realism had generally addressed the social question through overtly and sometimes explosively political subjects. Presenting images of a society reconciled to and based on a de-spiritualized concept of man, the painter had clearly been guided by concepts he shared with Proudhon. After *The Studio*, however, we find Courbet withdrawing from this stance, turning rather more to landscape, and hence apparently

diverging from the social function of the artist proposed by Proudhon. Yet, if we may judge by *The Studio*, Courbet may well have begun, despite Proudhon, to see landscape as a more effective, if more subtle, social tool.[18]

No other genre better reveals man's attitudes toward both the world and art than landscape painting, for in it the artist encounters the stuff of nature in its raw state. Artists who accept this state ultimately convey as much about their metaphysics as do artists who openly transform the raw material into an idealized stage for human activity. When the artist is Courbet, who placed an unadulterated view of his native countryside in the central position of his real allegory, this metaphysical revelation becomes a proclamation. For the idealist, the essence of nature resided in a concept that only human art could disclose; his ennoblement of the scene through association with literary subject matter became an analogy for his own ennobling creative perception, which the classical tradition linked to his ability to imagine the perfect intentions of God. For the Realist, the sacred function of the artist was to reveal that the reality of nature resided in her surfaces and physical substances. Whereas in the romantic ideal, man dominated nature through creative reason, Courbet left his mark as a physical man on nature through the contact with her that was evidenced by the materiality of paint: the real in nature was concrete and physical, just as paint is real and physical in the work of art. The physical status of paint as a concrete constituent of painting metonymically revealed the concreteness of a real world made up of specific and material fragments like those Courbet chose as subjects.[19]

The scale of Courbet's pictures, which in so many instances was that of life itself, or even larger than life, as in some late still-lifes (figs. 31 and 32), emphasized the physical presence of reality. So did his style, with its broad brushstrokes, its palette-knife work, and its burgeoning crust of thick pigment. Moreover, that the fish of figure 32 are dead and the apples of figure 31 are rotting are manifest references to finite existence. Such paintings thus became positivist reinterpretations of the theme of *vanitas*, just as a series of pictures of the sea (fig. 33) turned the romantic symbol of the infinite and the spiritual—Victor Hugo's "Ma Destinée"—into a wall of brute physical force. Although the scale of Courbet's marines could not be larger than life, as were the still-lifes, the presence of frail boats on the shore in the

foreground, as in the Louvre version of the theme, or of tiny skiffs on the horizon, as in the Berlin picture shown in figure 33, emphasized physical disproportionality. Any romantic notion one might be tempted to project is quickly dispelled by the weight and presence of the painting's surface.

In Courbet's landscapes, we are often brought to the deepest part of the woods, where the purest water flows out of the earth from a spring or grotto, or where the illusion of physical proximity creates a sense of intimacy with the trees (fig. 34). At other times, we are transported to a plain or a valley, where rocky cliffs have risen up from underneath their rich loam and grass blanket, yet where the moss has begun to close the cycle, to cover them up again. In contrast to the painters of Barbizon, Courbet's views are rarely distant or brooding; they are actual.[20] In fact, many of his pictures called landscapes are less views of the land or of subjects, human or other, in the land, than closeups of subjects in their natural environment or experiences of growth and movement in nature. They are not born of the frustration of being an outsider to the countryside, of holding nature as an ideal or a goal; they are lived. Courbet, who loved to fish and hunt, knew the scenes he painted as part of his own habitat; he knew them matter-of-factly, familiarly, with neither fear nor awe. In the many magnificent works he produced in the 1860s, the artist's power and freedom as both a personality and a master craftsman border on the lyrical. One senses through the painterly vigor how his contact with these surroundings was a source of energy and renewal for his entire being. Indeed, in conveying the vitality of nature in this manner, Courbet was unselfconsciously expressing the very qualities that defined his own existence, and by extension that of other men.

Thus, Courbet's pictures implicitly harbor a metaphysical statement that his *Studio* had tried to articulate on a conscious level through allegory. While the average viewer of a Courbet landscape could hardly be expected to guess at such a deliberate rationale for a pictorial style, especially in a work of what was still presumed to be an inferior genre, on the other hand he could hardly come away from Courbet's art with his perception of reality unperturbed. The nature that Courbet perceived was as laden and as pregnant with physicality as any that had yet been represented in art. Whatever its success or failure in actually affecting the social realm, the moral principle underlying its style was that

art could promote social change to the extent that an experience of art could alter a vision of the world.[21]

Courbet's placement of a pure landscape of an identifiable site, painted with his usual vigor, at the center of his *Studio*, its geographical reality verified by the Franc-Comtois peasant boy, its metaphysical reality backed by the nude studio model whom Silvestre called a personification of Truth, sought to make clear the superiority and the social benefits of the Realist vision. Our recognition of a photographic source for the nude emphasizes that this was an anti-idealist truth, while at the same time our connection of the landscape with Courbet's provincial origins suggests that such literalism was part of personal observation.[22] Courbet's *Studio*, then, like the world of Proudhon, was a place where elitist values and preconceptions were turned on their head. First, an artisan, not a bourgeois, was at the center of society, where he was finely dressed and proud. Then, photography, not imagination, was the guide to truth, and topography could be vaunted for its personal as well as objective scientific associations. The notion that pure landscape was a vulgar genre because it treated nature as it was, rather than as, in classical parlance, it "ought to be," was reversed to uphold nature as it appeared as the only positive form of the real. In addition, the truth of Courbet's vision was recognizable through the unspoiled eyes of the peasant child, who may deliberately recall the boy of *The Stonebreakers* at an earlier age, just as the gravedigger of *The Burial* seemed to Buchon a younger version of the old man.[23] With *The Studio*, in other words, the narrative of social injustice opened by *The Stonebreakers* was brought to a close; its solution, based on cultural re-education, had been found. Finally, if the artist's creation was traditionally a microcosmic window on the world, then Courbet's landscape looked onto a world in which figures no longer held a privileged place.[24] Anticipating the attitude conveyed by impressionist style, Courbet appears to have accepted that the humanity inhabiting the world was no more or less important pictorially or thematically —hence ontologically—than other elements of the texture of natural phenomenality of which it formed a part.[25] Pure landscape painting thus became the most telling metaphor for Courbet's entire Realist enterprise: with his artistic ritual epitomizing all of human activity and its product symbolized as a pure landscape, he clearly suggested that the key to liberation was a

vision of reality that eliminated all external presuppositions in favor of a material truth.

Yet even in the painter's apparently subjectless, hence presumably his most purely descriptive paintings, nature has such physical power, and the painter's technical presence is so intrusive, that the viewer seeks an explanation in nonpictorial terms. In spite of Courbet's ostensible use of an aesthetic derived from or at least akin to photography—thus as indifferent to narratable human interaction as a mechanical device—his art did not completely abandon the realm of ideological painting; in fact it remained dependent on the concept of narration because the absence of narrative was central to its impact. There is more than a natural presence in these images: there is paint and personality—the frank display of workmanship by an artist at ease with his physicality. So rather than elide the ideological postures inherent in all narrative art, as Georg Lukács theorized the Naturalism of Zola had done, Courbet's peculiar naturalism embodied a purposive aesthetic contrast to history painting, signifying an alternative to its dominant ideological themes as well.[26] Still, Lukács can point us to a tension between radicalism and conservatism in Courbet that we know was characteristic of other utopian visions. For however apparently scientific and engaged, Courbet's prescription of a return to nature, or to natural perception, and to social structures grounded in man's oneness with the physical world, inevitably constituted as much a refuge from as a cure for society's present ills. Courbet's theme must therefore be presented as dialectically charged reconciliation. The dichotomy between painterliness (or pictorial individualism) and naturalism inherent in the style of the landscapes and still-lifes and further suggested by the presence of pure landscape in the interior of the workshop, embodies man's paradoxical and painful duality as both natural and laboring being, as both object and subject in the world. Realist art was the key to transcending this condition: through art—to cite a term both Courbet and Proudhon took from Hegel—a synthesis could be attained.[27]

IX

COURBETISM AND POSITIVISM

FROM the point of view of pictorial style, then, the unique mark of Courbet's art resides in the double significance of his painterly surface. On the one hand, our perceptual fusion of its substance with that of the forms it represents leads to an awareness of the substantiality of natural objects themselves. On the other hand, as brute pigment laid on by a heavy hand, it signifies the impertinent physical presence and rustic individuality of the worker-artist. Both aspects of this radical double declaration of the artist's manhood and of nature's physicality—and in passing of the "objectness" of art—are directly related through Proudhon to the new philosophical premises of the 1840s. If Hegel's statement that philosophy is the world comprehended in thought is valid, then more is true for Courbet's art. For each of his works is a symbol, a physical incarnation, a "real allegory" of the world comprehended by a new concrete consciousness. According to Comte's positivism, with which, after all, Proudhon actually compared Courbet,[1] and from which Proudhon himself gained a great deal, it was this consciousness, that is, a method of viewing the world based on empirical observation rather than on preconception, that would provide the impetus for the transformation of society. It was the prefiguration of this process of social transformation that for Proudhon constituted the value of Realist art as it emerged from the physical encounter between liberated man and the material of his world. But that is not to trivialize each Courbet landscape, still-life, hunting scene, or nude as a deliberate exercise in social didacticism. The point is that having discovered the moral end of his works, Courbet was free to concentrate on them from the point of view of their means. Realism for Courbet thus perfectly reconciled the apparent contradiction between the modernist preoccupation with and expres-

76

sion of the internal characteristics of art and an other-oriented art of social propaganda, closer to that actually proposed by Proudhon, but which might ultimately have resulted in little more than a Soviet style of social realism.

The key to this new possibility for art lay in the philosophy of that great system maker, Auguste Comte, whose emphasis on the essential similarity between the laws of natural and social phenomena also ultimately laid the basis for modern sociology.[2] Comte insisted that philosophy become scientific and practical rather than metaphysical and speculative. He believed that social reorganization would proceed not from imagination and its absolute principles, but from the unbiased observation of what exists.[3] Such observation would reveal the evolutionary tendency within the present society in order to facilitate its progress toward the future. This concept helped define the function of art in most mid-nineteenth-century utopian systems, including those of Sabatier and Bruyas and eventually that of Proudhon.

That Baudelaire fully understood the connection between these positivist demands and Realism in 1855 may be suggested by his comment that Courbet's "war on the imagination" was "in favor of an external, positive, and immediate nature."[4] For although he had by now decided that he no longer subscribed to Courbet's fundamentally social conception of art, nor to its empirical bias, Baudelaire used characteristically Comtian terms to describe it. In fact, it was probably to Comte, the point of whose philosophy was ultimately social reorganization, that the 1850s owed its new wariness of imagination. Imagination was said to characterize the second or metaphysical stage in the evolution of human thought as Comte explained it, for it was the faculty that led to what Comte labeled "the vain search after absolute notions."[5] As an example of how much Proudhon owed to this idea, one need only cite his *Philosophie du progrès* of 1853, the principal theory of which was that absolutism was the antithesis of progress.[6] More specifically, an important essay that Comte republished in 1854 had made of imagination a direct target. In the *Plan des travaux scientifiques nécessaires pour réorganiser la société* (1822), he wrote: "It is necessary in politics, as in other sciences, that the offices of observation and of imagination should be rendered perfectly distinct and the latter subordinated to the former."[7] It was exactly this operation that Courbet had accomplished in his particular yet exemplary realm by isolating

his own individuality from the power of tradition and then opting to use his vision to observe the world and study its laws. In so doing, Courbet implicitly claimed to have entered a positive stage of consciousness, the third and final stage of man's social and intellectual evolution according to Comte. Even Théophile Silvestre's apparently innocuous definition of Realism in 1856 as "the negation of imagination" and "the pre-eminence of visible and palpable truth" might then also have suggested to his contemporaries the positivist premises that were to engender the new social order.[8]

However, neither Courbet nor Proudhon adopted all of Comtian philosophy wholesale. Both utterly rejected the fusion of science and religion that Comte, like Saint-Simon, eventually developed; in addition they refused to accept Comte's inherently conservative aim. For Comte's formula for social change was concerned in fact to preserve the orderly evolution of the status quo: revolutions could be eliminated if only men would view their environment objectively. Proudhon, on the other hand, believed strongly that the natural tendency of society ought to have been to evolve along the trajectory determined by the 1789 Revolution. His view of its culmination in the full liberation of the individual and the disappearance of government thus pointed up a fundamental disagreement with Comte, for whom man was to be "dethroned from his central position and reduced to the rank he really occupies."[9] Comte's atomistic view of humanity as little more than an aggregate mass of undifferentiated beings found no more acceptance with Proudhon than had collectivist systems that deprived man of mastery over his own destiny and submerged him in the social mechanism. What Proudhon assimilated from Comte, then, were the generally scientific attitudes of the positivist method, with their accent on material reality. Indeed, it was his apparent ability to fuse them with a quasi-romantic conception of individualism that converted Baudelaire and Courbet, whose sympathies had been romantic in 1848, to what later became known as Realism.

Proudhon's Hegelian notion that art emerged out of the individual artist's appreciation of his own world, that is, to use Proudhon's words, out of his communion with nature, appeared to resolve the tensions between a social art and art for art's sake by respecting both the phenomenality and the individuality of

man, making them both integral parts of the same essence. "I am both *objective* and *subjective*," Courbet claimed; "I have made my synthesis."[10] Silvestre, whose positivist definition of Realism was cited a moment ago, gave equally full play to those of Courbet's polemics that placed a strident emphasis on this subjectivist theme: "Je suis courbetiste voilà tout," Courbet had declared, according to Silvestre. "Mine is the only painting worth appreciating; I am the first and sole artist of my times; others are students or copyists. . . . I am not only a painter, but a man; I can give my reasoned opinion in morality, in philosophy, in politics, in poetry, as in painting. . . . I am accused of vanity! I am in fact both the freest and the most arrogant man on Earth."[11]

Here Courbet struck a note that harked back to the luncheon with Nieuwerkerke. After the declaration of principles that was quoted near the beginning of this study, Nieuwerkerke had observed: "M. Courbet, you are uncommonly proud." Courbet's answer to this had been: "I am surprised that you have only just now noticed this, Sir, for I am the proudest and most arrogant man in France."[12] Courbet's vanity was just one more telling expression of his interpretation of Proudhon's anarchistic project, for the absence of authority was to allow the completely untrammeled expression of man's individuality and pride. Everyone could conceive of himself at the center of an integrated system of social relations. The singular position of the worker-artist at the center of society in *The Studio* thus signified triumph rather than tragic isolation from his fellow man. Far from acting out man's condition as essentially one of alienation in a material world, Courbet confidently assimilated all of mankind to himself in a magnanimous gesture. He optimistically affirmed universal materialism as the key to liberty and social justice, while at the same time he fulfilled his own romantic striving toward personal self-glorification. Art embodied wholeness achieved through dialectical interaction with nature.

One may now reproduce Courbet's Realist Manifesto in its entirety with the hope that the ambiguities of its language are sufficiently resolved for it to read as an only too familiar litany:

REALISM

The title of Realist was imposed on me just as the title of

romantic was imposed on the men of 1830. Never have titles given an accurate idea of things; if it were otherwise, works would be superfluous.

Without attempting to comment on the greater or lesser appropriateness of a name that nobody, it is to be hoped, can be expected to understand clearly, I will limit myself to a few words of explanation in order to avoid future misunderstandings.

I have studied, apart from any preconceived system and without biases, the art of the ancients and the moderns. I have no more wished to imitate the one than to copy the other; nor was it my intention, moreover, to attain the useless goal of *art for art's sake*. No! I simply wanted to draw forth from a complete knowledge of tradition the reasoned and independent understanding of my own individuality.

To know in order to be capable, that was my idea. To be able to translate the customs, the ideas, the appearance of my epoch according to my own appreciation of it, to be not only a painter, but a man, in a word, to create living art, that is my goal.[13]

The substantive paragraphs of this statement—the last two—are ultimately no more than a clearer and less literally Proudhonian version of the last paragraph of the now familiar section of Courbet's letter about the meeting with Nieuwerkerke. Courbet's premise was that in order to shed preconceptions, one must first be able to perceive them and their influence; only through knowledge of oneself and one's relation to his surroundings—in this case, to the artistic environment created by tradition—could one appreciate what was original and independent in his own predispositions. Although this seems obvious enough as a condition for complete artistic freedom, Courbet at the same time specifically denied the validity, as an alternative to tradition, of art for art's sake, for he deemed this a frivolous and useless kind of individualism. In other words, Courbet rejected the unbridled reign of the imagination that had been the romantic response to the problem of artistic liberation. Yet he took the romantic insistence on individual freedom as a point of departure from which to direct his creative efforts toward some constructive purpose. This purpose, which he described in the final

paragraph of his declaration, was to represent reality as he saw it in order to contribute to social progress. A living art meant for Courbet an art that partook organically of its own times, an art that was an actual participant, to paraphrase Proudhon, in the movement of contemporary society. Such participation naturally presupposed a unity between the artist and his world. For in Courbet's thought, artistic freedom and individualism were in no way contradicted by the fact that man, by his very nature, was part of the real world. He believed that attempts to escape the world of empirical fact were futile and arbitrary, and indeed that all intellectual and social liberation depended, on the contrary, on the recognition and acceptance of man's positive existence.

Although Courbet and Proudhon agreed that it was the responsibility of art to proclaim this law, we have already seen them in some disagreement as to the exact method the artist was to employ. While Proudhon favored something akin to blatantly moralizing propaganda, Courbet's pictorial achievement revealed the unique ability of art to mirror human consciousness on a deeper level in order to effect a new basic perception of the world. As this new perception was acquired, through either the making or the viewing of art, man attained his freedom. To be a painter of the sort envisaged by Courbet was inevitably to be a man, just as being a man—a positive individual in the world of phenomena—was the essential basis of Courbet's Realism. The living art that was produced was the solution to the problem of contemporary society. That is, Courbet, like Proudhon, rejected political solutions because he saw the problem of man in the 1840s and 1850s as a problem of consciousness. Solutions could not be imposed from the outside; rather, the first step in liberation was to remove all systems of organization dependent on concepts external to man. Although Courbet's art was not specifically political, its threatening political implications, not just in *The Burial*, but in virtually every work he produced, were clear enough. Its rationale was made explicit in *The Studio*, where social justice, as depicted through Courbet's self-representation as a *maître*, as an independent worker-painter, was equated with an artistic style. That style, in which individualism and positivism were fused through the free handling of paint describing an actual topographical site, signified not so much a

81

particular political system or view as a mode of authentic perception and unalienated action in the world. Its effective realm of militancy was cultural.

To take consciousness itself as the object of art, one must also accept the object of consciousness—the real world. Proudhon saw this interdependence, as had Auguste Comte, and he saw it in Courbet, which is again why he connected the two.[14] It is in this context that one can finally understand the string of notions Courbet seems to have listed as equivalents in a declaration of 1851. In a newspaper called *Le Messager*, Courbet claimed that he was "not only a socialist, but a democrat and a republican as well: in a word, a supporter of the entire Revolution, and above all, a Realist, that is to say, a sincere lover of the veritable truth."[15] He refused to limit his revolutionary posture to any specific system called up by the name of any particular group. The revolution he promoted was a revolution of the most all-inclusive sort—a revolution in consciousness. The priority in Courbet's intentions of consciousness and of aesthetic education as his mode action on it was signified by placing his posture as a Realist "above all" else. Thus, the fiction he promoted in 1855 that the title of Realist had been imposed on him without his consent was in fact a subterfuge that allowed him to give to what he felt was an impossibly vague word a definition that satisfied his own requirements.

X

CRITICAL IDEALISM AND THE ARTIST
IN SOCIETY

WHILE this is not the place for a thorough study of Proudhon's aesthetics, some review is necessary, however postscriptive it may appear, in order to understand Proudhon's reactions to the Courbet of *The Studio* and thus to judge the divergence between the two men. Courbet had taken Proudhon's theory of the liberating development of work into art as a rationale for making the artist's profession a model for all human activity. He used it to justify his own individuality and to confirm the superiority of his vision. But the coincidence of views of Courbet and Proudhon was to prove no more than temporary; the social type with which each was mainly concerned—artist and artisan respectively—remained fundamentally distinct in their minds. One might say Proudhon resented Courbet's romantic appropriation of the worker/workshop theme. He accused Courbet of wanting to be a "universal man," holding rather that the artist must, like any other man, submerge himself in the service of truth and social justice, as the inevitable ends of human development.[1] Although Courbet would have differed with Proudhon only on the degree of the artist's subordination, his expression of ideas through a Realist concept of artistic vision, epitomized by pure landscape, also ignored Proudhon's clear preference for subject matter overtly relevant to social issues.

When it came to dealing directly with the problems of aesthetics and perception, Proudhon fell back on the traditional belief that aesthetic ideals somehow embody moral truths as a presupposition underlying his version of the artistic function. While it is true that Proudhon's notion of the ideal was influenced by positivism, the nature and function of idealism were cen-

tral to the definition of art in *Du principe de l'art*. By contrast, Courbet had altogether banished the notion of ideal from his vocabulary. For this reason, it is significant that *Du principe de l'art* was in part motivated by the philosopher's realization that *The Studio* already anticipated what, for men like Zola, the absence of an idealist aesthetic and moral standard would allow. In opposition to the Proudhon of *Du principe de l'art*, they saw an only too happy marriage between naturalism and the individualism of *l'art pour l'art*. The special case of art thus revealed how far from pure materialism were Proudhon's philosophy and that of mid-nineteenth-century France of which it formed a part.[2]

Proudhon has informed us that *Du principe de l'art* was originally conceived as a four-page brochure, written at Courbet's request, to serve as an introduction and explanation to *The Priests, or The Return from the Conference* (fig. 35).[3] Courbet had executed this painting during 1862 and 1863 in a studio near Saintes, where it had already caused something of a stir. It was subsequently rejected by the Salon jury from the 1863 Salon, and was even prohibited from joining the Salon des Refusés. The essay by Proudhon was to accompany a private exhibition of the work, first in Courbet's Paris studio on the Rue Hautefeuille, then on an English tour.[4] Proudhon's letters to friends while he was writing the piece profess amazement that what had begun as a four-page pamphlet was becoming a two-hundred-page book. But these expressions probably covered a certain satisfaction: Proudhon had at several points in other treatises dealt with the problem of art, and *Du principe de l'art* offered the opportunity to collect, integrate, and expand on these earlier statements. As he wrote to a correspondent named Delhasse, the work was a complement to the enterprise of his earlier writings: the former had always dealt with politics and economics; now he would give a greater place to "transcendent" spheres such as morality and literature.[5]

Since *Du principe de l'art* is not well known in its entirety, and no more than a few paragraphs have appeared in English, it deserves to detain us slightly more than might otherwise be necessary.[6] But first, its antecedents in Proudhon's earlier writings, in which art is subordinated to other contexts with which he was clearly more preoccupied, will suggest the broad philosophical basis of the analysis he later developed. Moreover,

while *Du principe de l'art* often provides little more than an extension or clarification of earlier positions, it also contains a response to what Proudhon felt were the misinformed or misguided actions of his followers, Courbet and Castagnary. Anyone familiar with the philosopher's argumentative character will recognize that these circumstances made brevity impossible and severely blunted whatever impact Courbet's own ideas might have had on *Du principe de l'art*. Indeed, the increased narrowness of Proudhon's aesthetic theory in the 1860s was surely part of the overall rigidification of his thought that had already become apparent to observers such as Alexander Herzen in the late 1850s.[7] Typically, the philosopher's response to Courbet's theoretical forays was utter exasperation.[8]

There are two significant places where Proudhon mentioned art in the 1840s. We are already familiar with the passages from the *Système des contradictions économiques, ou Philosophie de la misère* of 1846 (see appendix III), but a few years earlier, in the *De la création de l'ordre dans l'humanité, ou Principes d'organisation politique* (1843), Proudhon had written in a more practical vein:

We can hope one day to attain a theory of beauty in which painting, architecture, and sculpture will be treated like exact sciences, such that artistic composition will be similar to the construction of a ship, the integration of a mathematical curve, or the calculation of stress and strain. It is then that the artist, once long ago the man of imagination and faith, now having become a man of reason and science, will shine forth at the highest rank of pure reason. His mission will be to synthesize on canvas or in marble, with pigments or the chisel, the most diverse points of view and elements whose series [i.e., whose principles] are obviously transcendent. Society, history, customs, laws, beliefs, physical and moral relationships, passions, ideas . . . will be all the more beautiful and ravishing when submitted to more exact laws, to a deeper and more complex form of reasoning [sériation]. There, reflection and method will surpass the most felicitous instinct, and the moment will approach when, thanks to theories of aesthetic synthesis and serial integration, the rational production of beauty will outreach the marvels of spontaneous inspiration, just as modern sci-

85

ence surpasses ancient fables and the philosophy of history surpasses legend.[9]

This theory, which we saw Courbet evoke by using the concept of series in his discussion of *The Studio*,[10] was based on philosophical precepts that directly anticipate the concerns of Realism. Moral and political sciences, Proudhon contended, must accomplish three operations:

1. Show that the series is the formal and absolute law of nature and intelligence; 2. Take as the object of study man, his history, his opinions, his customs, his virtues and his crimes, his works, and his follies; 3. Recognize the series inherent in each of his tendencies and manifestations.[11]

Proudhon was proposing a Comtian study of society in which art would participate, while he was using the terms we earlier saw him convert to his own purposes from Fourier and Hegel. That is, the focus on man as an object of study and the notion that society and hence even art, like the natural sciences, obeyed fixed, quasi-mathematical laws were Comtian, while the language of serialism stressed a method of reasoning that integrated the transcendental and the empirical spheres. This concept of art could not have been more ostensibly anti-romantic and anti-utopian.

The second major feature of what was to become Proudhon's theory of art was already manifest in the passages from the *Philosophie de la misère* we studied earlier. Now these lines may be reconsidered from the point of view of their context in that particular treatise. Recall that Proudhon had related the sexual drive and the work drive to the same basic quality in man's nature. The development of work into art was to result in the sublimation of sexual and associated power drives (property and other forms of possession) so that, in Proudhon's terms, work and "asceticism" became identified. This asceticism was crucial for the theory of social development contained in the *Philosophie de la misère*, for it assured proper control over population, leading to stability of employment, of consumption, and of distribution of wealth.[12] The passages on art were contained in the final section of the *Système des contradictions*, which dealt with population, and provided a demonstration of the interdependence of spiritual progress and material well-being. Proudhon can be

seen here characteristically seeking a philosophical basis on which to ground practical politico-economic solutions. Although it was in passing that he discussed art in the *Philosophie de la misère*, introducing the discussion with little apparent concern for its intrinsic value, he did so on premises already established in the *De la création de l'ordre*.

Earlier in the *Philosophie de la misère*, Proudhon accused artists of venality and egotism for exploiting the beautiful as a commodity; contrary to Saint-Simon, he placed them in the lowest-ranking social sphere.[13] He saw as falsehood the separation between artistic ideal and society (and hence social responsibility) that had given the artist an arbitrary authority over his creation. In the passages in the *Système* on the development of art from work, Proudhon had attempted to demonstrate how, on the contrary, the artistic impulse emerged as a consequence of man's natural self-adoration, as expressed in his craft. The image of perfection toward which he strove took as its model an inner idea formed from the experience of reality. The theory of art for art's sake denied this relationship by asserting total artistic freedom. Although it was not until the *De la justice* of 1858 that Proudhon attacked *l'art pour l'art* by name, it was clearly this particular offshoot of romanticism that he already opposed in the *Philosophie de la misère*, seeing it as the complete negation of what all logical arguments proved was the necessarily social function of art.[14]

In a chapter of the *Philosophie du progrès* of 1853 (appendix IV) Proudhon combined these two aspects of his conception of art—art as a positivist social science and art as a natural development out of physical work—into an historical argument interlocking art and society. Not only did this directly anticipate *Du principe de l'art*, but, thanks to its brevity, it may in many ways be more clear. In his earlier writings, as well as in early passages of the *Philosophie du progrès*, Proudhon had stressed that transcendental notions such as God (or beauty, he would later add) were mere symbolic references to something that, however internal or imagined, was actually a sense-derived concept. Progress consisted of the increasing understanding of these principles and resulted in man's gradual assumption for his own account of images he had previously considered God-given—that is, imposed on his being by an external agent. Deliberately appropriating religious terminology, Proudhon related art to the

"immortality of the soul" and its "apotheosis." In this context these became especially loaded terms, for he now gave them a new, positive value:

> The immortality of the soul is nothing other than the elevation of man through reason to the ideality of his nature and the taking possession of his own divinity.
>
> The radiating forehead of Moses, the assumption of Eli, the transfiguration of Christ, and even the apotheosis of the Caesars were so many myths that used to serve to express this idealizing process.
>
> Art and religion have as their goal to make us work unceasingly, stimulated by their particular means of excitation, toward the apotheosis of our souls.
>
> Hence, the theory of progress promises not immortality, as had religion; it gives it to us, it lets us enjoy it in this life; it teaches us to attain it and to know it.
>
> To be immortal is to possess God in oneself. . . . We know God through justice.[15]

Art then was a means to this final stage of civilization, for its existence was witness to the potential for perfection man held within himself. Proudhon's argument was double-edged: art bore witness to the existence of an ideal of man; and it was a stimulus to the actual achievement of such an ideal for man. The dynamics of this double situation tied art inextricably to the inevitable process of social evolution.

For Proudhon, aesthetics and morality had parallel origins: in either realm experience was the basis for the ideal that man was striving to attain. As separate categories, they reflected the two basic modes of knowledge—sensory and intellectual. It followed that "what morality reveals to our consciousness in the form of precepts, aesthetics has as its purpose to reveal to our senses in the form of images." The characteristic of aesthetic operation was that "figures presented to the senses" were "explicit in their significations, positive and realist in their type."[16] This crucial fact explained the uselessness of idealizing, classicizing styles, whose regularized forms gave rise to a kind of idolatry in which man worshipped an arbitrarily established purity. By ideal, as he extensively explained in *Du principe de l'art*, Proudhon understood simply a physiognomical or other characteristic type derived from experience, not a featureless distillation. The

latter dominated only as the result of religious dogmas that posited man's ideal far away from him and urged him to adore it as end in itself.[17]

Criticizing apriorism, which had characterized the eclecticism of Cousin and others, Proudhon wrote in the *Philosophie du progrès*:

Divine Plato, those gods of which you dream are non-existent. There is nothing in the world greater and more beautiful than man.

But coming from the hands of nature, man is miserable and ugly; he becomes sublime and beautiful only through *gymnastics, politics, philosophy, music,* and especially— something you would never have guessed—*asceticism.* (By *asceticism,* one must understand industrial activity or WORK, reputed to be base and servile by the ancients [Proudhon's note].)[18]

It was through various forms of natural activity, especially work, that man found ennoblement—as had already been explained in the *Philosophie de la misère.* For as work developed, its product came closer and closer to its perfect type. Proudhon asked of Plato: "What is the beautiful?" And he answered: "You [Plato] said it yourself: it is the pure form, the typical idea of the true. The idea, as idea, exists only in the mind; it is represented with greater or lesser fidelity and perfection by nature and by art."[19] Then, he proclaimed, rephrasing the arguments of the *Philosophie de la misère*:

Art is humanity.

All of us while we live are artists, and our occupation [métier] is to erect in our persons, in our bodies and souls, a statue to BEAUTY. Our model lies within ourselves; those gods of marble and bronze adored by the vulgar masses are no more than a reference [étalon].[20]

The purpose of art, Proudhon reasoned, was not, as the ancients believed, to glorify the gods; "it is to work toward the deification of men, both by celebrating their virtue and beauty and by execrating their ugliness and their crimes."[21] Here he boldly asserted the duty of the artist to hold up a mirror to all members of society, using *The Peasants of Flagey* as an example.[22] The final stage of civilization, Proudhon maintained, would be ac-

complished through the asceticism of work, and would be enjoyed by free men as "heroes, sages, and artists."[23] He might have said, by all men as "worker-artists" enjoying their "apotheosis."

Proudhon opened *Du principe de l'art* by observing the contradictions between contemporary schools of art. While disclaiming any competence to judge their stylistic forms aesthetically, he held that one could understand their social meaning by penetrating to underlying principles. In a philosophical discussion in his second chapter, he set forth what he called the three bases of art. As the first principle, he maintained that man had an inherent ability, called "aesthetic faculty," to perceive types and judge them qualitatively.[24] The a priori status of this ostensibly Kantian notion did not trouble him, for he saw it as a category of perception, not as a creative or synthetic function.[25] On the contrary, the false concept of aesthetic judgment as a third and equal category had led to the misguided theory of *l'art pour l'art*.[26]

The second basis for art Proudhon gave was the now familiar contention that art arose from man's *amour-propre*—from his desire for self-improvement in order to approach his self-ideal more closely. The third was the common-sense premise of man's capacity for the imitation of the products of nature; thus Proudhon stressed the mechanical process. Proudhon added that because the aesthetic faculty operated in an objective, disinterested fashion, the object that stimulated it could not be entirely of its own creation but rather had to be part of a reality external to it. Hence, the aesthetic faculty depended at least partially on empirical observation for its functioning.[27]

Proudhon's third chapter clearly spelled out his concept of the ideal and the inevitability of its social application. We are already sufficiently familiar with his reasons for linking the ideal to the real world of matter; now he contended that every art work, by combining something of the ideal—of the perfect type —and something of the real or natural, contained within itself an implicit comparison between the two. Man's aesthetic faculty allowed him to judge the superiority of the former; thus art contributed to man's improvement. The artist was like any other professional working to perfect his product; he operated through his own pictorial brand of figures of speech—emphatic or expres-

sive ways of provoking awareness of the ideal. Since art was essentially "concrete, particular, and determinative like nature," its expressive devices were related to the tension between ideal and real. Proudhon labeled this unique artistic characteristic an "idealism," and defined art as *an idealist representation of nature and ourselves for the purpose of the physical and moral improvement of our species.*"[28]

The second section of *Du principe de l'art* examined the history of art in the light of these laws. Taking up the argument of the *Philosophie du progrès*, Proudhon repeated that "in thinking of God, man dreams of himself" and that "the figures by which he represents divinity are in fact homages to himself."[29] Even under religious dogma, art had had a social mission: "Having become a means of civilization, an instrument both political and religious, art . . . little by little acquired through its community of thought and the constancy of tradition a collective force above the level of the individual."[30] Proudhon criticized those schools too exclusively devoted to an arbitrary ideal of beauty, such as were found in the Classical period or the Renaissance. He preferred the more direct approach to real life of the Dutch masters, whom he saw as Courbet's predecessors.[31] More interesting is his attack on the nineteenth-century schools of classicism and romanticism and on selected contemporary artists. He contrasted the classicists' proposition that beauty was absolute and eternal with the romantics' insistence that the essence of art lay in an expression of personal feeling. He reasoned dialectically that there was some truth in both notions: while all people of all times may well constitute a single family and all languages a single tongue, the proof that the ideal could evolve indefinitely lay in its dependence on the real. The complete artist should then be neither classic nor romantic; he should seek the ideal proper to his time and place.[32]

While Proudhon thus gave a reasoned basis for the adage, *il faut être de son temps!*, he still believed in a universal standard based on the link between art and social progress. Hence, his contempt for one brand of naturalism was plain when he recounted Horace Vernet's apparent indifference to the thought-content of his own pictures.[33] On the other hand, he attacked the history painting of Jacques-Louis David because it was conjectural and archeological: David had either not witnessed the events he portrayed or failed to depict them faithfully.[34] Dela-

91

croix was faulted for his personal and supernatural ideal, Ingres for his worship of pure form without reference to ideas.[35] These two constituted equally irrational tendencies because they avoided the basic function of reason, which was observation.[36] To reiterate Proudhon's premise, observation was the foundation of the ideal and the mainspring of its social influence. "There is no aesthetic without philosophy," he concluded. "Art must become more rational; I mean it must learn to express the aspirations of the present epoch just as it expressed the intuitions of primitive times. . . . It must march in unison with the universal movement of the present and be infused by it." Proudhon saw it as no small service to have demonstrated this necessity to artists, not through a priori reasoning but, as in this second section of *Du principe de l'art*, on the basis of extant art works themselves.[37]

At this point Proudhon introduced Courbet as the painter who best illustrated the ideal of observation—"the real point of art." His first concrete example was *The Peasants of Flagey Returning from the Fair* (fig. 10), part of his description of which I quoted earlier. No picture better demonstrated the artist's location in time and place: Courbet was a Frenchman of the Jura expressing the ideal of that particular milieu, even if it was an ideal of mediocrity that infuriated Parisians. Through devices long since established in the theories of the physiognomists, the outer physical characteristics of Courbet's figures revealed the inner mind of unaffected, natural man:

> To paint men in the sincerity of their nature and their civic and domestic functions, with their actual physiognomy, above all with no poses; to surprise them, so to speak, in the nakedness of their mentalities [dans le déshabillé de leurs consciences], not simply for the pleasure of jeering, but with the goal of general education and as a matter of aesthetic information; this appears to me to be the true point of departure of modern art.[38]

> Our idealism consists of teaching us to know ourselves, of improving day by day through exposure not to models conceived a priori and more or less ingeniously represented, but through information constantly furnished by experience and philosophical observation.[39]

Art has as its object to lead us to the knowledge of ourselves by revealing all our thoughts, even our most secret ones, and all our tendencies, virtues, vices, follies and thereby to contribute to the development of our dignity and to the perfection of our being.[40]

These principles constitute the best known part of *Du principe de l'art* because they represent the activist conclusions of Proudhon's philosophical viewpoint. Note how for him the ideal was still a tool of moral suasion. That is why he instinctively imputed narrative meanings to Courbet's ostensibly descriptive aesthetic. Proudhon saw Courbet as the chief practitioner of this new idealism, and as if insisting on arriving at its principles through induction, he proclaimed them in the context of a discussion of four of Courbet's paintings—*The Peasants of Flagey* (fig. 10), *The Sleeping Spinner* (fig. 14), *The Burial at Ornans* (fig. 9), and *The Bathers* (fig. 13).

Here Proudhon paused in his discussion of Courbet to consider the implications of the "nouvelle école" he saw emerging.[41] It can be shown with reasonable certainty that this interruption was caused by his reading of some art criticism by one of his admirers, Jules-Antoine Castagnary.[42] One of Castagnary's articles was cited in the footnotes to *Du principe de l'art*, and his *Salons* of 1863 and 1864 must have come to Proudhon's attention at around this time, either just before the philosopher temporarily put aside the writing of his treatise in late 1863, or just as he took it up again in mid-1864.[43] The article Proudhon cited had appeared a day after another essay, where the critic had treated Courbet's *Return from the Conference* in concluding a discussion of the "école naturaliste."[44] Although anyone reading Castagnary in 1863 would have thought he showed the greatest respect for Proudhon's ideas, Proudhon himself, as was often his case, picked up on a minor disagreement in order to hone his own thought further.[45]

Of naturalism, Castagnary had written: "The naturalist school affirms that art is the expression of life in all its modes and degrees and that its sole aim is to reproduce nature in giving it a maximum of power and intensity: it is truth balanced with science."[46] Of Courbet, he observed: "The great claim of Courbet is to represent what he sees. It is even one of his favorite axioms

that whatever cannot be projected onto the retina is outside the domain of painting."[47] Although the first of these two statements could still have been accepted by Proudhon, the second must have gone too far.[48] So did Castagnary's contention that *The Return from the Conference* (fig. 35) was a satire.[49] In his own chapter on the "nouvelle école," Proudhon flatly rejected such a suggestion.[50] Then he addressed himself to the so-called "writers of the new school":

> Beware . . . your realism would compromise truth, which you nevertheless profess to serve. The real is not the same as the true; the first concerns matter itself, the second the laws that regulate it; only the latter is intelligible and only it can be the object and aim of art; the former has no meaning in itself. The early schools of art departed from truth by way of the ideal; do not yourself depart from it by way of the real.[51]

For Proudhon, both pure idealism and pure realism were instances of unideated formalism that refused to recognize the necessary connection between art and society. Since it was at approximately this point that he cited Castagnary's September 1863 article, these lines read as an answer to him.[52]

The importance of the dialogue with Castagnary, which may have other less significant echoes in *Du principe de l'art*, is that it appears to have led Proudhon to define the idealism particular to the new Realist school as a "critical idealism." For one thing, he reasserted that social gain was indeed to be the objective of art.[53] He said it might be well to call Realism *art humain* (undoubtedly referring to Castagnary's term 1857, *art humanitaire*, which in turn harked back to the vision of the advent of an *époque humanitaire* in art that Proudhon himself had propounded in the *Phliosophie du progrès* [see my second epigraph]), but this label described more its historical position than its actual function.[54] Comparing the new art to previous forms, most of which were dependent on religious dogma and absolute concepts, Proudhon found that its main characteristic was that it was "antidogmatic," a term synonymous for him with the words "critical" and "rational."[55]

Proudhon's attempt to encompass the concept of rationalism within his notion of critical idealism surely reflects Castagnary's contention in his *Salon of 1863* that the naturalist school of paint-

ing was a derivative of "modern rationalism."[56] Now Proudhon defined modern rationalism itself as a critical philosophical method:

> Just as there has existed since Descartes and Kant an anti-dogmatic or critical philosophy, there has in turn emerged, based on its example, a primarily critical literature. Similarly, art has renewed itself through criticism by following a development parallel to that of philosophy, science, industry, politics, and letters. . . .
>
> . . . Having become rational and reasonable, critical and just, marching in unison with *positive philosophy, positive politics*, and *positive metaphysics* . . . [art] can no longer promote tyranny, prostitution, and pauperism. An art of observation as well as inspiration, it would have to lie to itself and thereby destroy itself to do so.[57]

By critical, Proudhon meant something quite different from mere faultfinding: his references to Descartes and Kant as the founders of critical philosophy point rather to a process of reasoned observation and objective analysis modeled on that of the *Discourse on Method* or the *Critique of Pure Reason*, and squarely in the tradition of eighteenth-century French rationalism. Faultfinding and social benefit might well be the result, but "criticism" looked more for underlying principles than for condemnable symptoms. Since the real could only reflect such symptoms, "idealism" was a precondition for a "critical" and hence socially effective art.

When he had had no more than a vague idea of the method of Hegel, Proudhon had used the Fourierist term "seriation" to describe the rational, quasi-mathematical philosophical approach he advocated applying to social analysis.[58] Later, the term "synthesis" became part of his vocabulary to indicate the ostensibly objective results of a dialectical method he imagined he had borrowed from German philosophy. Courbet employed both terms also, and indeed in a letter to his father about *The Return from the Conference*, he declared his painting to be linked to philosophy through its similarly synthetic approach to reality. He and Proudhon were "two men who have synthesized society, one in philosophy, the other in art."[59] Describing the parallel between Courbet and the intellectual renewal of his times, Proudhon used the term synthetic, too. He did so within a series of now generally familiar adjectives; then he added a

number of specific comparisons. The well-known passage reads:

In sum, the critical, analytical, synthetical, humanitarian painter Courbet is an expression of his times. His work coincides with the *Positive Philosophy* of Auguste Comte, the *Positive Metaphysics* of Vacherot, and my own *Human Rights* or *Immanent Justice*; with the right to work and the right of the worker, announcing the end of capitalism and the sovereignty of the producers; with the phrenology of Gall and Spurzheim; with the physiognomy of Lavater.[60]

As in the passage I quoted previous to this one, there is a tripartite division of human activity into the areas of philosophy, politics, and metaphysics. We saw how Courbet's art was related to Comte's positivist philosophy, to Proudhon's anarchistic political economics, and, in Proudhon's view, to the sciences of phrenology or physiognomy, of which Gall, Spurzheim, and Lavater were the main practitioners. (Indeed Proudhon claimed that a painting was the equivalent of a philosophical "psychograph.")[61] The only as yet unfamiliar comparison was with Etienne Vacherot (1809-1897). Successor to his teacher Victor Cousin at the Académie des Sciences Morales et Politiques, Vacherot in 1858 published an important treatise entitled *La Métaphysique et la science, ou Principes de métaphysique positive*.[62] His stated purpose was to reconcile transcendentalist apriorism with the empirical method of scientific observation, probably in order to salvage some notion of God in a materialist world. However, he ended up with the very Comtian conclusions that natural laws were immanent in objects themselves rather than a priori, and that the function of metaphysics was the generalization of results based on scientific observation. His philosophy, like other French philosophies of his times, was an attempt to synthesize spirit and matter, to reconcile man's self-consciousness as mind and the overwhelming evidence of his materiality. It must have been a similar operation that Courbet and Proudhon saw themselves performing on society through synthesis, even though they arrived at differently slanted results.

The logical consequence of Proudhon's demonstration, especially from the point of view of Courbet's self-esteem, was an admonition. Ultimately, Proudhon was not sure which was worse for the artist, "the support of government or its restraints, schools and academies or complete liberty"; one could be misled by

both. He noted rather sarcastically: "Courbet, like all artists, wants to be infinite like the world and mysterious like the ideal. He especially wants to be the only representative of his genre among painters." Regardless of his position as the first artist to perceive the direction of history and to espouse it, Courbet had no claim to greater innate talent than those around him. The artist was no more than the inevitable product of a coherent social development.[63] The process of self-liberation had to involve acknowledgment of man's subjection to the laws of the material world. However staunch a defender of individualism, Proudhon asserted that the individual achieved fulfillment only within the terms of this dialectic. Not only should this principle constitute the final message of all art, it must be obeyed by the artist in his own actions. Being himself part of a larger collectivity, the genius expresses "a collective thought expanded by time," and his role is to represent it as an actor acts out the character he portrays. Like the actor—and like the historian, the poet, and the playwright as well—the painter must never let his own personality overshadow that of his characters.[64]

Anticipating Hippolyte Taine, Proudhon had written that art is always produced en situation.[65] The isolated genius produces nothing, for he has no contact with society. The artist must be a follower, "led and inspired by society; society is lost if it lets itself be inspired and led by art."[66] Like "the laborer, the scientist, or the philosopher," the more the artist observes, the more he discovers. "His inspiration is proportionate to the amount of observation"; contrary to the romantic notion of intermittent spontaneity, the veritable artist's inspiration never failed him.[67] "Up until this point," Proudhon concluded, "art had dwelt in a mystical and transcendent realm." Now, "the artist will be a citizen, a man like any other, following the same rules and obeying the same principles."[68] Even if Courbet's vanity might suffer by being so classified, Proudhon insisted that his reputation would eventually benefit.[69] Courbet and Proudhon thus agreed that the artist must be a man, indeed, a man of the people, a worker. Where Proudhon profoundly disagreed was that, as an artist, Courbet embodied manhood in any way that made him superior to men in other professions.

———

Proudhon's appeal to Baudelaire and Courbet in 1848 had been

his apparent ability to reconcile the individual's romantic aspirations with his social and material essence. However in *Du principe de l'art* Proudhon made clear once and for all that the former was an illusion unless sought expressly in terms of the latter. Even if Courbet might willingly have accepted this principle, his own irrepressible ego overwhelmed such common-sense rules. Indeed Zola, who perhaps more than anyone else resented Proudhon's restrictions, saw Courbet's "personality" as the sine qua non of his art. We have perhaps forgotten that Zola's definition of art as "a corner of nature seen through a temperament" was made in direct reaction to Proudhon's proposals.[70] Too young actually to have witnessed Courbet's struggle to bring the real world into the artistic realm on an equal footing with past history, Zola saw this aspect of Courbet's contribution as a commonplace. Even though it provided the common ground between himself and Proudhon and was at the center of what his generation owed to that of Courbet and Proudhon, all that Zola saw in social theory was the yoke it placed on inspiration. His resistance to it typified the reluctance of so many artists to rally to the utopian cause.

Later generations of readers have followed Zola too zealously in construing the central question of *Du principe de l'art* as the philosophical basis for the social role of art. In such a reading, Proudhon's apparent role as a mere advocate of the idea of art as propaganda can all too easily be dismissed as limiting and trivial. Seen from the deep center of the mid-nineteenth century, however, his concern was with the very legitimacy of the practice of art. Prior to Realism, art had literally defied the premises of positivism and the new social philosophies by its claim of self-sufficiency. As the positive basis of art became axiomatic, its integration into the philosophy of historical progress—the restoration of its social role—followed with the nearly automatic exercise of logic. Proudhon was no mere propagandizer; he was a philosopher whose arguments were founded on reasoned deduction. He analyzed art within the same philosophical system that he applied to any other human endeavor. Realism, defined by Proudhon as critical idealism, and with its concomitant role in the inevitable flow of social development, was the only form that art could logically take.

Realism and anarchism were mutually dependent. Yet the freedom that was to emerge in an anarchist society was viewed

in different ways by Courbet and Proudhon. For both, economic self-determination was a main feature, but for Proudhon this could not be attained without giving up the mentality of the transcendent individual spirit. He could say that Courbet, intoxicated by the myth of liberty rather than by the responsibility it entailed remained essentially a romantic, and thus he could argue that Courbet was attracted to anarchism for the wrong reasons. However, Courbet had demonstrated that he accepted the Proudhonian vision of man. He could therefore protest that his self-glorification was no more than a symbolic dramatization of his rejection of the extra-determinism that Proudhon himself had always fought; Courbet's persona was an artistic "idealism." So Proudhon's suspicion of artistic freedom revealed a confusion between myth and substance brought on by his own application of preconceived ideals to social intercourse. Here again, Courbet anticipated the attitudes of certain artists of the 1880s.[71]

On this point Courbet may have sensed Proudhon's mind better than the philosopher himself. He recognized the truth of Proudhon's insight that the only free man was the man who played himself. He saw that, far from disappearing behind the characters he portrayed, the artist must at every instance portray the new positivist-anarchist incarnation of his self. Proudhon, who, like the rest of Courbet's contemporaries, was fooled by the painter's rhetoric, failed to recognize that this was the lesson of *The Studio* and of the interdependence of Realism and anarchism. After all, he himself had held in the *Philosophie du progrès* that the theory of progress promised man his apotheosis in the here and the now. He did not perceive the romantic roots of his own ideas, however opposed to romanticism he thought them to be.

XI

CONCLUSION

COURBET'S art is modern because it addresses itself to consciousness directly rather than through a subject external to itself. It does so by interposing its own physicality—thus displaying the peculiar law of its artifice and craft—between the viewer and the object of representation. It calls for observation and perception on the part of the viewer in the same way as these qualities are required of the artist, rather than for ratiocination based on preconceived ideas. The self-consciousness of this act was a principal theme of *The Studio*, and was a means of declaring the independence of art. Yet far from signaling the withdrawal of the artist into isolation and the withdrawal of art from public comprehension (as the myth of the avant-garde would have it), Courbet understood and justified the "modernist" gesture of Realism precisely for its power to affect men's minds. However grandiose it may appear to us, the idea that, through the effect of art, politics and society would be transformed, was no more naive a vision than other utopias of the day. Moreover, the nineteenth century differed from its predecessors on this subject mainly in the literalism with which it tried to put such principles into practice.

Contrary to the notion that Courbet's public was baffled by his effort, many men of the 1850s understood only too well the artist's intentions as having profound socio-political ramifications. These intentions were socialist and working class—that is, they represented the deepest and most permanent opposition to the higher classes that had, at least since 1852, become the solid base of Napoleon III's power.[1] If the social vision was now couched in more theoretical and utopian terms, if Courbet's art had lost its biting edge of 1849-1851, this may have been because

working class action had itself been reduced to memory and theory. Yet even though Courbet's art reflected the conditions and frustrations of Second Empire politics, it was referred to repeatedly through a perfectly transparent code word—the name of Courbet's philosopher-friend, Pierre-Joseph Proudhon. He and Courbet must once again be placed together, and inseparably, at the confluence of romanticism and positive consciousness that led to modern art.

What Courbet and Proudhon failed as social reformers to achieve for all of society, Courbet as a modern artist did achieve for art. In arrogating artistic authority to himself, he had claimed to act for all men to recover for humanity an art that had become separated from society as a whole. The aestheticization of work and the anchoring of art in the real world of labor were mutually reinforcing; yet their relationship also actualized Courbet's twin desire to be both unique and of his times. So constituted, the practice of painting was an individually liberating endeavor, which Courbet's central position in society charged with significance for all mankind. The duality of art was like the duality of man: "Art is Humanity!" Proudhon proclaimed in 1853. Through the lesson of art, one could become a real, self-conscious man and achieve what in the *Philosophie du progrès* Proudhon termed man's apotheosis—his reappropriation for himself of virtues previously alienated from him by his subservience to the concept of God. Affecting a double identity as worker and artist, Courbet attempted to embody and to embrace the totality that social and cultural conditions had destroyed. And even though landscape and *The Studio* were in some sense a refuge, a place where his ego could transcend the contradictions of the present world, the painter used them to strike out militantly against social and artistic repression.

In the utopian realm of art, Courbet found the exhilarating freedom to believe in the authenticity and importance of his own perceptions of the world and to use them as the basis of self-interested economic activity. His choices and his sincerity, however bounded, have endowed his artistic forms and enterprise with a compelling morality that makes of the contradictions within his art a source of richness and permanent value. It is not only, as Meyer Schapiro has written, that "Courbet . . . belongs to the period of transition from the cultured artist of historical painting, who moves with an elaborate baggage of lit-

erature, history and philosophy and whose works have to be understood as well as seen, to the artist of the second half of the nineteenth century, who relies on sensibility alone, working directly from nature or feeling, an eye rather than a mind or an imagination." (From Baudelaire's still aristocratic point of view, Schapiro adds, "this newer type of artist was . . . a mere artisan, ignorant and plebian.")[2] It is that Courbet's art embodies the self-conscious brashness that accompanied both the death of such illusions and the birth of a new vision while at the same time it represents the persistent, perhaps nostalgic, belief of Courbet and most of his generation that the old and the new worlds need not be mutually exclusive.

APPENDICES

APPENDIX I

Courbet's letter to Bruyas of about October 1853 describing the luncheon with Nieuwerkerke.

Je suis envers vous, mon cher ami, d'une malhonnêteté affreuse, mais vous allez me pardonner quand vous saurez que je travaille comme un nègre.

Je suis parti de Paris quelques jours après que je vous ai mis un mot dans la lettre que vous écrivait Silvestre.

Arrivé à Ornans, j'ai été obligé d'aller en Suisse, à Berne et à Fribourg pour des affaires, ce qui m'a contrarié et retardé pour les tableaux que j'avais envie d'entreprendre.

Cela me contrariait d'autant plus que si j'étais allé vous voir j'aurais mis le même temps et c'eût été pour moi plus utile et plus agréable.

J'ai reçu, mon cher ami, avec le plus grand bonheur, votre lettre pleine d'affection et de courage.

Il faut du courage.

J'ai brûlé mes vaisseaux. J'ai rompu en visière avec la Société. J'ai insulté tous ceux qui me servaient maladroitement. Et me voici maintenant seul en face de cette Société.

Il faut vaincre ou mourir.

Si je succombe, on m'aura payé cher, je vous le jure.

Mais je sens de plus en plus que je triomphe, car nous sommes deux et à l'heure qu'il est à ma connaissance, seulement peut-être 6 ou 8, tous jeunes, tous travailleurs acharnés, tous arrivés à la même conclusion par des moyens divers.

Mon ami, c'est la vérité, j'en suis sûr comme de mon existence, dans un an nous serons un million. Je désire vous raconter un fait.

Avant que je ne quitte Paris, M. Nieuwerkerque, directeur des Beaux-Arts, m'a fait inviter à déjeuner, au nom du Gouvernement, et de crainte que je ne refuse cette invitation, il avait pris

pour ambassadeurs: MM. Chenavard et Français, deux *satisfaits*, deux *décorés*.

Je dois dire à leur honte qu'ils remplissaient un rôle gouverne-mental vis-à-vis de moi. Ils préparaient mon esprit à la bienveil-lance et secondaient les vues de M. le directeur.

D'autre part, ils auraient été contents que je me rendisse comme eux.

Après qu'ils m'eurent bien conjuré d'être ce qu'ils appelaient *bon enfant*, nous nous rendîmes au déjeuner, chez Douix, au Palais-Royal, où M. de Nieuwerkerque nous attendait.

Aussitôt qu'il m'aperçut, il s'élança sur moi en me pressant les mains et s'écriant qu'il était enchanté de mon acceptation, qu'il voulait agir franchement avec moi et qu'il ne me dissimu-lait pas qu'il venait pour me convertir.

Les deux autres échangèrent un coup-d'oeil qui voulait dire: quelle maladresse! Il vient de tout gâter.

Je répondis que j'étais tout converti, que pourtant s'il pouvait me faire changer de manière de voir, je ne demandais pas mieux que de m'instruire. Il continua en me disant que le gouverne-ment était désolé de me voir aller seul, qu'il fallait modifier mes idées, mettre de l'eau dans mon vin, qu'on était tout porté pour moi, que je ne devais pas faire la mauvaise tête; enfin toutes sortes de sottises de ce genre.

Puis il termina en me disant que le Gouvernement désirait que je fasse un tableau dans toute ma puissance pour l'exposition de 1855, que je pouvais compter sur sa parole et qu'il mettrait pour condition que je présente une esquisse et que le tableau fait, il serait soumis à un conseil d'artistes que je choisirais et à un comité qu'il choisirait de son côté.

Je vous laisse à penser dans quelle fureur je suis entré après une pareille ouverture.

Je répondis immédiatement que je ne comprenais absolument rien à tout ce qu'il venait de me dire, d'abord parce qu'il m'affir-mait qu'il était un Gouvernement et que je ne me sentais nulle-ment compris dans ce Gouvrnement, que moi aussi j'etais un Gouvernement et que je défiais le sien de faire quoi que ce soit pour le mien que je puisse accepter.

Je continuai en lui disant que je considérais son Gouvernement comme un simple particulier, que lorsque mes tableaux lui plai-raient, il était libre de me les acheter et que je ne lui demandais qu'une seule chose, c'est qu'il laisse l'art libre dans son exposition

et qu'il ne soutienne pas avec un budget de 300,000 francs, trois mille artistes contre moi.

Je continuai en lui disant que j'étais seul juge de ma peinture, que j'étais non seulement un peintre, mais encore un homme, que j'avais fait de la peinture, non pour faire de l'art pour l'art, mais bien pour conquérir ma liberté intellectuelle et que j'étais arrivé par l'étude de la tradition à m'en affranchir et que moi seul, de tous les artistes français mes contemporains, avais la puissance de rendre et de traduire d'une façon originale et ma personnalité et ma Société, etc., etc. . . .

Ce à quoi il me répondit:

"M. Courbet, vous êtes bien fier!"

"Je m'étonne, lui dis-je, que vous ne vous en aperceviez seulement que maintenant, Monsieur, je suis l'homme le plus fier et le plus orgueilleux de France!"

Cet homme qui est le plus inepte que j'ai recontré peut-être de ma vie, me regardait avec des yeux hébétés.

Il était d'autant plus stupéfait qu'il avait dû promettre à ses maîtres et aux dames de la Cour qu'il allait leur faire voir comment on achetait un homme pour vingt ou trente mille francs.

Il me demanda encore si je n'enverrais rien à cette exposition

Je lui répondis que je ne concourrai jamais parce que je n'admettais pas de juges, que pourtant il pouvait se faire que je leur envoie par cynisme mon *Enterrement* qui était mon début et mon exposé de principes, qu'ils se démêleraient avec ce tableau comme ils pourraient, mais que j'espérais à moi seul (peut-être) de faire une exposition en rivalité de la leur, qui me rapporterait quarante mille francs en argent que je ne gagnerais certainement pas avec eux.

Je lui rappelais aussi qu'il me devait quinze mille francs pour les droits d'entrée qu'ils avaient perçus avec mes tableaux dans les expositions antécédentes, que les employés m'avaient assuré qu'individuellement ils conduisaient deux cents personnes par jour devant mes *Baigneuses*.

Ce à quoi il répondit la bêtise suivante: que ces personnes n'allaient pas pour les admirer.

Il me fut facile de répondre en récusant son opinion personnelle et en lui disant que la question n'était pas là, que soit pour critique, soit pour admiration, la vérité était qu'ils avaient touché les droits d'entrée et que la moitié des comptes-rendus des journaux portaient sur mes tableaux.

Il continua en me disant qu'il était bien malheureux qu'il se trouve au monde des gens comme vous, qu'ils étaient nés pour perdre les plus belles organisations et que j'en serais un exemple frappant.

Je me suis mis á rire aux larmes en lui assurant qu'il n'y aurait que lui et les académies que en souffriraient.

Je n'ose vous parler davantage de cet homme, je crains de vous ennuyer par trop.

Pour terminer, il finit par quitter la place, nous laissant en plan, dans la salle du restaurant.

Il allait passer la porte, je lui pris la main et lui dis:

"Monsieur, je vous prie de croire que nous sommes toujours aussi amis." Puis je me retournais de côté de Chenavard et de Français en les priant de croire aussi, qu'ils étaient deux imbéciles. Ensuite nous allâmes boire de la bière.

Voici encore un mot de M. de Nieuwerkerque qui me revient:

"J'espère, me disait-il, Monsieur Courbet, que vous n'avez pas à vous plaindre, le Gouvernement fait assez de coquetteries à votre égard.

"Personne ne pourra se flater d'en avoir eu autant que vous!

"Remarquez bien que c'est le Gouvernement et non pas moi que vous offre aujourd'hui à déjeuner."

Si bien que je suis redevable au Gouvernement d'un déjeuner.

Je voulais lui rendre, mais cela a mis en colère Chenavard et Français.

Vous voyez, mon cher ami, que nous avons carrière ouverte et nous pouvons nous livrer à notre indépendance avec connaissance de cause.

Je travaille ici avec acharnement. J'ai cinq à six tableaux en train qui seront probablement finis au printemps.

Ainsi vous voyez que quand même je ne vous écris pas, je songe à vous.

Je suis enchanté que vous vous reposiez sur moi. Je ne vous faillirai pas, soyez-en convaincu!

Faites-moi cet honneur, car j'ai pour garant une haine des hommes et de notre société, qui ne s'éteindra qu'avec moi.

Ce n'est pas qu'une question de temps, par conséquent vous êtes plus important que moi, vous avez entre les mains des moyens qui m'ont toujours manqués et qui me manqueront toujours.

Avec vos antécédents, votre intelligence, votre courage et vos

moyens pécuniaires vous pouvez nous sauver de notre vivant et nous faire franchir un siècle!

Sacrifiez tout au rétablissement de votre santé. Reposez-vous et ne vous donnez aucune peine, même en parole.

Vous n'avez à avoir dorénavant qu'une attitude confiante.

Je finirai aussi vite que je le pourrais ce que j'ai entrepris et en retournant à Paris j'irai voir à Montpellier, si vous y êtes encore et si vous êtes à Paris nous irons ensemble chercher votre galerie, si nous décidons une exposition.

Je ne puis vous envoyer mes *Baigneuses* car elles sont à Paris dans mon atelier.

Si vous avez le temps écrivez-moi.

Je vous demande excuse de tout ce parlage qui pourrait vous fatiguer et je suis votre tout dévoué ami.

Je vous salue encore.

<div align="right">

Gustave Courbet.
Ornans (Doubs)

</div>

APPENDIX II

Courbet's letter to Champfleury of Winter 1854-1855 describing **The Studio**

Mon cher ami,

Malgré que je tourne à l'hypocondrie, me voilà lancé dans un immense tableau, 20 pieds de long, 12 de haut, peut-être plus grand que l'Enterrement ce qui fera voir que je ne suis pas encore mort, et le réalisme non plus, puisque réalisme il y a. C'est l'histoire morale et physique de mon atelier, première partie; ce sont les gens qui me servent, me soutiennent dans mon idée, qui participent à mon action. Ce sont les gens qui vivent de la vie, qui vivent de la mort. C'est la société dans son haut, dans son bas, dans son milieu. En un mot c'est ma manière de voir la société dans ses intérêts et ses passions. C'est le monde qui vient se faire peindre chez moi. Vous voyez ce tableau est sans titre. Je vais tâcher de vous en donner une idée plus exacte en vous le décrivant sèchement. La scène se passe dans mon atelier à Paris. Le tableau est divisé en deux parties. Je suis au milieu piegnant. A droite, tous les actionnaires, c'est-à-dire les amis, les travailleurs, les amateurs du monde de l'art. A gauche, l'autre monde de la vie triviale, le peuple, la misère, la pauvreté, la richesse, les exploités, les exploiteurs, les gens qui vivent de la mort. Dans le fond, contre la muraille, sont pendus les tableaux du Retour de la foire, les Baigneuses et le tableau que je peins est un tableau d'ânier qui pince le cul à une fille qu'il recontre et des ânes chargés de sacs dans un paysage avec un moulin. Je vais vous énumérer les personnages en commençant par l'extrême gauche. Au bord de la toile se trouve un juif que j'ai vu en Angleterre traversant l'activité fébrile des rues de Londres en portant religieusement une cassette sur son bras droit et la couvrant de la main gauche il semblait dire "c'est moi qui tient le bon bout." Il avait une figure d'ivoire, une longue barbe, un turban puis une longue robe noire qui traînait à terre. Derrière lui est un curé d'une figure triomphante avec une trogne

rouge. Devant eux est un pauvre vieux tout grelu, un ancien
républicain de 93 (ce ministre de l'Intérieur qui, par exemple,
avait fait partie de l'Assemblé quand on a condamné à mort
Louis XVI, celui qui suivait encore l'an passé les cours de la
Sorbonne), homme de 90 ans, une besace à la main, vêtu de
vieille toile blanche rapiécée, chapeau brancard, il regarde à ses
pieds des défroques romantiques (il fait pitié au juif). Ensuite
un chasseur, un faucheur, un Hercule, une queue-rouge, un
marchand d'habits-galons, une femme d'ouvrier, un ouvrier, un
croquemort, une tête de mort dans un journal, une Irlandaise
allaitant un enfant, un mannequin. L'Irlandaise est encore un
produit anglais. J'ai recontré cette femme dans une rue de Lon-
dres, elle avait pour tout vêtement un chapeau en paille noire,
un voile vert troué, un châle noir effrangé sous lequel elle por-
tait un enfant nu sous le bras. Le marchand d'habits préside à
tout cela, il déploie ses oripeaux à tout ce monde qui prête la
plus grande attention, chacun à sa manière. Derrière lui est une
guitare, un chapeau à plume au premier plan.

Seconde partie. Puis vient la toile sur mon chevalet et moi
peignant avec le côté assyrien de la tête. Derrière ma chaise est
un modèle de femme nue. Elle est appuyée sur le dossier de ma
chaise me regardant peindre un instant; ses habits sont à terre
en avant du tableau, puis un chat blanc près de ma chaise. A la
suite de cette femme vient Promayet avec son violon sous le bras
comme il est sur le portrait qu'il m'envoie. Par derrière lui est
Bruyas, Cuenot, Buchon, Proudhon (je voudrais bien avoir aussi
le philosophe Proudhon qui est de notre manière de voir, s'il
voulait poser, j'en serais content. Si vous le voyez demandez-lui
si je puis compter sur lui). Puis vient votre tour en avant du ta-
bleau. Vous êtes assis sur un tabouret, les jambes croisées et un
chapeau sur vos genoux. A côté de vous, plus au premier plan
encore est une femme du monde avec son mari, habillée en grand
luxe. Puis à l'extrême droite, assis sur une table d'une jambe seule-
ment est Baudelaire qui lit dans un grand livre à côté de lui est
une négresse qui se regarde dans une glace avec beaucoup de co-
quetterie. Au fond du tableau, on aperçoit dans l'embrasure
d'une fenêtre deux amoureux qui disent des mots d'amour, l'un
est assis sur un hamac. Au-dessus de la fenêtre de grandes dra-
peries de serge verte. Il y a encore contre le mur quelques plâ-
tres, un rayon sur lequel il y a une fillette, une lampe, des pots,

puis des toiles retournées, puis un paravent, puis plus rien qu'un grand mur nu.

Je vous ai fort mal expliqué tout cela, je m'y suis pris au rebours. J'aurais dû commencer par Baudelaire, mais c'est trop long pour recommencer. Vous comprendrez comme vous pourrez. Les gens qui veulent juger aurons de l'ouvrage. Ils s'en tireront comme ils pourront. Car il y a des gens qui se réveillent la nuit en criant et en hurlant: je veux juger, il faut que je juge! Figurez-vous, mon cher, qu'ayant ce tableau dans la tête j'ai été surpris par une jaunisse affreuse qui m'a duré plus d'un mois. Moi qui suis toujours pressé quand je me résigne à faire un tableau. Je vous laisse à penser dans quelle inquiétude j'étais. Perdre un mois moi qui n'avais pas un jour à perdre. Enfin, je crois que j'y arriverai, j'ai encore deux jours par personnage, sans compter les accessoires, malgré cela il faut qu'il soit fait. J'enverrai 14 tableaux à l'exposition, presque rien que des nouveaux, exceptés l'Enterrement, les Casseurs de pierres et mon Portrait à la pipe que Bruyas vient de m'acheter 2,000 F. Il m'a acheté aussi la Fileuse, 2,500 F. J'ai eu de la chance, je vais payer ce que je dois et faire face à l'exposition. Je ne sais comment j'aurais fait tout cela, il ne faut jamais désespérer. J'ai un tableau de moeurs de campagne qui est fait de cribleuses de blé qui entre dans la série des Demoiselles de village, tableau étrange aussi. J'ai l'esprit fort triste, l'âme très vide, le foie et le coeur dévorés d'amertume. A Ornans je fréquente un café de braconniers et des gens du Gai Savoir. Je baise une servante. Tout cela ne m'égaye pas. Vous savez que ma femme est mariée, je n'ai plus ni femme, ni enfant. Il paraît que la misère l'a forcée à cette extrémité. C'est ainsi qui la société avale son monde. Il y avait 14 ans que nous étions ensemble. Il paraît que Promayet est très malheureux aussi. Tâchez de lui aider à trouver quelque chose. La fierté et l'honnêteté nous tuera tous. Dans ce moment-ci je ne puis rien faire, il faut absolument que je sois en mesure pour l'exposition. Dites à [illegible] que je n'ai pas reçu les toiles. Je vous embrasse de coeur.

<div style="text-align:right">Gustave Courbet</div>

(For the history of this letter, which now belongs to the Louvre, see René Huyghe, Germain Bazin, Hélène Adhémar, *Courbet: L'Atelier du peintre, allégorie réelle* [Monographies des peintures du Musée du Louvre, 3] Paris, 1944, p. 23.)

APPENDIX III

From Pierre-Joseph Proudhon, Système des contradictions économiques ou Philosophie de la misère, *Paris, 1846, II, chapter XIII*, part iii, section ii

Le travail est le premier attribut, le caractère essentiel de l'homme.

L'homme est travailleur, c'est-à-dire créateur et poète: il émet des idées et des signes; tout en refaisant la nature, il produit de son fond, il vit de sa substance: c'est ce que signifie la phrase populaire: *Vivre de son travail.*

L'homme donc, seul entre les animaux, travaille, donne l'existence à des choses que ne produit point la nature, que Dieu est incapable de créer, parce que les facultés lui manquent; de même que l'homme, par la spécialité de ses facultés, ne peut rien faire de ce qu'accomplit la puissance divine. L'homme, rival de Dieu, aussi bien que Dieu, mais autrement que Dieu, travaille; il parle, il chante, il écrit, il raconte, il calcule, fait des plans et les exécute, se taille et se peint des images, célèbre les actes mémorables de son existence, institue des anniversaries, s'irrite par la guerre, provoque sa pensée par la religion, la philosophie et l'art. Pour subsister, il met en oeuvre toute la nature; il se l'approprie et se l'assimile. Dans tout ce qu'il fait, il met du dessein, de la conscience, du goût. Mais ce qui est plus merveilleux encore, c'est que, par la division du travail et par l'échange, l'humanité tout entière agit comme un seul homme, et que cependant chaque individu, dans cette communauté d'action, se retrouve libre et indépendant. Enfin, par la réciprocité des obligations, l'homme convertit son instinct de sociabilité en justice, et pour gage de sa parole il s'impose des peines. Toutes ces choses, qui distinguent exclusivement l'homme, sont les formes, les attributs et les lois du travail, et peuvent être considérées comme une émission de notre vie, un écoulement de notre âme.

Les animaux s'agitent, sous l'empire d'une raison qui dépasse leur conscience; l'homme seul travaille, parce que seul il conçoit son travail, et qu'à l'aide de sa conscience il forme sa raison. Les animaux que nous nommons travailleurs, par métaphore, ne sont que des machines sous la main de l'un des deux créateurs antagonistes, Dieu et l'homme. Ils ne *conçoivent* rien, partant ils ne *produisent* pas. Les actes extérieurs qui semblent quelquefois les rapprocher de nous, le talent inné chez plusieurs de se loger, de s'approvisionner, de se vêtir, ne se distinguent pas chez les animaux, quant à la moralité, des mouvements de la vie organique: ils sont d'abord complets et sans perfectionnement possible. Quelle différence, au point de vue de la conscience, pouvons-nous découvrir entre la digestion du ver à soie et la construction de sa toile? En quoi l'hirondelle qui couve est-elle inférieure à l'hirondelle qui bâtit? . . .

Qu'est-ce donc que le travail? Nul encore ne l'a défini. Le travail est l'émission de l'esprit. Travailler, c'est dépenser sa vie; travailler, en un mot, c'est se dévouer, c'est mourir. Que les utopistes ne nous parlent plus de dévouement: le dévouement, c'est le travail, exprimé et mesuré par ses oeuvres . . .

L'homme meurt de travail et de dévouement, soit qu'il épuise son âme, comme le soldat de Marathon, dans un effort d'enthousiasme; soit qu'il consume sa vie par un travail de cinquante ou soixante années, comme l'ouvrier de nos fabriques, comme le paysan dans nos campagnes. Il meurt parce qu'il travaille; ou mieux, il est mortel parce qu'il est né travailleur; la destinée terrestre de l'homme est incompatible avec l'immortalité . . .

Les animaux n'ont, à bien dire, qu'une manière de dépenser leur vie, qui du reste leur est commune avec l'homme: c'est la génération. Dans quelques espèces, la vie dure jusqu'à l'instant de la reproduction: cet acte suprême accompli, l'individu meurt; il a épuisé sa vie, il n'a plus de raison d'existence. Dans les espéces dites travailleuses, telles que les abeilles et les fourmis, le sexe est réservé aux individus qui ne vaquent point au travail: les ouvrières n'ont point de sexe. Parmi les animaux que l'homme a soumis, ceux qu'il fait travailler avec lui perdent bientôt leur vigueur; ils deviennent flasques et mous; le travail est pour eux comme une vieillesse prématurée . . .

En résultat, le travail n'est point la condition des bêtes; et c'est pour cela que, l'homme supprimé, il y a solution de continuité

dans la nature, mutilation, défaillance, et par suite tendance à la mort.

Dans la nature, l'équilibre s'établit par la destruction. Les herbivores, les rongeurs, etc., vivent sur le règne végétal, qu'ils consumeraient bientôt, s'ils ne servaient de pâture aux carnassiers, lesquels, après avoir tout dévoré, finiraient par périr en se dévorant les uns les autres. L'extermination apparaît donc comme loi de circulation et de vie dans la nature. L'homme, en tant qu'animal, est soumis à la même fatalité; il dispute sa subsistance aux baleines et aux requins, aux loups, aux tigres, aux lions, aux rats, aux aigles, aux insectes, qu'il poursuit tous et qu'il tue. En fin de compte il se fait la guerre à lui-même et se mange.

Mais ce n'est point ainsi que doit se clore le cercle de la vie universelle, et tout ce que la chimie moderne nous révèle à cet égard est un outrage à la dignité humaine. Ce n'est pas sous la forme de sang et de chair que l'homme doit se nourir de sa propre substance: c'est sous la forme de pain, c'est du produit de son travail. *Hoc est corpus meum.* Le travail, arrêtant les anticipations de la misère, met fin à l'anthropophagie; au mythe féroce et divin succède la vérité humaine et providentielle; l'alliance est formée par le travail entre l'homme et la nature, et la perpétuité de celle-ci assurée par le sacrifice volontaire de celui-là, *Sanguis foederis quod pepigit Dominus.* Ainsi la tradition religieuse expire dans la vérité économique: ce qu'annonçait le sacrifice eucharistique de Jésus-Christ et de Melchisédech, ce qu'exprimait auparavant le sacrifice sanglant d'Aaron et de Noé, ce qu'indiquait plus anciennement encore le sacrifice humain de la Tauride, l'institution moderne du travail l'annonce de nouveau et le déclare: c'est que l'univers a été fondé sur le principe de la manducation de l'homme par l'homme; c'est, en autres termes, que l'humanité vit d'elle-même.

Dans le travail, comme dans l'amour, le coeur s'attache par la possession; les sens au contraire se rebutent. Cet antagonisme du physique et du moral de l'homme, dans l'exercice de ses facultés industrielle et prolifique, est le balancier de la machine sociale. L'homme, dans son développement, va sans cesse de la fatalité à la liberté, de l'instinct à la raison, de la matière à l'esprit. C'est

en vertu de ce progrès qu'il s'affranchit peu à peu de l'esclavage des sens, comme de l'oppression des travaux pénibles et répugnants. Le socialisme, qui au lieu d'élever l'homme vers le ciel l'incline toujours vers la boue, n'a vu dans la victoire remportée sur la chair qu'une cause nouvelle de misère: comme il s'était flatté de vaincre la répugnance du travail par la distraction et la voltige, il a essayé de combattre la monotonie du mariage, non par le culte des affections, mais par l'intrigue et le changement. Quelque dégoût que j'éprouve de remuer ces immondices, il faut que le lecteur se résigne. Est-ce ma faute, à moi qui n'ai pas charge d'âmes, si, pour établir quelques vérités de sens commun, j'ai besoin de déployer tout l'appareil de la logique?

Par cela même que le travail est divisé, il se spécialise et se détermine dans chacun des travailleurs. Mais cette spécialité ou détermination ne doit point être considérée, relativement au travail collectif, comme une expression fractionnaire: ce serait se placer au point de vue de l'esclavage, adopter le principe au moyen duquel l'utopie travaille de toutes ses forces à la restauration des castes. Que dit spécialité, dit pointe ou sommité, l'étymologie le prouve: *Spiculum, spica, speculum, species, aspico*, etc. Le même radical sert à désigner l'action de pointer et l'action de regarder. Toute spécialité dans le travail est un sommet du haut duquel chaque travailleur domine et considère l'ensemble de l'économie sociale, s'en fait le centre et l'inspecteur. Toute spécialité dans le travail est donc, par la multitude et la variété des rapports, infinie. Il suit de là que c'est par un système de transitions centralisées et coordonnées, dans l'industrie, la science et l'art, que chaque travailleur doit apprendre à vaincre le dégoût et la répugnance au travail, et nullement par une variété d'exercices, sans règle et sans perspective.

De même, par le mariage, l'amour se termine et se personnalise; et c'est encore par un système de transitions toutes morales, par l'épuration des sentiments, par le culte de l'objet auquel l'homme a dévoué son existence, qu'il doit triompher du matérialisme et de la monotonie de l'amour.

L'art, c'est-à-dire la recherche du beau, la perfection du vrai, dans sa personne, dans sa femme et ses enfants, dans ses idées, ses discours, ses actions, ses produits: telle est la dernière évolution du travailleur, la phase destinée à fermer glorieusement le cercle de la nature. L'*Esthétique*, et au-dessus de l'esthétique, la *Morale*, voilà la clef de voûte de l'édifice économique.

L'ensemble de la pratique humaine, le progrès de la civilisa-
tion, les tendances de la société, témoignent de cette loi. Tout
ce que fait l'homme, tout ce qu'il aime et qu'il hait, tout ce qui
l'affecte et l'intéresse, devient pour lui matière d'art. Il le com-
pose, le polit, l'harmonise, jusqu'à ce que, par le prestige du
travail, il en ait fait, pour ainsi dire, disparaître la matière.

L'homme ne fait rien selon la nature: c'est, si j'ose m'exprimer
de la sorte, un animal façonnier. Rien ne lui plaît s'il n'y apporte
de l'apprêt: tout ce qu'il touche, il faut qu'il l'arrange, le corrige,
l'épure, le recrée. Pour le plaisir de ses yeux, il invente peinture,
architecture, les arts plastiques, le décor, tout un monde de hors-
d'oeuvre, dont il ne saurait dire la raison et l'utilité, sinon que
c'est pour lui un besoin d'imagination, que cela lui plaît. Pour
ses oreilles, il châtie son langage, compte ses syllabes, mesure
les temps de sa voix. Puis il invente la mélodie et l'accord, il
assemble des orchestres aux voix puissantes et mélodieuses, et
dans les concerts qu'il leur fait dire, il croit entendre la musique
des sphères célestes et les chants des esprits invisibles. Que lui
sert de manger seulement pour vivre? il faut à sa délicatesse des
déguisements, de la fantaisie, un genre. Il trouve presque cho-
quant de se nourrir: il ne cède point à la faim, il transige avec
son estomac. Plutôt que de paître sa nourriture, il se laisserait
mourir de faim. L'eau pure du rocher n'est rien pour lui: il in-
vente l'ambroisie et le nectar. Les fonctions de sa vie qu'il ne
peut parvenir à maîtriser, il les appelle honteuses, malhonnêtes,
ignobles. Il s'apprend à marcher et à courir. Il a une méthode
de se coucher, de se lever, de s'asseoir, de se vêtir, de se battre,
de se gouverner, de se faire justice; il a trouvé même la perfec-
tion de l'horrible, le sublime du ridicule, l'idéal du laid. Enfin,
il se salue, il se témoigne du respect, il a pour sa personne un
culte minutieux, il s'adore comme une divinité! . . .

Toutes les actions, les mouvements, les discours, les pensées,
les produits, les affections de l'homme portent ce caractère d'ar-
tiste. Mais cet art même, c'est la pratique des choses qui le
révèle, c'est le travail que le développe; en sorte que plus l'indus-
trie de l'homme approche de l'idéal, plus aussi lui-même s'élève
au-dessus de la sensation. Ce qui constitue l'attrait et la dignité
du travail, c'est de créer par la pensée, de s'affranchir de tout
mécanisme, d'éliminer de soi la matière. Cette tendance, faible
encore chez l'enfant plongé tout entier dans la vie sensitive; plus
marquée chez le jeune homme, fier de sa force et de sa souplesse,

mais sensible déjà au mérite de l'esprit, se manifeste de plus en plus chez l'homme mûr. Qui n'a recontré de ces ouvriers qu'une longue assiduité à l'ouvrage avait rendus spontanément artistes, à qui la perfection du travail était un besoin aussi impérieux que la subsistance, et qui, dans une spécialité en apparence mesquine, découvraient tout à coup de brillantes perspectives? . . .

Or, de même que l'homme, par sa nature d'artiste, tend à idéaliser son travail, c'est un besoin pour lui d'idéaliser aussi son amour. . . . Cette faculté de son être, il la pénètre de tout ce que son imagination a de plus fin, de plus puissant, de plus enchanteur, de plus poétique. L'art de faire l'amour, art connu de tous les hommes, le plus cultivé, le mieux senti de tous les arts, aussi varié dans son expression que riche dans ses formes, a pris son plus grand essor vers les temps de la puissance du catholicisme. Il a rempli tout le moyen âge; il occupe seul la société moderne par le théâtre, les romans, les arts de luxe, qui tous n'existent que pour lui servir d'auxiliaires. L'amour, enfin, comme matière d'art, est la grande, la sérieuse, j'ai presque dit l'unique affaire de l'humanité. L'amour donc, aussitôt qu'il s'est déterminé et fixé par le mariage, tend à s'affranchir de la tyrannie des organes: c'est cette tendance impérieuse, dont l'homme est averti dès le premier jour par la tiédeur de ses sens, et sur laquelle tant de gens se font si misérablement illusion, qu'a voulu exprimer le proverbe: *Le mariage est le tombeau*, c'est-à-dire *L'EMANCIPATION de l'amour*. Le peuple, dont le langage est toujours concret, a entendu ici par amour la violence du prurit, le feu du sang: c'est cet amour, entièrement physique, qui, suivant le proverbe, s'éteint dans le mariage. Le peuple, dans sa chasteté native et sa délicatesse infinie, n'a pas voulu révéler le secret de la couche nuptiale: il a laissé à la sagesse de chacun le soin de pénétrer le mystère, et de faire son profit de l'avertissement . . .

Il savait pourtant que le véritable amour commence pour l'homme à cette mort; que c'est un effet nécessaire du mariage que la galanterie se change en culte; que tout mari, quelque mine qu'il fasse, est au fond de l'âme idolâtre; que s'il y a conspiration ostensible entre les hommes pour secouer le joug du sexe, il y a convention tacite pour l'adorer; que la faiblesse seule de la femme oblige de temps à autre l'homme à ressaisir l'empire; que sauf ces rares exceptions, la femme est souveraine, et que là est le principal de la tendresse et de l'harmonie conjugales . . .

C'est un besoin irrésistible pour l'homme, besoin qui naît spon-tanément en lui du progrès de son industrie, du développement de ses idées, du raffinement de ses sens, de la délicatesse de ses affections, d'aimer sa femme comme il aime son travail, d'un amour spirituel; de la façonner, de la parer, de l'embellir. Plus il l'aime, plus il la veut brillante, vertueuse, entendue; il aspire à faire d'elle en chef-d'oeuvre, une déesse. Près d'elle, il oublie ses sens, et ne suit plus que son imagination; cet idéal qu'il a conçu et qu'il croit toucher, il a peur que ses mains ne le souil-lent; il regarde comme rien ce qui autrefois, dans l'ardeur de ses désirs, lui semblait tout. Le peuple a une horreur instinctive, exquise, de tout ce qui rappelle la chair et le sang: l'usage des excitants bachiques et aphrodisiaques, si fréquent chez les Ori-entaux, qui prennent l'aiguisement de l'appétit pour l'amour, révolte les races civilisées: c'est un outrage à la beauté, un con-tre-sens de l'art. De telles moeurs ne se produisent qu'à l'ombre du despotisme, par la distinction des castes et à l'aide de l'iné-galité: elles sont incompatibles avec la justice . . .

Ce qui constitue l'art est la pureté des lignes, la grâce des mouvements, l'harmonie des tons, la splendeur de coloris, la convenance des formes. Toutes ces qualités de l'art sont encore les attributs de l'amour, en qui elles prennent les noms mys-tiques de CHASTETE, *pudeur, modestie*, etc. La chasteté est l'idéal de l'amour: cette proposition n'a plus besoin désormais que d'être énoncée pour être aussitôt admise.

A mesure que le travail augmente, l'art surgissant toujours du métier, le travail perd ce qu'il avait de répugnant et de pénible: de même l'amour, à mesure qu'il se fortifie, perd ses formes impudiques et obscènes. Tandis que le sauvage jouit en bête, se délecte dans l'ignorance et le sommeil, le civilisé cherche de plus en plus l'action, la richesse, la beauté: il est à la fois industrieux, artiste et chaste. Paresse et luxure sont vices conjoints, sinon vices tout à fait identiques. Mais l'art, né du travail, repose nécessairement sur une utilité, et correspond à un besoin; con-sidéré en lui-même, l'art n'est que la manière, plus ou moins exquise, de satisfaire ce besoin. Ce qui fait la moralité de l'art, ce qui conserve au travail son attrait, qui en éveille l'émulation, en excite la fougue, en assure la gloire, c'est donc la valeur. De même ce qui fait la moralité de l'amour et qui en consomme la volupté, ce sont les enfants. La paternité est le soutien de l'amour, sa sanction, sa fin. Elle obtenue, l'amour a rempli sa

carrière; il s'évanouit, ou, pour mieux dire, il se métamorphose
. . .

Tout travailleur doit devenir artiste dans la spécialité qu'il a
choisie, et selon la mesure de cette spécialité. Pareillement tout
être né de la femme, nourri, élevé sur les genoux de la femme,
fils, amant, époux et père, doit réaliser en lui l'idéal de l'amour,
en exprimer successivement toutes les formes.

De l'idéalisation du travail et de la sainteté de l'amour résulte
ce que le consentement universel a nommé VERTU, ou comme
qui dirait la force (valeur) propre de l'homme, par opposition
à la PASSION, force de l'être fatal, de l'être divin.

Le langage consacre ce rapport: VERTU, lat. *vir-tus*, de *vir*,
l'homme; gr. *arété*, ou *andreïa*, de *arès* ou *anêr*, l'homme. Les
antonymes sont, lat. *fortitudo*, de *fero*, porter, *fortis*, porteur,
robur, chêne et force; gr. *rômê*, force impétueuse, vigueur natu-
relle. L'hébreu dit *geborrah*, de *gebar*, l'homme; et par contre
eïal, force-vital; *éil*, mâle des animaux ruminants, d'où *élohim*,
dieu.

La vertu de l'homme, par opposition à la force divine, est
dans son affranchissement de la nature par l'idéal: c'est la liberté,
c'est l'amour, dans toutes les sphères de l'activité et de la con-
naisance. Le contraire de la vertu est le laid, l'impur, le discord,
l'inconvenant, la lâcheté, la contrainte.

C'est par la vertu (sous ce mot désormais nous avons une idée)
que l'homme, se dégageant de la fatalité, arrive graduellement
à la pleine possession de lui-même; et comme dans le travail,
l'attrait succède naturellement à la répugnance, de même dans
l'amour, la chasteté remplace spontanément la lasciveté. Dès ce
moment, l'homme, sanctifié dans toutes ses puissances, dompté
par le travail, ennobli par l'art, spiritualisé par l'amour, com-
mande à tout ce qui dans son être est le produit de la nature,
comme à tout ce qui vient de la raison et du libre arbitre.
L'homme l'emporte de plus en plus sur le dieu; la raison règne
au fort de la passion, et à la suite de la raison se manifeste
l'équilibre, c'est-à-dire la sérénité, la joie.

L'homme n'est plus alors cet esclave déshonoré, qui regarde
la femme et qui pleure de rage: c'est un ange en qui la chasteté,
le dédain de la matière, se développe en même temps que la
virilité. Comme le travail servile ne produit chez l'homme qu'une
impuissance désolée et maudite, ainsi le travail libre, rendu at-
trayant par la science, l'art et la justice, engendre la chasteté

attrayante, l'amour; et bientôt, à l'aide de cet idéal, l'esprit ga- gnant toujours sur la chair, la perfection de l'amour produit la répugnance du sexe . . .

L'amour, quant à l'oeuvre génératrice, a donc sa limite propre; la volupté conjugale a sa période dans la vie humaine, comme la fécondité et l'allaitement. Et dans cette nouvelle évolution, de même que dans toutes les autres, l'homme, ministre de la nature et chantre des destinées, ne fait pas la loi, il la découvre et l'exé- cute.

Je devise donc, avec le sentiment universel, la vie de l'homme en cinq périodes principales: enfance, adolescence, jeunesse, vi- rilité ou période de génération, et maturité ou vieillesse.

L'homme, pendant la première période, aime la femme comme mère; dans la seconde, comme soeur; dans la troisième, comme maîtresse; dans la quatrième, comme épouse, dans la cinquième et dernière, comme fille.

Ces périodes de l'amour correspondent à des périodes pareilles de la vie économique: dans l'enfance, l'homme n'existe, pour ainsi dire, qu'à l'état de bouture, ou comme les matériaux pré- parés de longue main à la confection et à l'entretien des ma- chines. Il est l'espoir, le gage, *pignus*, de la société. Dans l'ado- lescence, il est apprenti; dans la jeunesse, compagnon; dans la virilité, maître; dans la maturité, vétéran. . Inutile d'ajouter que cette double évolution s'entend de la femme aussi bien que de l'homme.

APPENDIX IV

From Pierre-Joseph Proudhon,
Philosophie du progrès, *Paris, 1853,*
"Première lettre: De l'idée du progrès;
Sainte-Pélagie, 26 novembre 1851,"
section X.

Je disais tout à l'heure que l'art avait pour objet, de même que le culte, de nous élever à l'immortelle béatitude par l'excitation de ses jouissances. Permettez-moi d'entrer à ce sujet dans quelques explications. C'est surtout au point de vue de l'art que le socialisme est accusé de barbarie, et le progrès de fausseté: il faut savoir jusqu'à quel point ce double reproche est mérité.

On nous dit: Quelle supériorité les modernes ont-ils obtenue sur les anciens, pour tout ce qui concerne les oeuvres de l'art? Aucune. Du premier bond, le génie humain, s'appliquant à la représentation du sublime et du beau, s'est élevé à une telle hauteur, qu'il lui a été depuis impossible de se surpasser. Admettons que l'idée du progrès, devenue fondamentale dans la philosophie et les sciences politiques, les régénère: de quelle utilité peut-elle être pour la peinture et la statuaire? Suffira-t-il de dire aux artistes qu'en vertu du progrès ils doivent, comme les mathématiciens, être toujours plus profonds et plus habiles, pour qu'en effet ils le deviennent? . . . Que si l'expression, et par conséquent la conception du sublime et du beau faiblit ou demeure stationnaire dans l'humanité, qui osera dire que celle du bien ou du vrai grandisse et se fortifie? La théorie du progrès, après avoir obtenu un triomphe plus ou moins sincère dans les questions antérieures, échoue sur la dernière, la plus séduisante et la plus impitoyable: plus malheureuse qu'Ulysse, elle est dévorée par les Sirènes; elle ne peut rien pour la Beauté! . . .

Telle est l'objection, que je dissimule d'autant moins qu'à mon propre jugement, l'art, abstraction faite de la période d'appren-

122

tissage, est par nature toujours égal à lui-même, dans un niveau inférieur à ses plus grandes sublimités. En quoi donc et comment rentre-t-il dans la théorie du progrès? comment le sert-il? comment lui fournit-il sa dernière preuve? Je vais essayer de le dire.

Ce que la morale révèle à la conscience, sous la forme de préceptes, l'esthétique a pour but de le montrer aux sens sous la forme d'images. La leçon exprimée par le Verbe est impérative dans sa teneur, et se réfère à une loi absolue; la figure présentée aux sens, explicite dans sa signification, positive et réaliste dans son type, se réfère également à un absolu. Ce sont deux modes de notre éducation, à la fois sensible et intellectuelle, qui se touchent dans la conscience, ne différant entre elles que par l'organe ou la faculté qui leur sert de véhicule.

Se perfectionner par la justice ou se faire saint, en observant la loi temporelle, et en la développant dans son entière vérité, tel est le but indiqué à l'homme par la morale;—se perfectionner par l'art, ou si j'ose me servir de cette expression familière, se faire beau, en épurant sans cesse, à l'instar de notre âme, les formes que nous entourent, tel est l'objet de l'esthétique. L'une nous enseigne la tempérance, le courage, la pudeur, la fraternité, le dévouement, le travail, la justice; l'autre nous purifie, nous pare, nous environne de splendeur et d'élégance: n'est-ce pas toujours la même fonction, procédant du même principe, et tendant au même but?—C'est partir de bas, direz-vous, que de faire commencer l'art au bain de propreté, à la coupe des ongles et des cheveux! Il n'y a rien de petit et d'ignoble dans tout ce qui touche à l'amélioration de l'humanité. La morale n'a-t-elle pas commencé par la défense de la chair humaine et de l'amour bestial? . . .

Il s'agit à présent de savoir comment cette théorie de l'art a été entendue et pratiquée, et comment il convient dorénavant qu'elle le soit.

Au commencement, l'homme pose loin de lui-même son idéal; il le concrète, le personnifie, en fait un être sublime et beau, dont il se dit l'image, et qu'il nomme Dieu. A ce moment, la religion, la morale, le culte, l'art, le merveilleux, tout est confondu: et l'on peut prédire que tels auront été conçus les dieux, tels seront plus tard les artistes et les poètes. Chez les Grecs, les premières images taillées furent celles des personnes divines; la première poésie chantée, c'est la religion qui l'inspira. Les dieux étaient beaux, d'une beauté achevée; leurs images durent donc être

belles, et tous les efforts des sculpteurs tendirent à leur donner
une perfection typique, qui, à force de se rapprocher de la Di-
vinité, finit par n'avoie plus rien de l'homme. Le culte et l'art
s'identifièrent au point que pendant un temps on ne fit de statues
que pour les dieux; c'eût été presque un sacrilège de faire par-
tager à de laids mortels les honneurs réservés aux éternelles
beautés. Tout le reste fut traité en conséquence. La poèsie fut
appelée la langue des dieux; jusqu'au dernier jour, les oracles se
rendirent en vers: parler en prose, c'est-à-dire en langue profane,
dans les temples, cela eût été d'une insigne inconvenance.

La théorie de l'art chez les Grecs découla donc tout entière de
la religion. Elle s'imposa à leurs successeurs; elle a régné jusqu'à
nos jours. L'artiste, d'après cette théorie religieuse, recherchait
en tout LE PLUS BEAU, au risque de sortir de la nature et de
manquer à la réalité. Son but, ainsi que l'a exprimé Raphaël,
était de faire les choses, non pas telles que les produit la nature,
mais comme elle devrait et ne sait ni ne peut les produire. Il ne
lui suffisait pas de révéler, par son oeuvre, la pensée de l'Absolu,
il tendait à la reproduire, à la réaliser. C'est ainsi que, l'imagi-
nation toujours tendue vers leur idéal, les Grecs arrivèrent, dans
l'expression du beau, à un point qu'on n'a jamais égalé, que
peut-être on n'égalera plus. Il faudrait, pour égaler et surpasser
les Grecs, qu'à leur exemple nous crussions aux dieux, que nous
y crussions davantage: or, c'est là qu'est l'impossible.

Le peuple partageait les idées et le sentiment des artistes:
c'est ce qui explique comment dans cette société profondément
idolâtrique, amoureuse de la forme par principe de religion, tout
le monde, en matière de littérature et d'art était compétent. La
religion imprimant aux esprits la même direction, aux caractères
la même physionomie, le sentiment esthétique se développait à
l'unisson, et tandis que parmi nous la littérature, la musique et
tous les autres arts sont un objet perpétuel de contradiction, chez
les Grecs c'était des choses de goût que l'on disputait le moins.
Jamais la démocratie ne se montra plus souveraine, et le juge-
ment populaire plus incorruptible. Les Athéniens n'avaient que
faire de consulter sur la beauté des statues et des temples les
philosophes de l'Académie, les aristarques du feuilleton ils s'y
connaissaient, pour ainsi dire, de naissance, comme en combats
et en festins. Les chefs-d'oeuvre de Phidias, ceux de Sophocle
et d'Aristophane étaient reçus, sans commission et sans jury, en

pleine assemblée du peuple, qui ayant appris à lire dans Homère, parlant sa langue mieux qu'Euripide, n'aurait pas souffert qu'un directeur des beaux-arts, à la nomination d'Aspasie, lui choisît ses déesses et ses courtisanes.

S'ensuit-il que les Grecs et leurs imitateurs aient rempli le but de l'art, au point que, désespérant de les égaler, il ne nous reste qu'à les copier et les traduire, à peine d'une décadence continue et inévitable?

Je suis si loin de le penser, que j'accuse précisément les Grecs, à force de rechercher l'idéal, d'en avoir amoindri l'emploi et méconnu le rôle, et que je fais remonter jusqu'à eux la cause de cette anarchie antiesthétique qui désole notre civilisation, supérieure sous tant de rapports.

Même dans la production du beau, la tendance à l'Absolu conduit à l'exclusion, à l'uniformité, à l'immobilisme. De là à l'ennui, au dégoût, finalement à la dissolution, la pente est irrésistible.

Les dieux et les héros, les déesses et les nymphes, les pompes sacrées et les scènes de batailles, une fois figurées, rendues avec leurs types célestes et leurs physionomies homériques, tout était fini pour l'artiste grec: il ne pouvait que se répéter. Il avait idéalisé dans ses dieux les âges, les sexes, toutes les conditions de l'humanité: le jeune homme, la vierge, le guerrier, la mère, le prêtre, le chantre, l'athlète, le roi, tout le monde avait son idole, comme on disait au moyen âge, son saint. Que pouvait-on exiger encore! Il n'y avait plus qu'un degré à franchir: c'était que, par un dernier effort d'idéalisation, l'artiste ramenât ces divines effigies à une forme suprême à peu près comme le philosophe opérait la réduction des attributs divins, faisait de toutes les personnalités immortelles un sujet invisible, insondable, éternel, infini, absolu. Mais un pareil chef-d'oeuvre était tout bonnement une chimère: c'eût été tomber dans l'allégorie, dans le néant. Un Dieu infini et unique, l'Absolu, en un mot, ne se représente pas: rien de ce qui est au ciel, sur la terre, ou dans la mer ne saurait le figurer, dit l'Hébreu Moïse. Au point de vue de l'art, l'unité de Dieu est la destruction du beau et de l'idéal: c'est l'athéisme.

Ainsi, la théorie de l'art, telle que la conçurent les Grecs, mène, d'idéalité en idéalité, c'est-à-dire d'abstraction en abstraction, droit à l'absurde: elle ne s'y dérobe que par l'inconséquence. Combien eût été surpris le philosophe de l'idéal, Platon, si on

lui eût démontré, par raisonnements socratiques, que toute sa philosophie reposait sur l'une ou sur l'autre de ces deux négations, la négation de Dieu ou la négation de la Beauté!

Divin Platon, ces dieux que tu rêves n'existent pas. Il n'y a rien au monde de plus grand et de plus beau que l'homme.

Mais l'homme, sortant des mains de la nature, est misérable et laid; il ne devient sublime et beau que par la *gymnastique*, la *politique*, la *philosophie*, la *musique*, et surtout, chose dont tu ne parais guère te douter, l'*ascétique*. (Par *ascétique*, il faut entendre ici l'exercice industriel, ou le TRAVAIL, réputé servile et ignoble chez les anciens [*note de Proudhon*].)

Qu'est-ce que le beau? Tu l'as dit toi-même: c'est la forme pure, l'idée typique du vrai. L'idée, en tant qu'idée, n'existe que dans l'entendement; elle est représentée, réalisée avec plus ou moins de fidélité et de perfection par la nature et l'art.

L'art c'est l'humanité.

Tous tant que nous vivons nous sommes artistes, et notre métier à tous est d'élever en nos personnes, dans nos corps et dans nos âmes, une statue à la BEAUTE. Notre modèle est en nous-mêmes; ces dieux de marbre et de bronze que le vulgaire adore, n'en sont que des étalons.

La *gymnastique* comprend la danse, l'escrime, la lutte, la course, l'équitation, et tous les exercices du corps. Elle développe les muscles, augmente la souplesse, l'agilité et la force, donne la grâce, prévient l'embonpoint et les maladies.

La *politique* embrasse le droit civil, le droit public et le droit des gens; l'administration, la législation, la diplomatie et la guerre. C'est elle qui, tirant l'homme de la barbarie, lui donne la vraie liberté, le courage et la dignité.

La *philosophie* enseigne la logique, la morale, l'histoire: c'est le chemin de la science, le miroir de la vertu, l'antidote de la superstition.

La *musique*, ou le culte des muses, a pour objet la poésie, l'éloquence, le chant, le jeu des instruments, les arts plastiques, la peinture et l'architecture.

Son but n'est point, comme tu le supposes, ô sage Platon, de chanter des hymnes aux dieux, de leur élever des temples, de leur ériger des statues, de leur faire des sacrifices et des processions. C'est de travailler à la déification des hommes, tantôt par la célébration de leurs vertus et de leurs beautés, tantôt par l'exécration de leurs laideurs et de leurs crimes.

Il faut donc que le statuaire, que le peintre, de même que le chanteur, parcoure un vaste diapason, qu'il montre la beauté tour à tour lumineuse ou assombrie, dans toute l'étendue de l'échelle sociale, depuis l'esclave jusqu'au prince, depuis la plèbe jusqu'au sénat. Vous n'avez su peindre que des dieux: il faut représenter aussi des démons. L'image du vice, comme de la vertu, est aussi bien du domaine de la peinture que de la poésie: suivant la leçon que l'artiste veut donner, toute figure, belle ou laide, peut remplir le but de l'art.

Que le peuple, se reconnaissant à sa misère, apprenne à rougir de sa lâcheté et à détester ses tyrans; que l'aristocratie, exposée dans sa grasse et obscène nudité, reçoive sur chacun de ses muscles la flagellation de son parasitisme, de son insolence et de ses corruptions. Que le magistrat, le militaire, le marchand, le paysan, que toutes les conditions de la société, se voyant tour à tour dans l'idéalisme de leur dignité et de leur bassesse, apprennent, par la gloire et par la honte, à rectifier leurs idées, à corriger leurs moeurs, et à perfectionner leur institution. Et que chaque génération, déposant ainsi sur la toile et le marbre le secret de son génie, arrive à la postérité sans autre blâme ni apologie que les oeuvres de ses artistes.

C'est ainsi que l'art doit participer au mouvement de la société, le provoquer et le suivre.

Et c'est pour avoir méconnu cette destination de l'art, pour l'avoir réduit à n'être que l'expression d'une idéalité chimérique, que la Grèce, élevée par la fiction, perdra l'intelligence des choses et le sceptre des idées.

Un temps viendra, ô Platon, où le Grec ayant mis en ses dieux toute beauté, s'en trouvera totalement dépourvu, et en perdra jusqu'au sentiment. Une triste et grossière superstition s'emparant alors des esprits, on verra les descendants de ceux qui jadis adorèrent des divinités si belles, se prosterner devant un dieu chenu et difforme, couvert de haillons, type de misère et d'ignominie; on les verra, par amour de cette idole, prendre la beauté en haine; se faire ignobles et laids par principe de religion. Les pieux, les saints se reconnaîtront à la crasse et à la vermine. Au lieu de la poésie et des arts, inventions de péché, ils pratiqueront le dénuement, se feront une gloire de la mendicité. Gymnases, écoles, bibliothèques, théâtres, académies, oeuvres et pompes de Satan, seront dévastés et livrés aux flammes: l'image d'un supplicié pendu au gibet sera pour les femmes le plus précieux des

bijoux. Se couvrir de cendre, se macérer d'abstinences, s'épuiser en oraison, fuir l'étude comme profane et l'amour comme impur, c'est ce qu'ils appelleront exercice (*ascétisme*) de piété et de pénitence.

Et cette religion, cette liturgie, ces mystères, ô Platon, ce sera la religion du *Logos*; et au nom de ce *Logos*, la raison sera detestée, la beauté maudite, l'art frappé d'anathème, la philosophie et les philosophes jetés aux flammes, et voués aux dieux infernaux.

L'Humanité alors, courbée dans une superstition infamante, et se croyant elle-même infâme et déchue, sera frappée d'une dégradation systématique et fatale. Plus d'idéal, ni dans l'homme, ni hors de l'homme: dès lors plus de poésie, plus d'éloquence, plus d'art, surtout plus de science. Autant, avec le culte de ses premiers dieux, la Grèce s'était élevée, autant, sous le joug de son nouveau Seigneur, elle s'abaissera. Car l'homme ne s'élève dans la raison et la vertu, qu'attiré par la beauté, et cette beauté, qui doit faire sa joie et son triomphe, sa foi consistera à la nier. Un Dieu absolu et inexprimable, manifesté sous une incarnation chétive et déshonorée; l'homme déclaré impur, difforme et méchant de naissance: quelle esthétique encore une fois, quelle civilisation pourrait sortir de cet horrible dogme?

Cependant la décadence ne sera pas éternelle. Ces hommes dégénerés auront appris deux choses, qui les rendront un jour plus grands et meilleurs que leurs pères: la première est que devant Dieu tous les hommes sont égaux; conséquemment que de par la nature et la Providence il n'y a pas d'esclaves; la seconde, c'est que leur devoir et leur honneur à tous est de travailler.

Ce que ni la gymnastique, ni la politique, ni la musique, ni la philosophie, réunissant leurs efforts, n'auront su faire, le *Travail* l'accomplira. Comme dans les âges antiques l'initiation à la beauté arriva par les dieux, ainsi, dans une postérité reculée, la beauté se révélera de nouveau par le travailleur, le véritable *ascète*, et c'est aux innombrables formes de l'industrie qu'elle demandera son expression changeante, toujours nouvelle et toujours vraie. Alors, enfin, le *Logos* sera manifesté, et les laborieux humains, plus beaux et plus libres que ne furent jamais les Grecs, sans nobles et sans esclaves, sans magistrats et sans prêtres, ne formeront tous ensemble, sur la terre cultivée, qu'une famille de héros, de savants et d'artistes.

NOTES

NOTES

UNLESS otherwise noted, all references to Proudhon's works are to critical editions of these texts published by the Librairie Marcel Rivière.

CHAPTER I

1. Jules-Antoine Castagnary, *Philosophie du Salon de 1857*, reprinted in *Salons, 1857-1879*, Eugène Spuller, ed., Paris, 1892, p. 2. (See below, chapter X.)

2. In 1866, Courbet sent an autobiographical note to Victor Frond that contained the following passage: "This man [Courbet], entirely independent, from the mountains of the Doubs and the Jura, republican at birth by his maternal grandfather, continued in the republican idea through his father, a sentimentalist liberal of 1830, and his Catholic republican mother. He left behind the ideas and teachings of his youth to follow, in 1840, the socialists of all sects. When he reached Paris, he was a Fourierist. He followed the disciples of Cabet and Pierre Leroux. Along with painting, he continued his philosophical studies. He studied the French and German philosophers, and for ten years, along with the editors of *La Réforme* and *Le National* [opposition newspapers], he participated in active revolution, until 1848. Then, his pacifist ideas failed against the reactionary onslaught of the liberals of 1830, the Jacobins, and those who would restore history mindlessly." (Quoted in Pierre Courthion, *Courbet raconté par lui-même et par ses amis, II: Ses écrits, ses contemporains, sa postérité*, Geneva, 1950, p. 27. The note to Frond was for the *Panthéon des illustrations françaises au XIXe siècle*. See the excellent commentary on this passage by Alan Bowness, "Courbet's Early Subject-Matter," in Ulrich Finke, ed., *French 19th Century Painting and Literature*, London and New York, 1972.)

While this description shows Courbet's debt to thinkers other than Proudhon in the 1840s, it also gives clear signs of his conversion to Proudhon. First, the philosopher himself was immensely indebted to these thinkers and the intellectual environment they all shared. Indeed, Courbet's description very closely parallels Proudhon's own intellectual development during the 1840s. Note that since Proudhon's death in the year before the quoted note, Courbet consistently pictured himself as one of Proudhon's disciples. On the other hand, the description could have fit many young and disenchanted members of the opposition to the July Monarchy in the 1840s. However, Courbet's mention of his pacifist failure and reactionary liberalism is especially Proudhonian.

From the vast literature on the social thought of this period, some helpful surveys may be singled out: Maxime Leroy, *Histoire des idées sociales*

en *France, Paris*, 1954, vols. II and III; Frank E. Manuel, *The Prophets of Paris: Turgot, Condorcet, Saint-Simon, Fourier, and Comte*, New York, 1965; and Paul Bénichou, *Le Temps des prophètes: Doctrines de l'âge romantique*, Paris, 1977.

3. I have especially profited from the following: Alan Bowness, *Courbet's "Atelier du peintre*," Charlton Lecture on Art, Newcastle upon Tyne, 1972, reprinted in Petra ten-Doesschate Chu, ed., *Courbet in Perspective*, Englewood Cliffs, N.J., 1977, pp. 121-138; Timothy J. Clark, *Image of the People: Gustave Courbet and the Second French Republic, 1848-1851*, and *The Absolute Bourgeois: Art and Politics in France, 1848-1851*, both London and New York, 1973; Pierre Georgel, "Les Transformations de la peinture vers 1848, 1855, 1863," *La Revue de l'art*, 1975, no. 27, pp. 69-72; Klaus Herding, "Das *Atelier des Malers*—Treffpunkt der Welt und Ort des Versöhnung," in Herding, ed., *Realismus als Widerspruch: Die Wirklichkeit in Courbets Malerei*, Frankfurt, 1978, pp. 223-247; Werner Hofmann, *The Earthly Paradise: Art in the Nineteenth Century*, New York, 1961, pp. 11-22 and "Courbets Wirklichkeiten," in exh. cat., *Courbet und Deutschland*, Hamburg and Frankfurt, 1978-1979, pp. 589-613; Benedict Nicolson, *Courbet: The Studio of the Painter*, London and New York, 1973; Linda Nochlin, "The Invention of the Avant-Garde," *Art News Annual*, 34, 1968, pp. 11-19; Meyer Schapiro, "Courbet and Popular Imagery: An Essay on Realism and Naiveté," *Journal of the Warburg and Courtauld Institutes*, 4, 1941, pp. 164-191; Hélène Toussaint, Paris, Grand Palais, exh. cat., *Gustave Courbet*, 1977-1978. Although neither Clark nor Schapiro focuses extensively on *The Studio* or on Proudhon, it will be clear that the kinds of questions they have raised about the context of Courbet's art provided a basic stimulus to my thinking. Many other excellent essays devoted to or touching on *The Studio* are mentioned in appropriate places in the notes.

4. On Courbet's portrait of Proudhon and his family, see Alan Bowness, "Courbet's *Proudhon*," *Burlington Magazine*, March 1978, pp. 123-130, and Klaus Herding, "Courbet und Proudhon: Ideologie und Bildstrucktur," unpublished paper given at the Courbet Colloquium, Frankfurt, March 1979. Herding sees Courbet's image of the philosopher with his family as an expression of Proudhon's conception of his own role and of his attitudes toward the family. (See also, Charles Léger, "Proudhon et Courbet: Histoire des portraits de Proudhon," *Bulletin de la Société des amis de Gustave Courbet*, 2 [1947], pp. 3-13.)

5. Marie-Thérèse de Forges, Paris, Musée du Louvre, exh. cat., *Autoportraits de Courbet* (Les Dossiers du département des peintures, 6), 1973. Gabriele Sprigath, "Courbets Atelierbild als programmatisches Selbstbildnis und als ästhetisches Programm," unpublished paper given at the Courbet Colloquium, Frankfurt, March 1979, discusses the relation between *The Studio* and earlier self-portraits. (See also, Gabriele Sprigath, "Die Parteilichkeit des freien Menschen," *Tendenzen*, 19, no. 122, Nov.-Dec. 1978, pp. 34-38, as a response to Klaus Herding, "Von der Kraft des Widerspruchs: Courbets Bedeutung," *Tendenzen*, 19, no. 120, July-August 1978, pp. 41-47.) For two extremely different but useful and highly provocative discussions of Courbet's early self-portraiture, see Clark, *Image of the People*, pp. 36-46 and Michael Fried, "The Beholder in Courbet: His Early Self-Portraits

and their Place in his Art," *Glyph: Johns Hopkins Textual Studies*, 4, Baltimore, 1978, pp. 85-129.

6. This connection was made but not fully exploited by Jack Lindsay, *Gustave Courbet: His Life and Art*, London, 1973, p. 130. The allusion of Courbet's painting to these issues would be better comprehended by English-speaking audiences if its title were more frequently translated as *The Workshop* rather than *The Studio*. For example, the *ateliers nationaux* created by the Luxembourg Commission after 1848 are usually given in English as National Workshops, not as National Studios. The latter somehow rings untrue. (On theories and history of the worker movement, see Camille Ernest Labrousse, *Le Mouvement ouvrier et les théories sociales en France de 1815 à 1848*, Paris, 1961. For greater detail, see Edouard Dolléans, *Histoire du mouvement ouvrier, 1831-1871*, Paris, 1936, vol. II and Dolléans and Gérard Dehove, *Histoire du travail en France, mouvement ouvrier et législation sociale*, Paris, 1953, vol. I.)

7. With a few exceptions, to which I shall refer at the appropriate time, the search for sources for *The Studio* has provided relatively little specific or new information regarding the artist's intentions (see chapter III, note 31). The relationship of Courbet's picture to the iconography of the artist's-studio theme has been amply studied in René Huyghe, Germain Bazin, and Hélène Adhémar, *Courbet, L'Atelier du peintre, allégorie réelle* (Monographies des peintures du Musée du Louvre, 3), Paris, 1944, pp. 19-21 and Matthias Winner, "Gemalte Kunsttheorie: Zu Courbets 'Allégorie réelle' und der Tradition," *Jahrbuch der Berliner Museen*, 1962, pp. 151-185. For general treatment of the theme, see Jeanine Baticle and Pierre Georgel, exh. cat., *Technique de la peinture: l'atelier* (Les Dossiers du département des peintures, 12), Paris, Musée du Louvre, 1976. Franzepp Würtemberger, "Das Maleratelier als Kultraum im 19 Jahrhundert," *Miscellanea Bibliotecae Herzianae* (Römische Forschungen, 16), Munich, 1961, pp. 502-513, deals with the atelier as a quasi-mystical center of inspiration. All of the above consider the symbolic significance, implied or intended, of the theme of the artist's workshop. More concrete is Alex Seltzer's comparison of *The Studio* to Horace Vernet's *Artist's Studio* in Seltzer, "Gustave Courbet: All the World's a Studio," *Artforum*, Sept. 1977, pp. 44-50.

8. Courbet to Champfleury, about October 1854. See my appendix II. Observation suggests the miller and the ass may have been painted out. In any case, the boy watching Courbet (the boy's head obscures part of the canvas) was a late addition. (See Lola Faillant-Dumas, "Etude au laboratoire de recherche des Musées de France," in Grand Palais, *Courbet*, p. 276.)

9. See Marie-Thérèse de Forges, "A Propos de l'Exposition 'Autoportraits de Courbet,'" *La Revue du Louvre et des Musées de France*, 22, 1972, pp. 451-456.

10. "The basis of Realism is the negation of the ideal. . . ." from the *Précurseur d'Anvers*, 22 August 1861. Quoted in Pierre Courthion, *Courbet raconté par lui-même et par ses amis, I: Sa vie et ses oeuvres*, Geneva, 1948, p. 160.

11. The term "ouvrier-peintre" was applied to Courbet by Jules-Antoine Castagnary in his *Philosophie du Salon de 1857* (in Castagnary, *Salons*,

p. 29). It had been used earlier in a scathing piece of criticism of 1851. (Elisa de Mirbel, *La Révolution littéraire*, 1851, quoted by Clark, *Image of the People*, p. 146.) The phrase had first been coined by Champfleury to describe the Le Nain brothers. (Champfleury, *Essai sur la vie et l'oeuvre des Le Nain, peintres laonnais*, Laon, 1850, p. 48. The significance of the revival of the Le Nains as an indication of the aesthetic of early Realism has been studied by Stanley Meltzoff, "The Revival of the Le Nains," *Art Bulletin*, 24, 1942, pp. 259-286.) The context of Champfleury's and Castagnary's use of the term is somewhat different from mine, however, and needs to be explained. The works of the contemporary *ouvrier-poète*, now long forgotten, consisted primarily of socialist rhymes and novels encouraged by the socialists' interest in the arts. (The songwriter Pierre Dupont may have drawn some inspiration from this movement.) In 1848, however, Champfluery mocked the idea of the worker-poet as an impossible contradiction; for him the two states of being it suggested were mutually exclusive (see Emile Bouvier, *La Bataille réaliste, 1844-1857*, Paris, n.d. [1913], pp. 32-34). Thus, coming from Champfleury, the words "worker-painter" to describe the Le Nains, were not necessarily meant as high praise, as we may too easily assume.

Castagnary's use of the term was clearly derogatory. It came after a discussion in which he accused Courbet of attempting to put Proudhon's moralizing conception of art into practice and of restricting his view to the baser aspects of reality in so doing. He concluded that Courbet was "un brave ouvrier peintre" who wasted much of his talent because he failed to understand the "aesthetics of his art" and believed that painting should have a social mission (Castagnary, *Salons*, pp. 28-30).

The fact is that Proudhon, as we shall see later in this study, addressed himself specifically to the problem of the evolution of the worker from a menial state to that of the artist. If Champfleury's estimation of the Le Nains was meant as a positive statement, then his change of heart about the notion of the worker-artist may reflect his association with Proudhon after 1848. Whatever the case may be for him, however, my use of the term here is meant to prefigure the exploration of the connection made by Proudhon between work and art that will come later in this study. This link was established principally through Proudhon's recognition of and insistence on the physicality of both, and it is for its connotation of the artist as a manual laborer that I find the term appropriate here.

I should hasten to add that my use of the expression for this purpose is not meant to have class overtones. No association between Courbet and an industrial, "mechanized," proletariat is necessarily intended; on the contrary, it will become clear that Courbet's image of his work was as an artisanal occupation thus open to inspiration. I would prefer the connotations of the French word *travailleur*, or perhaps the old-fashioned *maître-peintre*; for Courbet emphasizes this distinction, indirectly underlining and confirming the contradiction to which Champfleury referred within the term *ouvrier-peintre*. (See the end of chapter II.)

On the worker-poets, see Edgar Leon Newman, "Sounds in the Desert: The Socialist Worker-Poets of the Bourgeois Monarchy, 1830-1848," *Proceedings of the Western Society for French History Studies*, 3, 1976, pp. 269-299; Roger Picard, *Le Romantisme social*, New York, 1944, pp. 355-

379; and H. J. Hunt, *Le Socialisme et le romantisme en France: Etude de la presse socialiste de 1830 à 1848*, Oxford, 1935, pp. 294-338. The latter is still the principal study of socialism and the arts during this period.

12. On Marx's critique of Proudhon, see the end of chapter VI.

13. L. Enault, "Salon de 1851," *Chronique de Paris*, 16 February 1851, p. 120, quoted in translation by Clark, *Image of the People*, p. 9.

CHAPTER II

1. Bowness, Courbet's *"Atelier,"* and Nicolson, *Courbet: The Studio*, esp. appendix I, pp. 75-79, for the latter.

2. Alfred Bruyas, *Explication des ouvrages de peinture du Cabinet de M. Alfred Bruyas*, Paris, 1854. (Two earlier versions of this catalogue had been published: *Salons de Peinture de M. Alfred Bruyas*, Montpellier, 1852, and *Salons de Peinture de M. Alfred Bruyas (de Montpellier)*, Paris, 1853. Compared to the vastly enlarged work of 1854, the earlier editions are very close to each other, even though the 1853 edition was longer than its predecessor by about twenty pages. Very little from the 1852 and 1853 editions was left out of the 1854 tome.) Bruyas' ideas and their role in his collecting deserve separate study. In a poem entitled "Au Vrai Luxembourg des artistes," Bruyas appears to compare himself to the Medici (Bruyas, 1854, pp. 20-21).

3. On Bruyas, see Gerstle Mack, *Gustave Courbet*, London, 1951, pp. 106-107.

4. Courbet to Bruyas, 18 June 1853, in Bruyas, *Explication*, 1854, pp. 47-48.

5. Courbet to Bruyas, about October 1853, in Pierre Borel, ed., *Lettres de Gustave Courbet à Alfred Bruyas*, Geneva, 1951, pp. 66-67.

6. The exhibition does not seem to have been a financial success, however. For details on the plans with Bruyas and on the exhibition itself, see Mack, *Courbet*, pp. 112-114, and Georges Riat, *Gustave Courbet, peintre*, Paris, 1906, pp. 129-135.

7. Courbet to Bruyas, about October 1853, in Borel, *Lettres*, pp. 68-70. My translation, with the help of Mack, *Courbet*, pp. 109-110, and Bowness, *Courbet's "Atelier,"* p. 125.

8. Proudhon, *Qu'est-ce que a la propriété? ou recherches sur le principe du droit et du gouvernement, premier mémoire* (1840), p. 339. All references to works by Proudhon are to the Marcel Rivière editions published beginning in 1923, unless otherwise noted. All translations in this study are my own, unless otherwise noted. They are as literal as possible in order to convey the style and vocabulary of the original. When I have made a change or attempted an improvement in order to clarify meaning, either the added English word or the original French terms are given in brackets.

An excellent selected bibliography for the study of Proudhon is contained in the standard English-language biography: George Woodcock, *Pierre-Joseph Proudhon: A Biography*, London, 1956, pp. 281-285. Valuable introductions to Proudhon's thought are Célestin Bouglé, *La Sociologie de Proudhon*, Paris, 1911; Edouard Dolléans, *Proudhon*, Paris, 1948; Pierre Ansart, *Sociologie de Proudhon*, Paris, 1967; and Alan Ritter, *The Political Thought of Pierre-Joseph Proudhon*, Princeton, 1969.

9. "Community is the first form of slavery," he declared, justifying his argument on the theory that while communism was the "conscious negation of property, it was [nevertheless] conceived under the direct influence of all of its [property's] prejudices." (Proudhon, *Qu'est-ce que la propriété?*, p. 234.) Communism represented to an extreme degree the alienation found in other systems of government, the result of which for a man like Courbet could only be disastrous. Statism, then, was epitomized by the communist community, and was "essentially opposed to the free exercise of our faculties, to our noblest desires, to our most intimate sentiments. . . . The community thus violates the autonomy of conscience . . . by restricting the spontaneous action of both the mind and the heart." (Ibid., pp. 326-327.)

10. Proudhon, *Système des contradictions économiques, ou Philosophie de la misère* (1846), I, p. 85.

11. Proudhon, *Les Confessions d'un révolutionnaire* (1849), p. 62, quoted in Jacques Muglioni, ed., *Proudhon: justice et liberté, textes choisies*, Paris, 1962, p. 51.

12. Proudhon, *Idée générale de la révolution au XIX siècle* (1851), p. 344. The parallel with Michelet seems inescapable. Michelet's *Le Peuple* had appeared in 1846. In 1849, Proudhon founded the journal *Le Peuple*, which in 1850 was replaced by *La Voix du peuple*. It was there that he first expressed his ideas on the meaning of the Revolution, ideas closely related to Michelet's. One wonders also if Proudhon's use of the term "fatalité" derives from Michelet.

13. Proudhon, *Solution du problème social* (1848), nouvelle edition, Paris, 1868, pp. 39, 56, 67. Blanc's principal treatise was *Organisation du travail*, Paris, 1841.

14. *L'Atelier, organe spécial des ouvriers* was published from 1840 to 1850 by a group led by Anthyme Corbon, a believer in worker self-improvement (in 1859, he published *De l'enseignement professionel*). On *L'Atelier*, see Armand Cuvillier, *Un journal d'ouvriers, "L'Atelier,"* Paris, 1914. *L'Atelier* contained many works by worker-poets. Proudhon also opposed paternalistic right-to-work laws or charitable schemes such as the *ateliers nationaux* of the Luxembourg Commission, preferring to rely on the initiative of the individual.

15. Proudhon, *De la justice dans la révolution et dans l'Eglise* (1858), III, pp. 422-424. This work was being prepared in the early 1850s.

16. So says Woodcock, *Proudhon*, p. 257. Riat, *Courbet*, p. 61, dates the friendship between the two men from the years 1848 to 1849. Biographers of Baudelaire assume Courbet introduced Baudelaire to Proudhon at about this time. (See Enid Starkie, *Baudelaire*, New York, 1958, p. 176.) However, as Alan Bowness has remarked, the earliest reference to Courbet in Proudhon's *Carnets* (IV [1974], p. 69) is from 11 April 1851 while he was still in prison, and the philosopher refers to Courbet in an impersonal manner ("Monsieur Courbet, artiste-peintre") that suggests this could have been their first meeting (see Bowness, "Courbet's *Proudhon*," p. 124). This is a minor point, but one wonders if Proudhon, who was extremely formal, was not merely establishing in a formal way the identity of Courbet for his diary. Whatever the case, they seem to have become close enough during this final year of Proudhon's imprisonment that Courbet was present on the

day of his release. Soon after, Courbet began Proudhon's education in the visual arts with a visit to the studio of Chenavard (see Champfleury, *Souvenirs et portraits de jeunesse*, Paris, 1872, pp. 297-298).

17. Proudhon, *Justice*, I, p. 304.

18. Proudhon, *De la capacité politique des classes ouvrières* (1865, posthumous), pp. 124-126, quoted in translation from Stewart Edwards, ed., *Selected Writings of Pierre-Joseph Proudhon*, translated by Elizabeth Fraser, New York, Anchor Books, 1969, pp. 59-61.

19. Bruyas, *Explication*, 1854, pp. 12, 30, 39. Courbet seems to have begun to use this title in 1850 in the posters for his exhibitions at Ornans, Besançon, and Dijon. (See Courthion, *Courbet*, II, p. 29. The information is from a manuscript autobiography of Courbet in the Moreau-Nélaton documents at the Bibliothèque Nationale.) Courbet often signed letters using this title. The combination of the terms *maître* and *peintre* can only refer to the guild tradition, in which *peintre* designates the particular métier. (I owe thanks to William Sewell and to Albert Boime for helping me to clarify parts of this point.) On the term *artiste*, see Maurice Z. Schroder, *Icarus: The Image of the Artist in French Romanticism*, Cambridge, Mass., 1961, pp. 2-11.

20. Clark, *Image of the People*, p. 32.

Chapter III

1. Courbet to Bruyas, May 1854, in Borel, *Lettres*, pp. 19-22. "Inevitable," just as social progress was itself seen as inevitable.

2. See Linda Nochlin, "Gustave Courbet's *Meeting*: A Portrait of the Artist as a Wandering Jew," *Art Bulletin*, 49, 1967, pp. 209-222.

3. Ibid., pp. 214-217. On the history of the legend of the Wandering Jew, see George K. Anderson, *The Legend of the Wandering Jew*, Providence, R.I., 1965. For the last word on Courbet's lost portrait of Jean Journet, which was originally exhibited at the Salon of 1850-1851, see Jean Adhémar, "Deux notes sur des tableaux de Courbet, II: Sur le portrait de Jean Journet par Courbet," *Gazette des Beaux-Arts*, Dec. 1977, pp. 202-204. Journet was included by Champfleury among *Les Excentriques*, Paris, 2nd edition, 1856, pp. 72-101. Surely Journet outraged Parisians as much by his coarse manner, his strident tone, and his provincial accent as by his socialist views. And obviously Courbet was attracted to him, as he was to Proudhon, partly on the basis of this similarity to himself. Here indeed is an additional rationale for using the same formula used for Journet in an image of himself.

For interpretations of the Wandering Jew that Courbet would have known through his friendship with Champfleury, see Champfleury, *Histoire de l'imagerie populaire*, Paris, 1869, pp. 4-23, esp. p. 6.

4. Lindsay, *Courbet*, p. 119. In contrast to Courbet, however, the ideal of *compagnonnage* was highly structured and ritualized. The individual *compagnon* obtained work through his local groups rather than independently. In the 1840s, particularly after the publication of Agricol Perdiguier, *Le Livre du compagnonage*, Paris, 1840, *compagnonnage* became an important model for worker collectivism. (See Labrousse, *Le Mouvement*

ouvrier, pp. 71-78 and Martin Saint-Léon, *Le Compagnonnage*, Paris, 1901.)

5. On the ways in which Courbet's use of the term "Assyrian" relates to the discovery of Assyrian and Mesopotamian sculpture, see Robert L. Alexander, "Courbet and Assyrian Sculpture," *Art Bulletin*, Dec. 1965, pp. 447-452.

6. Bruyas, *Explication*, 1854, pp. 12 and 30. On this portrait, see Théophile Silvestre, *Les artistes français*, Paris, 1926, II, pp. 247-249.

7. Bruyas, *Salons*, 1853, p. 17, defines the "école actuelle" by those works of which he had formed a collection, that is, by masters such as Robert Fleury, Troyon, Delacroix, Rousseau, Diaz, Corot, Decamps, etc.

8. Ibid., p. 24. In the *Explication* of 1854, Bruyas cut the more cogent theoretical introduction to the *Salons de peinture* of 1852 and 1853 into pieces, using some as part of his commentary on individual works and dispensing totally with others. For convenience we shall turn frequently to the 1853 essay, which is whole (see chapter II, note 2).

9. On a title page to the 1854 essay, Bruyas described his catalogue in Fourierist terms as a series of "notes d'harmonie" (Bruyas, *Explication*, 1854, p. 3). But the duality "love-work," which he also constantly invoked, came straight from Saint-Simon. On Saint-Simon and the arts, see Donald Drew Egbert, *Social Radicalism and the Arts*, New York, 1970, pp. 119-133.

10. In 1855, Bruyas seems to have printed a single-page flyer, probably with the same declaration as its text, but with the title, "Solution d'artiste. Sa profession de foi." At last word, the sheet was missing from the Bibliothèque Nationale stacks (Imprimés, Rp. 13769). The "profession de foi" was a commonplace political gesture. See the Saint-Simonian "profession de foi" of Sainte-Beuve and Pierre Leroux in *Le Globe*, 18 January 1831.

11. Bruyas, *Explication*, 1854, pp. 6-7.

12. Ibid., pp. 32-33. Incidentally, Proudhon's friend Arnold Ruge had published lectures on the comic in 1837. (Ruge, *Neue Vorschule der Asthetik: Das Komische mit einem komischen Anhange*, Halle, 1837.)

13. Courbet to Bruyas, May 1854, in Borel, *Lettres*, p. 20. It is certainly worth noting that Proudhon found the irreverence of the ironical mode the perfect antidote to the pedantry and self-righteousness that he felt made men "stupid." "Liberty, like reason, can only exist and become manifest by holding her own works in contempt," he wrote in *Les Confessions d'un révolutionnaire* of 1849: "Ironie, vrai liberté!" he exclaimed. (Proudhon, *Confessions*, quoted in Muglioni, p. 108.) Beatrice Farwell's location of *The Bathers* in a tradition that began with the theme of Susanna and the elders and homage portraiture and developed into voyeuristic erotica lends support to the notion of irony. (Beatrice Farwell, "Courbet's 'Baigneuses' and the Rhetorical Feminine Image," in Thomas B. Hess and Linda Nochlin, eds., *Woman as Sex Object: Studies in Erotic Art, 1730-1790*, New York, 1972, pp. 64-79.) Courbet was surely mocking escapist trivia with his realistic image of the theme.

14. Bruyas, *Explication*, 1854, p. 33.

15. François Sabatier-Ungher, *Salon de 1851*, Paris, 1851 (first published in *La Démocratie pacifique*, 13, no. 27, 2 February 1851). Sabatier was married to the well-known opera-singer, Caroline Ungher.

16. Sabatier was born in 1818, Bruyas in 1821. The artists most frequently mentioned in Bruyas' earliest *Salons de Peinture* (1852), particularly the landscapists Rousseau, Corot, Troyon, and Diaz, were precisely those whom Sabatier had singled out for special praise in his *Salon de 1851* as the founders of a new school. (Sabatier, *Salon*, pp. 10-26.) Before then Bruyas had concentrated more exclusively on local talents such as Cabanel, Glaize, and Tassaert. Bruyas even possessed a picture of 1851 by Félix Ziem that was dedicated to the Sabatiers. (Bruyas, *Explication*, 1854, p. 29, no. 57.) This painting was a sunset landscape already in Bruyas' possession in 1852. (See Bruyas, *Salons de peinture*, 1852, p. 54, no. 110.)

17. Such an idea was of course hardly exclusive to Sabatier, and indeed Bruyas had been quoting Gautier to similar effect earlier—although again a Gautier of 1848 as yet unaware of Courbet. (Bruyas, *Explication*, 1854, p. 35.)

18. Bruyas, *Explication*, 1854, pp. 33-34. Sabatier wrote: "It was not easy to give dignity and style to modern costumes. I use the word style deliberately: for I see not a single mean detail [détail mesquin]; forms are always ample, and whatever is angular and skimpy [étriqué] in our clothing . . . is skillfully subsumed in the group mass." (Sabatier, *Salon*, p. 62.) Sabatier's convincing and even moving description of how grief and emotion characterized at least as many of the townspeople of Ornans as were portrayed as indifferent and grotesque was unique among the scathing attacks that *The Burial* mostly provoked. (Sabatier, *Salon*, pp. 60-61.) Even Champfleury saw little genuine sentiment in any of the physiognomies of *The Burial*. (Champfleury, in *Le Messager de l'Assemblée*, 25 February 1851, reprinted in Champfleury, *Le Réalisme*, G. and J. Lacambre, eds. Paris, 1973, pp. 158-167.)

19. Sabatier to Bruyas, *Explication*, 1854, pp. 208-210.

20. Sabatier, *Salon*, p. vi. The expression "gros de l'avenir" probably came from Pierre Leroux. (See chapter VII, note 1.)

21. Egbert, *Social Radicalism and the Arts*, pp. 121-122.

22. The notion that truth was the result of a quest was an old one. If its concretization in this particular manner smacks of the concepts of Freemasonry, in which man's progress toward truth was embodied in symbolic rites of initiation, it is only because a mystico-religious vocabulary was rampant in the 1830s and 1840s—for example, in the Saint-Simonian identity between politics and religion and its corollary, adopted by Bruyas, too, that the artist (and, for Bruyas, the patron) acceded to a sort of priesthood (see Bruyas, *Salons de peinture*, 1853, p. 33 under the rubric "Amour, Travail, Religion / Liberté"). By the 1850s, however, the intermixing of the Saint-Simonians and the followers of Fourier made labels among the various idealist-utopians difficult to affix, and thus Bruyas' peculiar concretization within his art collection of the search for truth and happiness can just as easily have been a naively formulated response to the general mix of utopian jargon as it may have been knowingly based on Freemasonry. (I would like to thank Frank Paul Bowman for his help in considering these problems. For further comments, see this chapter, note 29.)

23. Bruyas, *Explication*, 1854, p. 3.

24. Ibid., p. 28, no. 55. The relationship between Tassaert's pictures and

Courbet's *Studio* was first pointed out by Alan Bowness, on whose work I have attempted to build (see Bowness, *Courbet's "Atelier,"* pp. 132-133).

25. Sabatier to Bruyas, in Bruyas, *Explication*, 1854, p. 209.

26. Bruyas' role in suggesting autobiographical allegory to Courbet was first pointed out in Huyghe et al., *Courbet, L'Atelier*, p. 10, where it was recalled that Jules Laurens had made a large symbolic lithograph representing the important moments of Bruyas' life. In some interesting pages on *The Studio*, Pierre Georgel among other things suggests that *The Studio* is organized in terms of pairs of opposites, each pair constituted by one figure to the left and another figure to the right of Courbet (Georgel, "Les Transformations de la peinture," p. 71).

27. Bruyas, *Explication*, 1854, pp. 18-19, no. 15.

28. See Bénichou, *Le Temps des prophètes*, pp. 289-291, who cites the work of Eugène Rodrigues.

29. It is not clear whether the phrase is to be translated as "phase in the education of an artist of the grand family" or "phase in the artistic education of the grand family." If one thinks of the "grand family" as a metaphor for humanity as a whole, or at least initiated humanity, the latter would seem the better choice. (Note that in the passage of 1848, which Bruyas had quoted from Gautier [Bruyas, *Explication*, 1854, p. 33], Gautier used the term "la grande famille humaine.") After all, unless Bruyas was thinking of himself as the artist in question, it is doubtful he meant us to understand his schemata in reference to any singular, particular artist. (Incidentally if the Masonic interpretation of Courbet's *Studio* [see Paris, Grand Palais, *Courbet*, pp. 261-263] has any basis at all, it lies in these terms of Bruyas' rather than in anything of Courbet's own. Whatever the facts are regarding this matter, I hope it will become clear in the rest of this study, if it is not already, that I consider it a relatively minor side-issue. For more discussion, see this chapter, note 22.)

30. Edouard Houssaye in *L'Artiste*, 1855, I, p. 221, quoted in Huyghe et al., *Courbet, L'Atelier*, p. 24. Houssaye was apparently one of Courbet's intimates around 1855 (ibid., p. 23).

31. In addition to having recognized the relevance of Tassaert's pictures for the bifurcation in *The Studio*, Alan Bowness amply summed up the picture's relationship to other possible sources (Bowness, *Courbet's "Atelier,"* pp. 130-132). One can certainly agree with his conclusion that Rembrandt's *Hundred Guilder Print* and Velázquez's *Las Meninas* were the two most important for Courbet. It may be worth adding only that these two artists, along with Titian and Zurbarán, had received the warmest praise in Sabatier's discussion of Courbet's *Burial*. Rembrandt, whose division of his composition of the *Hundred Guilder Print* into opposing halves with Christ in the center was especially telling for Courbet, was praised by Sabatier as "the father of the new painting," for "he descended into contemporary society" (Sabatier, *Salon*, p. vii). Hofmann, *The Earthly Paradise*, p. 19, is to be credited with the comparison to the Rembrandt.

Chapter IV

1. Courbet to Bruyas, April 1855, in Borel, *Lettres*, p. 61. For discus-

sion of differences between Courbet's and Bruyas' conception of art, see chapter VIII.

2. Bruyas, *Explication*, 1854, p. 38. Although Bruyas' remarks contained the familiar, barely comprehensible mixture of cliché, homily, religion, and autobiography, they also included an instance or two of specifically Proudhonian terminology. For example, he wrote, "The property of others no longer concerns us (one is addressing Proudhon): whatever its value, it [property or value?] must be respected, and each in his [or its?] sphere!" However, the words Bruyas placed in the mouth of this figure were of the socio-religious category.

3. Ibid., p. 5.

4. Proudhon, *Système*, II, pp. 361-362. (See appendix III.)

5. Ibid., p. 362.

6. Proudhon, *De la création de l'ordre dans l' humanité* (1843), p. 297.

7. *Le Répresentant du peuple*, 1 April 1848.

8. Karl Marx, *Economic and Philosophic Manuscripts of 1844*, Dirk J. Struik, ed., New York, 1964. On Proudhon and Rousseau, see Silvia Rota Ghibaudi, *Proudhon e Rousseau*, Milan, 1965. For the polemic with Marx, see Karl Marx, *La Misère de la philosophie: réponse à la Philosphie de la misère de M. Proudhon* (1847). On Marx in Paris, see Auguste Cornu, *Karl Marx et Friedrich Engels: leur vie et leur oeuvre*, III, Paris, 1962, esp. pp. 225-234. See also Pierre Haubtmann, *Marx et Proudhon, Paris*, 1947, and Vincenzo Celsa, *Proudhon-Marx: Una polemica*, Palermo, 1971. I am grateful to Jerrold E. Seigel for helping me with references and ideas concerning the Germans in Paris and their impact during the 1840s.

9. Comte's *Cours de philosophie positive* was published from 1830 to 1842. On the intellectual sources for *De la création de l'ordre*, see A. Cuvillier's introduction to Proudhon, *Création de l'ordre*, pp. 5-31. On p. 19, note 3, Cuvillier gives a bibliography of French studies of Hegel that might have been available to Proudhon.

10. Woodcock, *Proudhon*, pp. 48-49.

11. The account of these discussions is given in the later chapters of Karl Grün, *Die Soziale Bewegung in Frankreich*, Darmstadt, 1845. My summary is based entirely on Woodcock, *Proudhon*, pp. 87-88, and Charles-Augustin de Saint-Beuve, *P. J. Proudhon, sa vie et sa correspondance, 1838-1848* (1872), Paris, 5th edition, 1875, pp. 206-216.

12. My account of Feuerbach and Ruge is based on and may at times paraphrase Karl Löwith, *From Hegel to Nietzsche: The Revolution in Nineteenth-Century Thought* (1941), translated by David E. Green, New York, 1964, pp. 71-91. Grün's epithet is cited by A. Cuvillier in the introduction to Proudhon, *De la création de l'ordre*, p. 28. Proudhon's debt to Feuerbach was not something he readily admitted (see Daniel Halévy, *La Vie de Proudhon, Paris*, 1948, pp. 360-384 ["Proudhon et les Allemands"]). See the publication of Proudhon's notations on Feuerbach's works in Pierre Haubtmann, *P. J. Proudhon: Genèse d'un antithéiste*, Paris, 1969, pp. 247-258.

13. The most cogent exposition of these ideas is Proudhon's *Idée générale de la révolution au XIXe siècle* (1851).

14. Courbet to Bruyas, May 1854, in Borel, *Lettres*, p. 21.

15. On Courbet's relations with Germany, see the exhibition catalogue *Courbet und Deutschland*, Hamburg, 1978. See also Mack, *Courbet*, p. 144, and Hans Voss, "Courbet à Francfort-sur-le-Main," *Bulletin de la Société des amis de Gustave Courbet*, 1958, no. 21, pp. 9-11. On Courbet's studio in Saintonge, see Roger Bonniot, *Gustave Courbet en Saintonge*, Paris, 1973.

16. Théophile Silvestre, *Histoire des artistes vivants, français et étrangers: études d'après nature*, Paris, 1856, p. 265. The French deserves to be quoted: "La peinture [*The Studio*], si l'on excepte la femme nue et l'artiste à son chevalet, est d'un ton louche, blafard et amolli, en comparaison de la pratique mâle et puissante que l'on admire dans les meilleurs parties de l'*Après-Dînée* et de l'*Enterrement d'Ornans*." A significant exception to these characteristics, besides the central group, is the skull to its left. For some thoughts on the connotations of the rough paint surface, see Charles Rosen and Henri Zerner, "The Revival of Official Art," *The New York Review of Books*, no. 4, 18 March 1976, pp. 32-39.

17. Faillant-Dumas, "Etude au laboratoire," in Grand Palais, *Courbet*, p. 276. By the rectangular palette Courbet may also be evoking plein-air painting, despite his location in the atelier. Rectangular palettes were generally part of outdoor painting sets carried in folding boxes into which the palette would fit snugly.

18. Delacroix commented that the convincing naturalism of Courbet's *Studio* was made ambiguous by the appearance of what looked like "a real sky in the middle of the painting" (Eugène Delacroix, *Journal*, 3 August 1855, quoted in Silvestre, *Les Artistes français*, II, p. 226).

19. Baudelaire, *Exposition Universelle 1855*, in H. Lemaître, ed., *Curiosités esthétiques: L'Art romantique, et autres oeuvres critiques*, Paris, Garnier Frères, 1962, p. 225. (All references to *Curiosités esthétiques* are to this edition unless otherwise noted.) In the caricature, the palette has grown to an outrageous size; it seems deliberately held parallel to the picture plane rather than horizontally, as would be more safe and would better reflect common practice. As Walter Cahn kindly pointed out to me, the caricature's suggestion of contact between Courbet's beard and his canvas is surely an allusion to the French term "barbouilleur."

The drapery resting on the top of Courbet's canvas has a double role. On the one hand, it suggests the physical "objectness" of the picture, not just because it rests on it as one object on another, but because it probably had a use in the productive process: it may have covered the unfinished canvas when the artist was not working on it so as to keep the paint from drying. On the other hand, it may suggest the sort of drapery that is pulled back to reveal an illusion—in this case a vision of the future of mankind to be found in a Realist oneness with nature. It would thus represent a Realist transformation of a motif found, for example, in Dutch paintings, where the pulled-back drapery is painted in trompe-l'oeil.

20. Proudhon to Pierre Leroux in *La Voix du peuple*, no. 74, 13 Decembre 1849, reprinted in *Idée générale*, p. 395; *Système*, I, p. 238.

21. Courbet's electoral declaration, published in *Rappel*, 15 April 1871, quoted in Courthion, *Courbet raconté*, II, p. 47.

22. Figure 25 is from Charles Léger, *Courbet selon les caricatures et*

les images, Paris, 1920, p. 34. Léger notes that *The Sleeping Spinner* of 1853 (fig. 14) was considered by some to be the result of Courbet's Proudhonian indoctrination (ibid., p. 22), too. (See chapter VIII, note 13.) Riat, *Courbet*, p. 107 recounts a discussion between Courbet and Proudhon in which Courbet called the spinner a "prolétaire." In 1850 Max Buchon included Courbet as a son of Franche-Comté among "those three impetuous rebels of the philosophical and literary world . . . Fourier, Proudhon, and Victor Hugo." (Buchon, "Annonce" in *Le Peuple, Journal de la Révolution sociale*, 7 June 1850, quoted in translation from Chu, *Courbet in Perspective*, pp. 62-63. [Also, see chapter V, note 21.])

23. Courbet to Champfleury, about October 1854, reproduced in its entirety in my appendix II.

24. "Je conquiers la liberté, je sauve l'indépendance de l'Art," Courbet to Bruyas, May 1855, in Borel, *Lettres*, p. 87. It was Baudelaire who made light of Courbet saving the world. In the notes for a projected article to be entitled "Puisque réalisme il y a," Baudelaire wrote: "Champfleury got him intoxicated. . . . On the basis of an innocent farce, Courbet theorized with a compromisingly rigorous conviction." At the end of the notes, Baudelaire added: "(Analysis of Nature, of Courbet's talent and of morality.)/ Courbet saving the world." (Baudelaire, *Curiosités esthétiques*, pp. 823-825.) See also chapter VI. On the Courbet legend, see Clark, *Image of the People*, pp. 21-35. Clark opens with a discussion of Baudelaire's project.

25. Castagnary coined the term "naturalism" in his Salon of 1863 (Castagnary, *Salons*, pp. 100-106). In 1857, he had deplored the influence of Proudhon on Courbet (see chapter I, note 11), but then later defended the artist against those who accused him of a role in the destruction of the Vendome Column. (See Castagnary, "Fragments d'un livre sur Courbet," *Gazette des Beaux-Arts*, 5, Jan. 1911, pp. 1-20; 6, Dec. 1911, pp. 488-497; 7, Jan. 1912, pp. 19-30, and Castagnary, *Gustave Courbet et la colonne Vendome: Plaidoyer pour un ami mort*, Paris, 1883. See also, Carl Baldwin, "Courbet and the Column," *Art News*, 70, May 1971, pp. 36-38.) Zola attacked the theories of Proudhon's *Du principe de l'art et de sa destination sociale* in *Mes Haines*, Paris, 1866. The attack on formalism has been a leitmotif of the strain of Marxist criticism represented by Georg Lukács. In addition to Lukács' many essays, see Ernst Fischer, *The Necessity of Art: A Marxist Approach* (German ed., 1959), London, 1963.

Chapter V

1. On the Delacroix, which was part of Bruyas' collection, see Charles de Tolnay, " 'Michel-Ange dans son atelier' par Delacroix," *Gazette des Beaux-Arts*, Jan 1962, pp. 43-52. On the Géricault, probably a portrait of the painter Jamar, see Lorenz Eitner, L.A. County Museum, exh. cat., *Géricault*, 1971, no. 56.

2. Courbet to Bruyas, December 1854, in Borel, *Lettres*, pp. 50-51; Courbet to Champfleury, appendix II; and Théophile Silvestre, *Histoire des artistes vivants*, pp. 264-265, and the later edition, *Les Artistes français*, II, pp. 140-141. According to a letter from Courbet to Buchon quoted by Riat, *Courbet*, p. 148, Silvestre used Courbet's notes but then turned them into something that made him sound ridiculous.

3. Courbet to Charles Français, winter 1854-1855, quoted in Paris, Grand Palais, *Courbet*, pp. 260-261.

4. Courbet to Champfleury, appendix II.

5. Courbet to Bruyas, December 1854, in Borel, *Lettres*, p. 87.

6. See Georges Dupeux, *French Society, 1789-1970*, translated by Peter Wait, London and New York, 1976, pp. 95-150. Jack Lindsay's contention that Courbet must have read Flora Tristan's *Promenades dans Londres* (1840), republished in 1842 as *La Ville monstre*, for information about conditions in England is formulated too literally (Lindsay, *Courbet*, pp. 129-130). But it does point us to a general body of opinion about the state of civilization in England that was also reflected in lithographs made by a number of well-known artists who had traveled to London, including Géricault, Charlet, and, in 1849, Gavarni.

7. The rest of this paragraph and parts of the next refer directly to Toussaint's work in Paris, Grand Palais, *Courbet*, pp. 251-260.

8. On Proudhon's anticlericalism, see Haubtmann, *Proudhon: Genèse d'un antithéiste*; on Proudhon's anti-Semitism, see Edmund Silberner, "Proudhon's Judeophobia," *Historica Judaica*, April 1948, pp. 61-80.

Fourier's well-known anti-Semitism may have had similar provincial origins. (He and Proudhon were from the same region.) One of Fourier's disciples published a volume identifying Jews with the financial imperialism he associated with Saint-Simonianism. (See A. Toussenel, *Les Juifs rois de l'époque, histoire de la féodalité financière*, Paris, 1845.)

9. See below, chapter VIII.

10. Silvestre, *Histoire des artistes vivants*, p. 264, made the identification as a poacher, but without reference to Napoleon III. Except for the absence from his interpretation of the all-important Proudhonian elements underlying *The Studio*, I am in complete agreement with Herding's excellent, ground-breaking article. (Herding, "Das *Atelier des Malers*.")

11. They are listed by Courbet in his letter to Champfleury as "a huntsman, a reaper, . . . a worker's wife, [and] a worker" (see appendix II). X-ray photographs suggest that the capped figure which is squeezed in next to the huntsman was added when the reaper was moved to the right. This maneuver explains why the figure was not mentioned to Champfleury. The identification of Bakunin, whom Toussaint at first saw as Alexander Herzen, was made by Michel Cadot, "Courbet Illustrateur de Michelet?" *Romantisme*, 8, 1978, no. 19, pp. 74-78. Cadot explains how Michelet's 1854 *Légendes démocratiques du Nord* suggested both Kosciuszko and Bakunin. In addition, Cadot suggests the worker's wife alludes to the Rumanian revolution of 1848. He shows how Courbet based this figure on an anonymous illustration to the Michelet representing Madame Rossetti, who had had a hand in the uprising. Cadot entirely confirms my hypothesis that these figures incarnate nationalist movements that became part of the foreign policy of Napoleon III.

12. See Woodcock, *Proudhon*, passim, and James Joll, *The Anarchists*, London, 1964, pp. 84-89.

13. Proudhon wrote: "Foreign policy is like domestic opinion. It is groping toward its destiny. . . . No more Poland! No more Italy! No more Hungary! Soon no more Turkey! Might one not whisper: No more France!

Oh shades of '92! . . . Diplomacy is like speculation and the weather. Encouraged by rain, the Czar makes a gesture toward the Emperor, who refuses. . . . With his eye fixed on the stock market clock, the latter perhaps awaits the hour of bourgeois chauvinism." (Proudhon, *Philosophie du progrès* [1853], p. 38.) Proudhon also opposed colonialism as a form of exploitation on an international scale. This theme may lie behind the Asiatic figure of the clown next to the undertaker. France had opened a concession in Shanghai in 1849. Mademoiselle Toussaint has proposed that the Hercules, who forms a group with the clown, be identified as Turkey, an obvious allusion to the Crimea (Paris, Grand Palais, *Courbet*, pp. 254-255).

14. Proudhon, *Solution*, p. 32. The Carnot to whom Proudhon refers is Hippolyte Carnot, the son of Lazare Carnot. The others were moderate members of the 1848 Provisional Government. Courbet had dealt with a related theme in an allegorical project of the late 1840s or early 1850s, which he eventually abandoned. Entitled *The Chariot of State*, the picture was called a socialist painting by Théophile Silvestre, who said it showed France pulled in all directions at once by contradictory revolutionary and reactionary forces, while Jesuits put sticks between the spokes of the chariot's wheels.

15. Proudhon, *Philosophie du progrès*, pp. 40-42.

16. Courbet to Bruyas, December 1854, in Borel, *Lettres*, p. 52.

17. For biographical details on the friends of Courbet represented in *The Studio*, see Nicolson, *Courbet: The Studio*, pp. 39ff. To the information on Cuenot should be added the evidence of his political sympathies noted in Clark, *Image of the People*, pp. 99-100.

18. The picture, now in the Pennsylvania Academy of the Fine Arts in Philadelphia, had already been exhibited in 1847 and 1848. Clark (*Image of the People*, p. 42) comments on the stylistic change the picture underwent when repainted for 1852.

19. Sabatier was first suggested by Linda Nochlin on the basis of the resemblance between the profile of the art lover and figure 16 (Linda Nochlin, "The Invention of the Avant-Garde," p. 15). It is further discussed by Nicolson, *Courbet: The Studio*, p. 39. I believe Papety's drawings of Caroline Ungher (Musée Fabre, Montpellier) show the same person as Courbet's female art lover. Sabatier's face is obscured because Courbet had no model to follow. He already knew the Sabatiers in 1854 (he sends them warm greetings through Bruyas in the letter of December 1854 [Borel, *Lettres*, p. 53]), but he must not have made figure 16 until his visit to the Midi in 1857. Otherwise, he could have asked Sabatier to send the drawing or a photograph of it to him. (See also Jean Claparède, "Le Séjour de Courbet à la Tour de Farges," *Bulletin de la Société des amis de Gustave Courbet*, 7, 1950.) The luxurious garment worn by the woman is reminiscent of the theme of *The Sleeping Spinner* (see chapter VIII).

Still puzzling is the couple of lovers. Perhaps they allude to some of the ideas of free love of earlier romantic socialism, but they must also stand for Courbet's former relationship with Virginie Binet.

20. On Buchon, see H. Frey, *Max Buchon et son oeuvre*, Besançon, 1940, and J. Henri Amiel, "Un Précurseur du réalisme: Max Buchon," *Modern Language Quarterly* 3, 1942, pp. 279-390, as well as Bouvier, *La Bataille réaliste*, pp. 183-198.

21. See Clark, *Image of the People*, passim and esp. pp. 111-116. The full text of Buchon's "Annonce" is reproduced in ibid., pp. 162-164.

Buchon had remarked that the gravedigger, whom he identified as a vinegrower, recalled the old man of Courbet's *Stonebreakers*. He implied that the pride and robustness of this man, who presided over the burial of bourgeois, might soon make him the avenger of the stonebreaker's state of oppression. In a key section of the book just cited (pp. 111-113), Clark has demonstrated how by 1850 a proletarianized vinegrower class had become radicalized, and how, combining with other groups drawn to socialism, it was probably perceived in Paris as a threat to established order. Yet Clark sees Parisian hostility toward *The Burial at Ornans* itself as less linked to this socialist threat than to Courbet's actual portrayal of a class-structured rural society. However equivocally Courbet viewed such a structure as part of his own identity and experience, his image, according to Clark (pp. 147-153), so exploded the myth of a monolithic rural utopia that it caused panic in his Parisian audience.

This subtle yet central argument hinges on the peculiar importance of a "rural myth" for Paris. In Clark's view, recent immigrants from the countryside needed the myth of their roots as evidence of their virtuous self-made status in the city. I would propose in addition, however, that *The Burial* actually subverted such a myth by converting it or appropriating it to socialism. This was the romantic utopian socialism that (one might almost say) was endemic to a region that had Fourier, Proudhon, and Victor Hugo as native sons, as Buchon himself observed in his "Annonce." (See chapter IV, note 22.) Its aim was ultimately the restoration of a now class-divided countryside to a precapitalist, cooperative society. Hence, such an ideology presupposed not the existence of but the disappearance of rural uniformity and harmony in a way that made the Parisian *parvenu*'s belief in their existence, if he did actually have such a belief, defy all logic. What Buchon's reading of Courbet's painting tells us, then, is that the nostalgic ideal of rural life had acquired a distinctly anti-bourgeois connotation by having been co-opted as a frame for political aspiration. He was placing the picture in a familiar context of rural radicalism, a context that would be fully consistent with both the Realism and the politics of Courbet's *Studio* as well.

22. Max Buchon, *Recueil de dissertations sur le réalisme*, Neuchatel, 1856, quoted in H. U. Forest, " 'Réalisme,' Journal de Duranty," in *Modern Philology* 24, 1926-27, p. 472.

23. Courbet to Francis Wey, 1850, from Courthion, *Courbet*, II, p. 78, quoted in Clark, *Image of the People*, pp. 9 and 113.

24. Schapiro, "Courbet and Popular Imagery." Riat, *Courbet*, p. 107, observed how Courbet's increasingly close relations with Proudhon came to interfere with his friendship with Champfleury.

25. See Schapiro, "Courbet and Popular Imagery," pp. 178-180. Rodolphe Töpffer's *Réflexions et menus propos d'un peintre genevois* were published posthumously in 1848 and were warmly received in Paris.

26. Attention was first drawn to the child in the foreground of *La Petite tombe* by Linda Nochlin, *The Development and Nature of Realism in the Work of Gustave Courbet: A Study of the Style and its Social and Artistic*

Background, New York University Ph.D. Dissertation, 1963 (published as *Gustave Courbet: A Study of Style and Society*, New York, 1976), pp. 216-218.

27. Proudhon, *Carnets*, I, p. 88, quoted in Muglioni, ed., *Proudhon*, p. 171. Speaking of academies for art and artisanry, Proudhon asked, "Why this need for an authority? Why this intermediary between the student and the study room, the apprentice and the atelier . . .?" (Proudhon, *Idée générale*, p. 328). Proudhon was violently opposed to the Falloux law of 1850, through which the church had greatly increased its role in education. Coming so soon after 1848, this legislation was a remarkable victory for conservatives, whose influence Louis Napoleon acknowledged when he accepted the consequences of the law.

28. See Claude Pichois, "Documents baudelairiens: Baudelaire, Courbet, Emerson," *Etudes baudelairiennes*, 2, Neuchatel, 1970, pp. 69-71.

29. Courbet to Champfleury, see appendix II. For a general essay on the relationship between Courbet and Baudelaire, see Alan Bowness, "Courbet and Baudelaire," *Gazette des Beaux-Arts*, Dec. 1977, pp. 189-199. See also Clark, *Image of the People*, passim. Along with Baudelaire's book and the mirror behind him, Jeanne Duval is also an attribute in Courbet's programmatic portrait of his friend as an artist—in contrast to himself—withdrawn from the world into poetry, eroticism, and the self. Baudelaire's head is contained within the mirror as Courbet is within his landscape.

Chapter VI

1. Quoted by Alan Bowness in the introduction to Paris, Grand Palais, *Courbet*, p. 13.

2. Charles Baudelaire, *Salon of 1846* in *Art in Paris, 1845-1862*, translated and edited by Jonathan Mayne, London and New York, 1965, p. 45.

3. Champfleury, review of Courbet in *L'Ordre*, 21 September 1850, quoted in Clark, *Image of the People*, p. 127. See also Yoshio Abe, "Un Enterrement à Ornans et l'habit noir baudelairien," *Etudes de langue et littérature françaises*, 1, Tokyo, 1962, pp. 29-41.

4. Baudelaire, *Salon of 1846*, p. 44.

5. Baudelaire, "Pierre Dupont," from Pierre Dupont, *Chants et Chansons* (Paris, Martinon, 1851) in Lemaître, ed., *Curiosités esthétiques*, pp. 556-557. See Clark, *Absolute Bourgeois*, pp. 169-171.

6. See Paris, Petit Palais, exh. cat., *Baudelaire*, 1968-69, no. 218. (See this chapter, note 9). If Courbet did not in fact meet Proudhon until 1851 (see chapter II, note 16), it is possible that Baudelaire may have had a hand in the introduction. But given their similar origins and experiences of the countryside, I think it is doubtful that Baudelaire needed to convert Courbet to Proudhon. The opposite seems far more likely, no matter which of them made personal contact first. But my point here is not so much to deal with problems of priority as to suggest ideas held in common.

7. Proudhon, *Système*, II, pp. 371-372. Proudhon relied for proof of his contentions more on the empirical observation of populations (Malthus and Comte) and on etymology (the literal and the obscene meanings of the word *besogner*) than on any explicit behavioral theory.

Many socialists, including Marx, saw art as aesthetic labor. Proudhon's sources are surely multiple. His ideas may have had strong roots in the tradition of the worker-artist (see chapter I, note 11), but, of the utopians, Blanc, Fourier, and Etienne Cabet (*Voyage . . . en Icarie*, Paris, 1839) most closely approached his views. The relation between work and sex smacks both of the vitalism of Michelet and of the principle of "passional" attraction underlying Fourier's theories. Saint-Simonianism was rife with erotic liberalism, rendered notorious by Saint-Simon's disciple Enfantin.

8. Proudhon, *Système, II*, pp. 374-375 (see appendix III).

9. Paris, Petit Palais, *Baudelaire*, no. 218 bis. It is translated as the first epigraph in Clark, *Image of the People*, p. 9. Clark translates and discusses the entire passage from the point of view of Baudelaire's interest in Proudhon in his *Absolute Bourgeois*, pp. 163-169. The passage is reproduced in facsimile as the frontispiece to Baudelaire, *Curiosités esthétiques et autres écrits sur l'art*, Julien Cain, ed., Paris, Hermann, 1968.

10. Baudelaire, *The Painter of Modern Life*, translated and edited by Jonathan Mayne, London and New York, 1965, p. 32. In the continuation of the passage Baudelaire copied from the *Philosophie de la misère*, Proudhon's analysis of the drives motivating the production of art—hence of the essentially popular origins of art—fairly suggests Baudelaire avant la lettre. It was in this passage that the now combined love and work drives resulted in the embellishment of woman, thus proving the existence of an ideal within man's concept of himself:

> Man does nothing according to nature: he is, I daresay, an animal who likes to make improvements [un animal façonnier]. He likes nothing on which he has not left his mark. . . . For the pleasure of his eyes, he invented painting, architecture, the plastic arts, . . . none of the utility of which he can explain, except that they satisfy the needs of his imagination, and they please him. For his ears, he polishes his language, counts syllables, and measures rhythm. Then he invents melodies and chords, assembles orchestras. . . . He has a way of going to bed, of rising, of sitting, of dressing, of fighting, and of governing that does him justice; he has even found the perfection of the horrible, the sublime of the ridiculous, the ideal of the ugly. Finally, in his forms of greeting, in his respect for himself, and in the fastidious cult of his own person, he adores himself like a divinity! . . .
>
> Man has an irresistible need, one born spontaneously from the progress of his industry, from the development of his ideas, the refinement of his senses and the delicacy of his manners to love his wife as he loves his work, with a spiritual love; to mold her, to dress her up, to embellish her. The more he loves her, the more he wants her to be brilliant, virtuous, and listened to; he aspires to make of her a masterpiece, a goddess. (Proudhon, *Système*, II, p. 375 [see appendix III].)

Unexpected as it may seem, the claim of Baudelaire's "In Praise of Cosmetics" that art lifted man above nature, and consequently that "good is always the product of some art," found this strong parallel in Proudhon. Indeed, the example of female fashion and "maquillage" that Baudelaire used as a kind of empirical proof of his theory may well have been lifted

directly from Proudhon. (Baudelaire's passages are contained in *The Painter of Modern Life*, pp. 32-33.)

For Proudhon's view of women, see Proudhon, *La Pornocratie, ou Les Femmes dans le temps modernes* (posthumous, 1875), Paris, Rivière, 1939. Few thinkers rival Proudhon's traditionalist view of women as inferior objects dependent on and subservient to man. In his own relations with women, Proudhon was extremely formal and diffident. (See Daniel Halévy, *Le Mariage de Proudhon*, Paris, 1955. For a few comments on Proudhon's views, see Jacques Langlois, *Défense et actualité de Proudhon*, Paris, 1976, pp. 162-164.) However, Proudhon's views ought to be considered in two further contexts. First, he had strong doctrinal differences of opinion with two notorious female social romantics, George Sand and Flora Tristan. Second, already opposed to any form of social theology, he would have been doubly contemptuous of those which posited a redemptive "feminine" principle, usually personified by the Virgin Mary, seconding the masculine figure of God. Proudhon's negative views of women in general and of these aspects of their mid-nineteenth century role could only have been mutually reinforcing. (On the latter context, the so-called "romantic heresy," see Bénichou, *Le Temps des prophètes*, esp. pp. 423-453. For a general discussion of mid-nineteenth century feminism and the arts, see Picard, *Le Romantisme social*, pp. 383-402.)

11. The poet declared the artistic impulse to be the best evidence of the immateriality and primitive nobility of the human soul and of its inherent desire to rise above material nature toward the ideal. (Baudelaire, *The Painter of Modern Life*, p. 32.)

12. Proudhon, *Système, II*, p. 378 (see appendix III). Proudhon's concept of the ideal is discussed at greater length in chapter X. While ostensibly accepting the material, Proudhon does so only in order to transcend it. His linking of value to spiritual rather than to physical labor separates him profoundly from Marx, who saw Proudhon as still susceptible to certain bourgeois myths.

13. Baudelaire, *Curiosités esthétiques*, p. 825. (See chapter IV, note 24).

14. Pierre Leroux, *De l'humanité, de son principe, et de son avenir, où se trouve exposée la vraie définition de la religion et où l'on explique le sens, la suite, et l'enchaînement du Mosaïsme et du Christianisme*, Paris, 1840, 2 vols. As the long title indicates, Leroux's work was one of a persistent type combining the notion of social progress with a secularized religious faith. (See David Owen Evans, *Le Socialisme romantique, Pierre Leroux et ses contemporains*, Paris, 1948, and Jack Bakunin, *Pierre Leroux and the Birth of Democratic Socialism, 1797-1848*, New York, 1976. On the general question, see Donald Geoffrey Charlton, *Secular Religions in France*, Oxford, 1963.)

15. Marx's harsh critique of Proudhon is contained in Marx, *The Poverty of Philosophy* (1847), Moscow and London, 1956, esp. pp. 142-162 on division of labor. Marx's points are clearly and succinctly presented, much as I have tried to sum them up, in his letter to P. V. Annenkov of Dec. 28, 1846 (appendix to ibid., pp. 201-217). I am grateful to Meyer Schapiro for his view of these issues.

16. See Clark, *Image of the People*, pp. 21-35, 114-116, and 121-154, on Courbet's class identity and its expression in his art.

Chapter VII

1. In 1861 Courbet wrote: "Painting is an essentially *concrete* art and can only consist in the representation of *real and existing things*. It is a completely physical language, the words of which consist of all visible objects; an object which is *abstract*, not visible, non-existent, is not within the realm of painting." (Courbet, letter from the *Courier du dimanche*, 25 December 1861, in Courthion, *Courbet-raconté*, II, pp. 205-207, quoted in translation from Nochlin, *Realism and Tradition in Art 1848-1900: Sources and Documents*, Englewood Cliffs, N.J., 1966, p. 35.) Moreover, it is worth noting that as advanced a social thinker as Pierre Leroux had been preoccupied throughout the 1830s with the problem of creating a form of artistic symbolism suitable for the times. Against the concept of art for art's sake, he urged forms that would represent the invisible through the medium of the visible, perhaps thus anticipating the idea of real allegory. (See Pierre Leroux, "Du style symbolique," *Le Globe*, 8 April 1829; "Aux philosophes: De la poésie de notre époque," *Revue encyclopédique*, Sept.-Nov. 1831; and his articles "Allégorie," "Art," and "Symbole," in *Encyclopédie nouvelle*, vols. I and VIII, 1834 and 1841 respectively.) Leroux meant that only poetic representation which was founded on the principle of metaphor, would serve to reveal meanings beyond the surface reality to which the proponents of *l'art pour l'art* appeared to restrict themselves. Only a symbolic art might serve a social role. It is probably Leroux who popularized a phrase we earlier saw taken up by Sabatier: "le présent est gros de l'avenir." Leroux said the aphorism was a paraphrase of Leibniz. (David Owen Evans, "Pierre Leroux and his Philosophy in Relation to Literature," *Publications of the Modern Language Association*, 44, i, March 1929, pp. 274-289.)

2. Max Kozloff has taken what he saw as the contradictory notion of "real allegory" as a springboard for discussion of levels of reality within *The Studio*. (Kozloff, "Courbet's *L'Atelier*: An Interpretation," *Art and Literature*, 3, Autumn-Winter 1964, pp. 162-183.) Champfleury's objection that "an *allegory* can no more be *real* than can a *reality* become allegorical," is well known (Champfleury, "Du réalisme. Lettre à Madame Sand," first published in *L'Artiste*, 2 Sept. 1855, reprinted in *Le Réalisme*, Paris, 1857, p. 279.) So is Proudhon's "I have heard Courbet call his pictures real allegories: an unintelligible expression, especially because it is in contradiction with itself. What! He calls himself a Realist and he spends his time on allegories!" (Proudhon, *Du principe de l'art et de sa destination sociale* [1865, posthumous], pp. 224-225.) Other reflections on Courbet's term are cited in Huyghe et al., *Courbet, l'Atelier*, pp. 24-25.

Further discussion of pictorial and literary allegory can be found in Angus Fletcher, *Allegory: The Theory of a Symbolic Mode*, Ithaca, N.Y., 1964. For an interpretation of the artist as a cult figure and his studio as his *sanctum sanctorum*, see Würtemberger, "Das Maleratelier als Kultraum."

3. The full title was *Tableau historique d'un Enterrement à Ornans* (Silvestre, *Histoire des artistes vivants*, p. 255).

4. Papety had at first underlined his contemporary socio-political inten-

tions pictorially by showing a locomotive in the background of the picture. This clearly would have placed his classical scene in the near future rather than in the past, but he seems to have preferred utimately to preserve an historical verisimilitude in this work that made its allusion to the past legible as present theory only through its verbal clues. (See the study by Nancy A. Finlay, "Fourierist Art Criticism and the *Rêve de bonheur* of Dominique Papety," *Art History*, 2, no. 3, Sept. 1979, pp. 327-338.) Linda Nochlin has suggested that there might be a link between Courbet and Papety through Papety's project for *The Last Day of Slavery*. (See Nochlin, "The Invention of the Avant-Garde.")

5. In French the lines accompanying *The Romans* were, " 'Plus cruel que la guerre le vice s'est abattu sur Rome, et venge l'univers vaincu' (*Juv. Sat.* VI)." (*Explication des ouvrages* . . . *Salon de 1851*, no. 400.)

If the suggestion made by one observer—that the two figures to the far right of *The Romans* were meant as contemporary nineteenth-century on-lookers, socialists indeed—is correct, then Couture can be said to have moved ever so slightly, as Papety had at first been tempted to do by placing a locomotive in the background of the early version of the *Dream of Happiness*, toward Courbet's method. (Eugène Loudon, *Le Salon de 1855*), Paris, 1855, pp. 15-16, cited by Toussaint in Paris, Grand Palais, *Courbet*, p. 265. I have often wondered if Couture might have had in mind a satire of Papety's and Fourier's idealist utopia based on love and the satisfaction of the passions.)

6. Courbet had dabbled in more traditional forms of allegory several times before and had encountered similar problems. According to Silvestre, his *Classical Walpurgis Night* was apparently meant to symbolize nature escaping from the hands of science. Presumably his *Man Saved from Love by Death*, which was another self-portrait as well, alluded to the baser instincts above which man might rise in Proudhonian society. Both paintings were either destroyed or abandoned. (On Courbet's use of allegory, see Alan Bowness in Paris, Grand Palais, *Courbet*, p. 13, to which I am indebted for many observations bearing on this point. The two pictures are described in Silvestre, *Histoire des artistes vivants*, pp. 253-254. The interpretation of the latter is strictly my own speculation.)

7. See chapter III.

8. Shroder, *Icarus*, p. 182, notes that whereas the mysterious and aristocratic cat stood for the artist, the bourgeois was symbolized by the dog. A brief general discussion of the cat in mid-nineteenth-century visual art is contained in William Hauptmann, "Manet's Portrait of Baudelaire: An Emblem of Melancholy," *Art Quarterly*, New Series, 1, no. 3, Summer 1978, pp. 229-230.

9. Silvestre, *Histoire des artistes vivants*, p. 265.

10. Courbet, in the *Précurseur d'Anvers*, 22 August 1861. Quoted in Courthion, *Courbet raconté*, I, p. 160.

11. Although Realism and utopian classicism appear as antipodes, they may both, much like Proudhonian anarchism and utopian harmonism, have been reactions to the failure of artistic romanticism and political liberalism to satisfy the aspirations of most elements of society.

12. Courbet to Bruyas, December 1854, in Borel, *Lettres*, p. 87. Mademoiselle Toussaint's use of the term "first series" to support her Masonic interpretation of *The Studio* in no way precludes my hypothesis (Paris, Grand Palais, Courbet, p. 262). As I have said (chapter III, note 29), however, I can accept her idea only in the very broadest sense possible, that is, to the extent that Freemasonic vocabulary and concepts had themselves become part of a general mode of utopian thinking in the 1840s and 1850s.

13. Courbet to Champfleury, see appendix II. In *Du principe de l'art*, p. 221, Proudhon notes that Courbet often spoke of the series.

14. Proudhon, *De la création de l'ordre*, pp. 458-459. ✔

15. Ibid., p. 192 and p. 170. The main body of Proudhon's critique of Fourier appears on pp. 166-170. Another Fourier, a physicist and mathematician unrelated to the first, developed techniques of breaking down periodic functions into series, now called Fourier analysis. Proudhon is still using the concept of series in the *Philosophie du progrès*, p. 59.

16. On Courbet's pictures as studies of social roles, types, and *métiers*, see Schapiro, "Courbet and Popular Imagery," pp. 168-169. I am further indebted to Professor Schapiro for suggestions made to me personally regarding this point.

17. Hofmann, *The Earthly Paradise*, p. 19.

18. Harry Levin, *The Gates of Horn: A Study of Five French Realists*, New York, 1966, p. 70.

CHAPTER VIII

1. Duranty, on the subject of Champfleury's preference for bourgeois and peasant subjects, wrote: "Realism is accused of being exclusive, of wanting the study only of peasants and bourgeois. This accusation is based on stupidity and bad faith. M. Champfleury is not realism, he is a realist. He does peasants and bourgeois because he knows their world, which he has studied at length. He does not wish to deal with what he does not know." (*Réalisme*, 15 February 1857.)

2. Champfleury, *Le Réalisme*, p. 10.

3. Courbet put up four commandments on his studio wall: "1. Do not do what I do. 2. Do not do what others do. 3. If you did what Raphael used to do, you would have no existence of your own. Suicide. 4. Do what you see and what you feel, do what you want." (Quoted in translation in Boudaille, *Courbet*, p. 82.)

4. Champfleury, "De la réalité dans l'art," in *Le Réalisme*, pp. 92-93.

5. Courbet to Champfleury, appendix II.

6. Löwith, *Hegel to Nietzsche*, p. 81.

7. Proudhon, *Du principe de l'art*, p. 70.

8. Ibid., p. 110. Proudhon purported to be quoting from his *De la justice*.

9. Bruyas, *Explication*, 1854, pp. 212-225.

10. Sabatier, *Salon*, p. viii.

11. Proudhon, *Système*, I, p. 392. In *Du principe de l'art*, it became apparent how necessary some form of idealist concept was to Proudhon's

advocacy of the social purpose of art. This concept, as distinguished from an absolute transcendental ideal, is discussed in chapter X.

12. Proudhon, *Philosophie du progrès* (1853), p. 94. This well-known passage was quoted by Champfleury in his "Lettre à Madame Sand" on Courbet in 1855 (see Champfleury, *Le Réalisme*, pp. 270-285, esp. pp. 278-279), then by Castagnary in 1857 (Castagnary, *Salons*, pp. 27-28).

13. Werner Hofmann, "Uber die *Schlafende Spinnerin*," in Herding, ed., *Realismus als Widerspruch*, pp. 212-222. Hofmann shows how the making of thread from the raw material of nature, which thread is then transformed into woven material—amply displayed in the picture by the woman's clothing and the upholstery of her chair—serves as a metaphor for the production and materiality of art. Proudhon himself, speaking of the painting in *Du principe de l'art* (p. 173), compared the Spinner to an artist, for her work was derived from the desire for embellishment. Hence, the painting suggested the derivation of art from work, a socialist theme. In addition, it presented the idea in a slightly erotic atmosphere (somewhat overinterpreted by Hofmann, I believe) that combined sensuality and work as the attributes of physicality. *The Sleeping Spinner* was thus consistent with the principles Proudhon saw underlying rural society, and in which he saw the basis for a reconciliation in French politics that would make possible the solution of social problems. (See Proudhon on *The Peasants of Flagey*, discussed further on in this chapter.) The painting might be considered an updated version of Velázquez's famous *Las Hilandaras: The Myth of Arachne*.

14. On this painting, see Patricia Mainardi, "Gustave Courbet's Second Scandal: *Les Demoiselles de Village*," *Arts Magazine*, 53, no. 5, 1979, pp. 95-103; and Diane Lesko, "From Genre to Allegory in Gustave Courbet's *Les Demoiselles de Village*," *Art Journal*, 38, no. 3, Spring 1979, pp. 171-177. The latter suggests the allegorical significance of Courbet's charity scene by comparing the three sisters to the three graces and by establishing the subject's relationship to a specific political context. If the imagery of the painting was in fact so loaded, it might explain Courbet's statement in his letter to Champfleury on *The Studio* that the *Demoiselles* was a "tableau étrange." Perhaps similar allusions which have yet to be discovered were made in *The Grain Sifters* and even in *The Bathers*, which Courbet termed part of a "phrase curieuse" in his career. In 1854, moreover, Courbet had decided to show that even a beggar was capable of charity when he saw those even less fortunate than himself. The resulting picture, *L'Aumône d'un mendiant* (Glasgow Museum), was not executed until 1868. (See Benedict Nicolson, "Courbet's L'Aumône d'un mendiant," *Burlington Magazine*, Jan. 1962, pp. 73-75.)

For the possibility that Proudhon's *Philosophie du progrès* might have influenced Courbet's *Wrestlers* (Budapest, Museum of Art), see Klaus Herding, "*Les Lutters* 'détestables': critique de style, critique sociale," in *Les Réalismes et l'histoire de l'art, Histoire et Critique des Arts*, no. 4-5, May 1978, pp. 95-106, esp. p. 101, note 59.

15. In *The Toilet of the Dead Woman* (Northampton, Mass., Smith College Museum of Art), begun around the same time as *The Burial at Ornans* was being painted, Courbet further elaborated on rural attitudes

toward death. Indeed, his image of its matter-of-fact integration into apparently everyday activity was so successful that for many years there was no difficulty in understanding the picture as the representation of bridal preparations. (See Paris, Grand Palais, *Courbet*, no. 25.) The figures in the painting give no hint of specific emotional attitudes traditionally associated with death. Indeed, the moment chosen might have been repugnant to less hardy souls than those of the countryside, for the cadaver was to be shown naked. Only later retouching, probably by another hand, converted the deceased to a clothed bride-to-be. It is remarkable how many of the observations made by Linda Nochlin in an article on the picture as a bride's toilet remain true despite the reidentification of the subject. (Nochlin was aware Courbet had done a *Toilette de la morte* but lacked the information to identify it as this picture. See Nochlin, "Gustave Courbet's *Toilette de la mariée*," *Art Quarterly*, 34, no. 1, Spring 1971, pp. 30-54.) One of the main points of her study was to locate the ritual in the context of local customs. (For a more general treatment of the theme of death in Realist art, see Nochlin, *Realism*, London and Baltimore, 1971, pp. 57-101. For more comments on *The Burial at Ornans*, see note 17 of this chapter.)

16. Proudhon, *Du principe de l'art*, pp. 164-165. Another of his famous phrases was: "Humanity, essentially perfectible, never perfect . . ." (Proudhon, *Philosophie du progrès*, p. 73). One of the grounds on which Proudhon attacked communism was that it demanded moral perfection and material sacrifice to a degree quite incompatible with man's imperfect and unheroic nature.

17. The Proudhonian explanation of reactions to Courbet's art, which I have merely developed further here, may be supplemented by Clark, *Image of the People*, pp. 121-154. (See chapter V, note 21.) The parallel between Courbet's "additive" picture structures and his anti-authoritarian politics has been part of the literature on Courbet at least since Sabatier called the painter's style "democracy in art." (Sabatier, *Salon de 1851*, p. 63. See Linda Nochlin, "Innovation and Tradition in Courbet's *Burial at Ornans*," *Essays in Honor of Walter Friedlaender*, New York, 1965, pp. 119-126, reprinted in Chu, *Courbet in Perspective*, pp. 77-87.) However, it may be useful to comment a little more on the relationship between this "a-compositional" mode of representation and Courbet's conception of utopia as ideologically neutral. Although *The Burial at Ornans* does read principally as an additive, frieze-like composition reminiscent of popular imagery, it contains a narrative structure too, and the moment the painter has chosen within the funeral ceremony must be included as an integral part of his formal strategy. The procession to the grave has not yet ended: its leaders, the priest and his factotums, the pallbearers, and the important male members of the village have arrived, while the women seen in the back row of the painting are still filing around the grave to our right. (This reading was suggested to me by Robert McVaugh.) They are looking more or less in the direction of their movement, thus paying what appears to be less attention to the center of interest than those who have arrived at the graveside. Their movement will bring them into the viewer's space to include him in the ceremony in much the same manner as the grave itself

projects forward from the picture. (See earlier in this chapter for this point.)

The purpose of this illusion is to emphasize our own experience of an uncomfortable moment in the proceedings, a moment during which ritual is suspended, indeed—as the questioning look of one of the altar boys suggests—during which the continuum of meaning so amply filled by the rhetoric of ceremony has temporarily given way to a vacuum. In contrast, the priest's expression is that of a man accustomed to his role as supplier of meaning: he looks confidently through the pages of his Good Book where he knows just how to find the ready-made passage that will alleviate the uneasiness of the moment with a ready-made thought. Only the gravedigger is indifferent to the priest's power. Within the extremes represented by the two of them and by the inquisitive child, the community at large acts out a familiar routine with varying degrees of sincerity. The crucifix stands out as an ambiguous prop.

Although Courbet has chosen a "non-moment," or an instant of suspended action for his image, he has done so deliberately, fully conscious of the tensions created by the absence of the expected signifiers of meaning. The community is displayed as an assemblage of diverse individuals, linked only by time and place and by mortality, rather than by an overriding structure signifying a common psychology. The artist's anti-hierarchical approach to the group is not a sign of indifference, however. It is a sign of his respect for the particularity and integrity of the raw material of life, the result of a sensitive and direct personal approach to individuals. (Courbet of course knew all the people he represented in his picture. They had come to his studio in Ornans to be painted one by one.) This was a way of painting that emulated in its human relationships the principles embodied in the political program of anarchism. Similar compositional characteristics are present in other multi-figure compositions such as *The Toilet of the Dead Woman* (see earlier in this chapter, note 15) and *The Picnic of the Hunting Party* (Cologne, Wallraf-Richartz Museum).

18. Nochlin observed Courbet's turn toward landscape in *Gustave Courbet*, p. 223. (See also note 21 of this chapter.)

19. This is one of the major themes in Nochlin, *Realism*, especially pp. 182-184, where the author cites Roman Jakobson's characterization of Realist style as metonymic.

20. The best assessment of the meaning of Barbizon art is Robert L. Herbert, Boston, Museum of Fine Arts, exh. cat., *Barbizon Revisited*, 1962, pp. 64-68.

21. To date, the most pointed treatment of Courbet's landscape painting is Klaus Herding's essential essay, "Egalität und Autorität in Courbets Landschaftsmalerei," *Städel-Jahrbuch*, New Series, 5, 1975, pp. 159-199. Herding's contention that the individual triumphing over authority is manifest both in the subject matter and in the particularized forms of Courbet's landscapes has helped to reinforce and clarify my own related view. (See also Herding, "Farbe und Weltbild: Thesen zu Courbets Malerei," in *Courbet und Deutschland*, pp. 477-492.) Herding is in part anticipated by Lorenz Dittmann, "Courbet und die Theorie des Realismus," in Helmut Koopman and J. Adolf Schmoll, *Beiträge zur Theorie der Künste in 19.*

Jahrhundert, Frankfurt, 1971, I, pp. 215-239. Repeating the traditional parallel between style and politics in Courbet's art (see also earlier in this chapter, note 17), Dittmann sees Courbet's style as related to Proudhon's anarchism because of the painter's refusal to subordinate figures to one another. (He also qualifies the style as epic by its objectivity and its sculptural quality.) Herding addresses the question of the political content of ostensibly apolitical works in a more direct way. Noting, as I have, that the central motif of *The Studio* is a landscape, he sees *The Studio* not as a conclusion but as a new beginning. In this new phase, the countryside of Franche-Comté becomes the ideological antipodes of Paris. (Herding, "Egalität und Autorität," pp. 164-166.) Both Herding and Dittmann see the figure of the huntsman, present in many of Courbet's major later works, as a primary example of unalienated activity in free surroundings. (Herding, "Egälitat und Autorität," pp. 176-178; Dittmann, pp. 238-239.) Dittmann ends his essay with the following quotation from Courbet: "The hunter is a man of independent character who has a free mind or at least the sentiment of freedom. He is a wounded soul, with a heart that encourages him to linger in the vagueness and melancholy of the forest." (Quoted in Dittmann, p. 239, from Courthion, *Courbet raconté*, II, p. 39.) Courbet seems to be implying that only a man who has a sense of his own mortality can be totally free.

22. Silvestre, *Les Artistes français*, p. 140, writes that "une femme personnifie le modèle vivant ou la Vérité." The point is that the live model, who stood for contact with "real" nature in standard studio practice, here acknowledges the truth of Courbet's landscape, perhaps even seeming to guide the painter as if she were his muse. On Courbet's use of a photograph by Villeneuve on which to base this figure, see Aaron Scharf, *Art and Photography*, revised edition, New York, 1974, pp. 131-133.

23. Buchon, "Annonce," p. 62. (See chapter V, note 21.)

24. Hofmann, *The Earthly Paradise*, p. 17, wrote: "It is the window that looks out on the unambiguous world of real things."

25. One might speculate that this attitude allowed Courbet to leave the pictures he had intended to show as present in his studio, namely, *The Bathers* and *The Peasants of Flagey*, in their state as pure landscape. Theoretically, the landscape itself would evoke its inhabitants. The large picture on the wall, which Courbet may ultimately have decided to paint out, closely approximates the landscape of *The Peasants of Flagey*, with its trees to the left and hill in the center. The picture leaning against the wall, which is hidden by the central group of the artist at his easel, is similar in size and format to *The Bathers*, although its actual subject is obliterated. The only elements showing are landscape motifs. (The picture resting against the wall to the left, which is seen from the back only, could be *The Bathers*, too.)

26. This is to recall the terms of Georg Lukács, "Narrate or Describe? A Preliminary Discussion of Naturalism and Formalism" (1936), in *Writer and Critic and Other Essays*, New York, 1970, pp. 110-148. In his essay "The Beholder in Courbet," Michael Fried has pointed to the tendency of Courbet's art to break through the traditional separation between the world of the image and that of the beholder. In addition, Fried observes

the apparent continuity between the painter himself and the landscape he is executing in *The Studio*. My point of view incorporates such observations into the context of contemporary philosophical discussion. Such discussion never lost sight of the social ramifications of phenomenology; hence the inevitably social dimension and appropriateness to its times of Courbet's attempt to "absorb" the individual into the depicted—and, one should therefore add, the observed and comprehended—reality of his images.

27. Théophile Thoré's "Lettre à Théodore Rousseau" (in Thoré, *Salon de 1844*, Paris, 1844) may be relevant in this context, for despite the romantic transformation of landscape that Thoré saw taking place through painting ("Painting is a veritable dialogue with the external world; it is positive and material communication. It is a domination that you exercise over nature . . ." [pp. ix-x]), he considered its social significance to reside in the alternative it proposes to the preoccupation of bourgeois society with the material things of industry: "It is certainly true that industry is as human as art. It is certainly true that it is linked to the arts by ties that are still mysterious to us; but until now the two worlds have been almost separate. For our civilization has divided man into segments unfamiliar with each other. Politics has always tried to create castes, instead of offering as its ideal a whole man in a whole society, as Pierre Leroux has said." (pp. xiv-xv.) Thoré goes on to suggest, with nostalgic references to Jean-Jacques Rousseau and to George Sand, that wholeness is to be recovered through a return to nature.

Thoré is an important figure who hovers in the background of this study. Although he remains outside my focus on the relationship between Courbet and Proudhon, he represents a social vision of art that parallels and often intersects theirs. Clearly they have sources in common, such as Saint-Simon and Pierre Leroux, whose influence of course can be found everywhere in the 1840s. The question of Thoré's direct influence on Courbet and Proudhon remains open to further study. It might only be mentioned that during the politically active years 1848-1851, their political views were divergent: Thoré was a supporter of Louis Blanc and Ledru-Rollin. (On Thoré, see Frances Suzman Jowell, *Thoré-Bürger and the Art of the Past*, New York, 1977.)

CHAPTER IX

1. Proudhon, *Du principe de l'art*, p. 228.

2. See Gertrud Lenzer, "Auguste Comte and Modern Positivism," in G. Lenzer, ed., *Auguste Comte and Positivism: The Essential Writings*, New York, 1975, introduction, pp. xvii-lxviii.

For an excellent, although brief, discussion of the relationship between positivism and naturalism in nineteenth-century French art after about 1860, see Richard Shiff, "The End of Impressionism: A Study in Theories of Artistic Expression," *Art Quarterly*, New Series, 1, no. 4, Autumn 1978, pp. 349-355. Shiff rightly warns against the confusing habit of associating positivism and a totally objective art too closely, although some nineteenth-century critics were themselves guilty, perhaps deliberately, of this exaggeration. (Note Baudelaire's remarks, cited further on [see this chapter,

note 4].) Comte himself recognized the subjective element in art. (See Donald Geoffrey Charlton, *Positivist Thought in France during the Second Empire*, Oxford, 1959.)

But it should further be recalled that Comte prescribed a social function for art: "What philosophy elaborates, art will propagate and adapt for propagation, and will thus fulfill a higher social office than in its most glorious days of old." (Comte, *Cours de philosophie positive* [1830-1842], chapter XV, in Lenzer, ed., *Comte*, p. 305.)

3. Lenzer, "Auguste Comte," in *Comte*, pp. xliv-xlv.

4. Baudelaire, *Exposition universelle*, p. 226. In a statement of 1862 published in the essay "Peintres et aquafortistes," Baudelaire similarly denigrated Courbet's social aims, but affirmed that he had at least contributed to re-establishing a "disinterested and absolute love of painting." (Baudelaire, *Curiosités esthétiques*, p. 409.)

5. From Auguste Comte, *Cours de philosophie positive*, lesson I, in Lenzer, ed., *Comte*, pp. 71-72.

6. Proudhon, *Philosophie du progrès*, p. 131. The influence of Comte on Proudhon was a deep and generalized one that Proudhon rarely acknowledged specifically. On this point, see Théodore Ruyssen's introduction to *Philosophie du progrès* in the Rivière edition (see chapter II, note 8).

7. Lenzer, ed., *Comte*, p. 33.

8. Silvestre, *Histoire des artistes vivants*, p. 276.

9. Lenzer, ed., *Comte*, p. 34.

10. Quoted in Silvestre, *Histoire des artistes vivants*, p. 243.

11. Ibid.

12. See appendix I.

13. Gustave Courbet, "Le Réalisme," in *Exhibition et vente de 38 tableaux et 4 dessins de l'oeuvre de M. Gustave Courbet, Avenue Montaigne, 7, Champs-Elysées*, Paris, 1855, p. 2. My translation, although aided by Nochlin, *Realism and Tradition*, pp. 33-34, is more literal in order to preserve the accuracy of certain of the French terms.

14. Proudhon, *Du principe de l'art*, p. 228.

15. Courbet, letter in *Le Messager*, 19 November 1851, quoted in Riat, *Courbet*, p. 94.

CHAPTER X

1. Proudhon, *Du principe de l'art*, p. 221.

2. The two classic studies of Proudhon's theory of art are: Max Raphael, *Proudhon, Marx, Picasso; trois études sur la sociologie de l'art*, Paris, 1933; and Jean G. Lossier, *Le Rôle social de l'art selon Proudhon*, Paris, 1937. Essentially, the former takes up Marx's critique of Proudhon (see the end of chapter VI) and argues that there are contradictions inherent in any attempt to fuse apriorism with positive empiricism. Raphael prefers Marx's materialist view; he is less interested in Proudhon's attempted synthesis as an historical phenomenon. The excellent study by Lossier is mainly valuable for situating the social role of art according to Proudhon in the history of previous approaches to the question by other nineteenth-century social theorists. (See also Rachmiel Brandwajn, *La Langue et l'esthétique de*

Proudhon, Warsaw, 1952 and Werner Haedelt, *Die Asthetik Proudhons*, Krefeld, 1958.)

3. Proudhon to Max Buchon, 24 August 1863, in Proudhon, *Correspondance*, Paris, 1874-1875, XIII, p. 134, and Proudhon to F. G. Bergmann, 24 August 1863, in ibid., p. 136, both cited by Jules L. Peuch in his Introduction to Proudhon, *Du principe de l'art*, p. 2, note 1 (see further on in this chapter, note 8).

For an account of the destruction of *The Return from the Conference*, see Charles Léger, *Gustave Courbet*, Paris, 1929, pp. 96-97. The reproduction of the picture is made from Riat, *Gustave Courbet*, p. 203.

4. For details of the Saintonge reaction to *The Return from the Conference*, of the picture's origins, and of the plans to exhibit it, see Bonniot, *Courbet en Saintonge*, pp. 137-150, 265-272, and 300-310.

5. Proudhon to Gustave Chaudey, 11 September 1863, in *Correspondance*, XIV, p. 146, and Proudhon to Félix Delhasse, 7 July 1864, in ibid., XIII, p. 319, both cited by Puech in Proudhon, *Du principe de l'art*, p. 2, note 1, and p. 3.

6. Two translations are projected, one into English by Alan Bowness, the other into German by Klaus Herding.

7. Herzen's account of Proudhon's late ravings and intolerance is contained in his memoirs: Alexander Ivanovich Herzen, *My Past and My Thoughts: The Memoirs of Alexander Herzen*, translated by Constance Garnett (1924-1928), New York, 1968, II, pp. 818-822. Herzen's chapter 41 (pp. 805-822) is a lively account of his relationship with Proudhon in Paris in the 1840s. (For more detail, see Raoul Labry, *Herzen et Proudhon*, Paris, 1928.)

8. Proudhon's views of Courbet are contained in a number of letters. To Max Buchon, he wrote: "At Courbet's request I have undertaken to write something about the picture of the *Priests* [*The Return from the Conference*] and on what is called *realism*. This was supposed to be FOUR pages long and serve as an explanation of the painting in question. I will soon have ONE HUNDRED SIXTY pages; that is, instead of an advertisement, I have written a treatise. Consequently, Courbet is quite uneasy, and he bombards me with eight-page letters: you know how he writes, how he argues!" (Proudhon, *Correspondance*, XIII, p. 134.)

On 1 June 1864 Proudhon wrote to Gustave Chaudey: "I have just received an enormous letter from Courbet. I think he must have gone to the oldest storekeeper in Ornans in order to find the most dirty, yellow, and coarse notebook of school paper to write to me on. One would think the letter was written in the century of Gutenburg. The ink is of the same kind. Courbet doesn't write often, but when he puts himself to it, watch out! This time he has covered no less than fourteen pages with wine dregs. It will be a task to read all that. He talks about his rejected painting, of which he encloses a photograph. After *The Priests*, they shouted *hola!* after *Venus and Psyche*, they will shout *haro!*—as soon as my last proof is finished I am going to get back to my study of Art. I have to finish it." (Proudhon, *Correspondance*, XIII, p. 294.)

According to notations on Courbet's letters to Proudhon cited by Bonniot, *Courbet en Saintonge*, p. 310, Proudhon's conclusion regarding Courbet

was, "Oui, décidément, il est bête!" In *Du principe de l'art*, p. 229, he noted: "One can always arrive at an understanding with a philosopher, a scientist, an industrialist [etc.]. . . , with anything that calculates, reasons, plots, or debates, but with an artist, it is impossible."

9. Proudhon, *De la création de l'ordre*, pp. 216-217.

10. See above, chapter VII.

11. Proudhon, *De la création de l'ordre*, p. 154.

12. This was a rebuttal of the free-love ideas of Enfantin and Fourier. One can only speculate on the extent to which Courbet saw his own relative celibacy in these terms after his separation from his mistress and their son. Note that he considered her marriage to another man to have been forced upon her by material necessity. "That is how society swallows up its own members," he commented (Courbet to Champfleury, appendix II). Moreover, the extent to which the substantiality of nature in Courbet's style is erotic sublimation is also a matter of conjecture. (In this he anticipated Cézanne; see Meyer Schapiro, "The Apples of Cézanne: An Essay in the Meaning of Still-Life," in *The Avant-Garde, Art News Annual*, 34, 1968, pp. 35-53.) The whole question of Courbet's nudes needs to be examined in this light too.

13. Proudhon, *Système*, II, pp. 226-227.

14. Proudhon, *De la justice*, III, p. 534, quoted by Puech, in Proudhon, *Du principe de l'art*, p. 7. On the theory of *l'art pour l'art*, see the classic study by Albert Cassagne, *La Théorie de l'art pour l'art en France, chez les derniers romantiques et les premiers réalistes*, Paris, 1906.

15. Proudhon, *Philosophie du progrès*, p. 86.

16. Ibid., pp. 89-90. (See appendix IV for the original passage in its entirety.)

17. Ibid., pp. 90-92.

18. Ibid., p. 93.

19. Ibid.

20. Ibid.

21. Ibid., p. 94.

22. Ibid. The passage is quoted in chapter VIII.

23. Ibid., p. 96. This passage, in translation, is cited as my second epigraph. As with the previous citations from this chapter of the *Philosophie du progrès*, the original passage is given in its entirety in appendix IV.

24. Proudhon, *Du principe de l'art*, pp. 51-52.

25. On the contradictory aspects of this theory, see Raphael, *Proudhon, Marx, Picasso*.

26. Proudhon, *Du principe de l'art*, p. 185. Proudhon specifically denied the division of consciousness into more than the two categories he called "conscience" and "science," that is, reason and perception.

27. Only under apparent duress did Proudhon admit that the art object could contain elements of an artist's personal vision, which it combined with this reproductive aspect. (Ibid., pp. 53-56.)

28. Proudhon's own italics (ibid., pp. 59-68). He is very close to Comte here, both in his conception of the ideal and in his view of its social influ-

ence. (See Comte, *Cours de philosophie positive*, 5th edition, Paris, 1894, VI, pp. 826-835.

29. Ibid., p. 72.

30. Ibid., p. 74.

31. Ibid., pp. 97-99.

32. Ibid., pp. 105-109.

33. Ibid., pp. 139-143.

34. Ibid., pp. 111-119 and p. 233.

35. Ibid., pp. 120-129 and p. 145.

36. See also ibid., p. 232.

37. Ibid., pp. 154-159.

38. Ibid., p. 171.

39. Ibid., p. 168.

40. Ibid., p. 186.

41. That such a break occurred in the work on *Du principe de l'art* is evidenced by Proudhon's letter to Chaudey of 1 June 1864 (quoted earlier in this chapter, note 8). In chapter XVI of *Du principe de l'art*, Proudhon referred to the *Venus and Psyche* of which, as he mentioned in the letter, he had just received a photograph. This was the first of the chapters left unfinished at his death on 19 January 1865. The break must therefore have occurred somewhere between chapters, for in late 1864 Proudhon was also completing *De la capacité politique des classes ouvrières*.

42. The theory contained in Castagnary's *Philosophie du Salon de 1857* —even its title—had been directly modeled on Proudhon's *Philosophie du progrès*. Castagnary took Proudhon's definition of art as both personal and a reflection of the present world and society, to be a commonplace (see further on, note 45). He saw the Salon of 1857 as the first manifestation of what Proudhon (in the *Philosophie du progrès*) had called the "époque humanitaire." (See further on in this chapter and note 54, this chapter.) But most identifiably Proudhonian was his description of previous epochs and their contrast with the new era: history was the progressive negation of authority over man, an authority man had himself created by looking outside himself for an ideal, which he called God. The history of art, at first principally religious, then concerned with heroes that were nearly godlike, illustrated this progression. In the Salon of 1857 the dominance of landscape, portraiture, and genre scenes showed that man had finally taken himself as the essential subject of art, reappropriating for himself the qualities once attributed to God. Castagnary addressed the artist: "Once they [the gods] have disappeared, the virtues and grace you had endowed them with revert to you. . . . Through your apotheosis of man, you will justify the morality of art" (Castagnary, *Salons*, pp. 5-16). These terms directly reflect those of Proudhon's *Philosophie de la misère* (appendix III) and *Philosophie du progrès* (appendix IV). In addition to this internal evidence of Castagnary's debt to Proudhon, one may cite Courbet's letter to Gustave Chaudey, following Proudhon's death, in which the painter listed Castagnary as a disciple as well as a friend of Proudhon. The letter is reproduced in its entirety in Puech's Introduction to Proudhon, *Du principe de l'art*, pp. 40-41, notes.

The influence of Proudhon on Castagnary has been discussed by Joseph C. Sloane, *French Painting Between the Past and the Present*, Princeton, 1951, pp. 65-69. Théophile Thoré's idea that an art "for man" could be found in landscape is surely related to this context, too, as Sloane suggests. (See for example, Thoré, "Lettre à Béranger," in *Salon de 1845*, Paris, 1845, pp. xvi-xix. See also chapter VIII, note 27.)

43. Since both Proudhon and Castagnary were involved in the affairs of *The Return from the Conference* (Bonniot, *Courbet en Saintonge*, pp. 300-310), it is not unthinkable that they were actually in personal contact at the time.

44. The article by Castagnary cited by Proudhon was entitled "Les Deux Césars" and appeared on 13 September 1863, in the *Courier du dimanche*. Castagnary discusses Clésinger's busts of Caesar and Napoleon, which he saw at Barbédienne's during a trip to Florence. He argues against idealization, holding individualization to be crucial for our perception of the personal qualities that lead to heroic greatness. On 12 September 1863, there had appeared Castagnary's concluding article on the Salon of 1863, from the series published in the Brussels newspaper, *Le Nord*. (Proudhon had lived in exile in Brussels from 1858 to 1860.) It is evident from Proudhon's discussion that he was familiar with the content of at least these and perhaps earlier articles on the Salon, publication of which had begun in May 1863 in both the *Courier du dimanche* and *Le Nord*. (The locations of the articles from *Le Nord* are given in Castagnary, *Salons*, p. 100.)

The articles in the *Courier du dimanche* are far more brief, and the article on Courbet is more general than in *Le Nord*. Castagnary pretends to be writing after the death of Courbet and his older contemporaries. Courbet's name has survived beyond even those of Ingres and Delacroix. He writes: "[Courbet] does *The Burial, The Peasants of Flagey, The Stone-breakers, The Village Maidens*, . . . [etc.], fifty episodes in a triumphant epic, each in turn either stirring or mocking, where society is surprised to find its image seized and fixed for the first time. He makes landscapes . . . , indescribable pages, where the French countryside is revealed in all its rustic magnificence, where the fresh air of the fields expands in the lungs and the odor of the woods fills the nostrils. He does animals . . . , which surpass in their realism and in their power of execution all that was previously known in the genre. . . ." (Castagnary, "Salon de 1863—Gustave Courbet," *Courier du dimanche*, 28 June 1863, p. 6.)

Proudhon may have conflated more than a single article in his footnote reference. (I would like to thank Filiz Eda Burhan for help in researching this problem in Paris.)

45. In 1857, Castagnary had been critical of Courbet, holding that the painter had taken Proudhon too literally—that he spoiled both his own individualism and his naturalism by attempting paintings with an immediate moralizing impact. Castagnary saw Proudhon's theory, which he knew from the *Philosophie du progrès*, as one in which a deeply personal yet completely naturalist art would eventually accomplish the general education of mankind. He saw no contradiction between ideas he had otherwise inherited and Proudhon's philosophy when he wrote that the vision the artist puts in his work is personal, "it is himself, his mind, his heart," and

that art was "not a copy, not even a partial reproduction of nature, but an eminently subjective product, the result of a purely personal conception." Hence, "art is one of the highest acts of the human personality." Following Saint-Simon, Castagnary submitted that the subjective conception of beauty was "not an isolated or fractionary act with regard to the rest of human manifestations. Whatever the vigor of his individuality, the artist is always not the expression of but the culmination of the society that preceded him. He inherits the intellectual capital accumulated by preceding generations; it is in this capital that he finds the raw material of his education. . . . He epitomizes society . . . he is superior to society, because having come after, he is society and himself as well." (Castagnary, *Salons*, pp. 4-5.)

These opinions are not unlike what I have proposed as Courbet's interpretation of Proudhon's philosophy in 1855—and perhaps Castagnary thus lends that view some support—but in fact Castagnary seems to have understood Courbet as already coming closer to the social activism that was to characterize *Du principe de l'art*. This understanding was based on his belief that Courbet had made a systematic choice of subject matter among the uglier aspects of human life; he felt a more objective naturalism would not have been so deliberately one-sided.

Castagnary .interpreted the passage from Proudhon's *Philosophie du progrès* that called the artist's attention to "the vast panorama [diapason]" of reality as being less exclusive than Courbet's reading of it. The "aesthetic error" of Courbet's art was then not the philosopher's fault. He added: "It is debatable, in fact, as to whether art can have an immediate moral impact like the moral of a fable. [It should not act like satire or comedy.] . . . It is not meant for the specific education of one generation in order to direct its activity towards particular goals. Its goal is the general education of man and humanity. It acts, slowly but surely, on the very source of our ideas and sensations." (Castagnary, *Salons*, pp. 28-29.)

By 1863, Castagnary, who had befriended Courbet since 1860 (Bonniot, *Courbet en Saintonge*, p. 11), had changed his tune.

46. Castagnary, *Salons*, pp. 104-105.

47. Ibid., p. 149.

48. The latter statement must be read as a narrowing down or qualification of the former. As such, it again points up the distinction between Courbet's Realism and that of the likes of Bruyas. Proudhon's disagreement with Castagnary on this issue, discussed later, locates Proudhon closer to Bruyas than he surely would have liked.

49. Castagnary, *Salons*, p. 150. In 1857, however, Castagnary had disparaged satire. (See earlier in this chapter, note 45.)

50. Proudhon, *Du principe de l'art*, p. 187. Earlier, Proudhon, too, had favored irony as a means of social criticism.

51. Ibid., p. 188.

52. Moreover, in his article on *The Return from the Conference*, Castagnary had cut short his description of the subject of the painting with the exclamation, "But God keep me from attempting to explain such a subject here! I have no desire other than to estimate its aesthetic value." (Castagnary, *Salons*, p. 150.) Such a statement, made with a certain irony,

can be taken as a deliberate echo of Proudhon's periodic proclamations of incompetence to tread in any aesthetic sphere; his realm was ideological, and there he claimed to know Courbet's mind even better than Courbet himself. (Proudhon, *Du principe de l'art*, p. 221.)

53. Castagnary had tried to mitigate this idea in 1857. (See earlier in this chapter, note 45.)

54. Ibid., p. 189. Castagnary's use of the term occurs in his *Salons*, p. 15. For his source, see Proudhon, *Philosophie du progrès*, p. 96, note 2 (Proudhon's note). Although this note was clearly Castagnary's proximate source, the term *humanitaire* was far from unique to Proudhon but, rather, was common to most of the utopians.

55. Proudhon, *Du principe de l'art*, p. 190.

56. Castagnary had written: "It [the new school of painting] issues from the depths of modern rationalism. It springs from our philosophy which, re-locating man in society, from which the sensualist philosophers [les psychologues] had removed him, has made social relations the principal object of its study from now on. It springs from our morality which, having sub-stituted the imperative notion of justice for the vague notion of love, has firmly grounded human interrelationships. . . . It springs from our politics which, having posited equality between individuals as its principle and equality of well-being as its goal, has banished false hierarchies and de-ceitful social distinctions from our minds." (Castagnary, *Salons*, p. 140.) The French often referred to the sensualist philosophers as "les psycho-logues."

57. Proudhon, *Du principe de l'art*, pp. 190-192.

58. In Proudhon's *De la création de l'ordre*, as discussed above, in chapter VII.

59. Courbet to his father, 28 July 1863, quoted without reference by Riat, *Gustave Courbet*, p. 208. The entire passage reads: "Right now I am in correspondence with Proudhon; together we are producing an important work that will link my art to his philosophy and his work to mine. It is a pamphlet that will be sold at my exhibition in London with his portrait as well as mine: two men who have synthesized society, one in philosophy, the other in art, and both from the same region. I still have seven pages to transcribe to him before 6 o'clock. I must close now."

60. Proudhon, *Du principe de l'art*, p. 228.

61. Ibid., p. 227. The best explanation of the relationship between art and phrenology (the science of determining human character by close ex-amination of facial structure) is Frances Jowell's analysis of Thoré's "De la phrénologie dans ses rapports avec l'art" of 1833. If man could be thor-oughly and scientifically understood, valid plans could be made for future society. (Jowell, *Thoré-Bürger*, pp. 3-5.)

62. On Vacherot, see Léon Ollé-Laprune, *Etienne Vacherot, 1809-1897*, Paris, 1898; D. Parodi, "La Philosophie de Vacherot," *Revue de métaphy-sique et de morale*, 7, July 1899, pp. 463-502 and December 1899, pp. 732-750 (concentrating almost exclusively on *La Métaphysique et la science*); M. Boutroux, "Notice sur la vie et les oeuvres de M. Etienne Vacherot," *Compte rendu des séances et travaux de l'Académie des sciences morales et politiques*, vol. 162, 1904, pp. 513-539. To my knowledge, no one has

studied the possibility that Vacherot had an influence on Proudhon. Their political ideas were different, for although both were opposed to the regime of Napoleon III, Vacherot was less a utopian than a democratic republican. Passages on art from his *La Démocratie* of 1860 bear some striking, but most likely coincidental, resemblances to Proudhon. For example, the work opened with the following statement: "It is as true in politics as it is in art, morals, and geometry: *truth* must be carefully distinguished from *reality*. The celebrated definition that reduces literature to no more than the expression of society is perfectly accurate if one sticks to experience and to history; but in order to be *true*, one must add the expression *ideal*. Reality can well be the *material* of art; it is only the ideal that gives it form and essence. Art is always and everywhere the expression of the beautiful, no matter what basis of ideas, sentiments, or passions form its substance." (Vacherot, *La Démocratie*, Paris, 1860, p. 1.) In his brief chapter on art, Vacherot wrote that art must replace religion as the focus of man's imagination and sensibility. He contrasted figural representation and narrative expression as modes distinguishing visual and verbal arts, but he insisted that art retained its "high moral mission" (ibid., pp. 79-80). Note that although his vocabulary was similar to Proudhon's, art for Vacherot was still essentially preoccupied with beauty. Like his teacher, Victor Cousin, Vacherot made beauty a condition of the true and believed it affected men through its charm. Proudhon's disagreement with these ideas had been obvious since the *Philosophie du progrès* of 1853.

63. Proudhon, *Du principe de l'art*, p. 229, text and note.

64. Ibid., pp. 223-224.

65. Ibid., p. 257.

66. Ibid., p. 272. Here Proudhon objects to the Saint-Simonian concept of a vanguard caste of artists.

67. Ibid., p. 275. This is again modeled directly on Comte, *Cours*, VI, p. 833.

68. Ibid., p. 276.

69. Ibid., p. 229, note.

70. Emile Zola, *Mes Haines* (1866), Paris, François Bernouard, 1928, p. 24. The definition was repeated in his article on the Salon of 1866 in *L'Evénement* of 11 May 1866; hence it was there that it appeared in print for the first time. However, in the 15 May article, Zola referred to his essay on Courbet and Proudhon as having been written the previous year, immediately upon the publication of *Du principe de l'art*, and quoted the passage from that essay that began: "My Courbet, for me, is simply a personality" ("Mon Salon," in *Mes Haines*, p. 232). Zola repeated his definition of art in an attack on Hippolyte Taine ("M. H. Taine, artiste," in *Mes Haines*, p. 176).

71. On the sympathetic attitude toward anarchism of artists such as Pissarro, Signac, and others, see Eugenia W. and Robert L. Herbert, "Artists and Anarchism: Unpublished Letters of Pissarro, Signac, and Others," *Burlington Magazine*, 102, Nov. 1960, pp. 473-482 and Dec. 1960, pp. 517-522; and Eugenia W. Herbert, *The Artist and Social Reform: France and Belgium, 1885-1898*, New Haven, 1961.

Chapter XI

1. Theodore Zeldin, *The Political System of Napoleon III* (1958), New York, 1971.
2. Schapiro, "Courbet and Popular Imagery," p. 181.

SELECT BIBLIOGRAPHY

ONLY works either of general interest or of major use for this study are listed here. For other works consulted, see the footnotes. The editions actually used are given, with one exception: for simplicity's sake, the works of Proudhon are listed only in the original edition.

Ansart, Pierre. *Sociologie de Proudhon.* Paris, 1967.

Baudelaire, Charles. *Curiosités esthétiques, L'Art romantique et autres Oeuvres critiques.* Ed. H. Lemaître. Paris, 1962.

Bénichou, Paul. *Le Temps des prophètes: Doctrines de l'âge romantique.* Paris, 1977.

Bonniot, Roger. *Gustave Courbet en Saintonge.* Paris, 1973.

Borel, Pierre. *Lettres de Gustave Courbet à Alfred Bruyas.* Geneva, 1951.

Bouvier, Emile. *La Bataille réaliste, 1844-1857.* Paris, n.d. [1913].

Bowness, Alan. *Courbet's "Atelier du peintre."* Charlton Lecture on Art, Newcastle upon Tyne, 1972.

Bruyas, Alfred. *Explication des ouvrages de peinture du Cabinet de M. Alfred Bruyas.* Paris, 1854.

Castagnary, Jules-Antoine. *Salons, 1857-1879.* Ed. E. Spuller. Paris, 1892.

Champfleury, Jules. *Le Réalisme.* Paris, 1857.

Charlton, Donald G. *Secular Religions in France.* Oxford, 1963.

Clark, Timothy J. *The Absolute Bourgeois: Art and Politics in France, 1848-1851.* London and New York, 1973.

————. *Image of the People: Gustave Courbet and the Second French Republic, 1848-1851.* New York and London, 1973.

Cornu, Auguste. *Karl Marx et Friedrich Engels: leur vie et leur oeuvre,* Vol. III. Paris, 1962.

Courbet Documents. Collected by E. Moreau-Nélaton and G. Riat. Paris, Bibliothèque Nationale, Cabinet des Estampes.

Courbet und Deutschland. Hamburg, Kunsthalle, exh. cat., 1978.

Courthion, Pierre. *Courbet raconté par lui-même et par ses amis.* 2 vols. Geneva, 1948 and 1950.

Dehove, Gérard and Dolléans, Edouard. *Histoire du travail en France, mouvement ouvrier et législation sociale,* Vol. I. Paris, 1953.

Dolléans, Edouard. *Histoire du mouvement ouvrier, 1831-1871,* Vol. II. Paris, 1936.

————. *Proudhon.* Paris, 1948.

Dupeux, Georges. *French Society, 1789-1970.* Translated by P. Wait. London and New York, 1976.

Georgel, Pierre. "Les Transformations de la peinture vers 1848, 1855, 1863," *La Revue de l'art,* 27(1975), pp. 69-72.

Herding, Klaus. "Das *Atelier des Malers*—Treffpunkt der Welt und Ort des Versöhnung," in Herding, ed. *Realismus als Widerspruch: Die Wirklichkeit in Courbets Malerei.* Frankfurt, 1978, pp. 223-247.

————. "Egalität und Autorität in Courbets Landschaftsmalerei," *Städel-Jahrbuch,* New series, 5(1975), pp. 159-199.

Hofmann, Werner. *The Earthly Paradise: Art in the Nineteenth Century.* New York, 1961, pp. 11-22.

Hunt, H. J. *Le Socialisme et le romantisme en France: Etude de la presse socialiste de 1830 à 1848.* Oxford, 1935.

Léger, Charles. *Courbet.* Paris, 1929.

————. *Courbet selon les caricatures et les images.* Paris, 1920.

Lenzer, Gertrud. *Auguste Comte and Positivism: The Essential Writings.* New York, 1975.

Löwith, Karl. *From Hegel to Nietzsche: The Revolution in Nineteenth-Century Thought.* New York, 1964.

Lukács, Georg. "Narrate or Describe? A Preliminary Discussion of Naturalism and Formalism," *Writer and Critic and Other Essays.* New York, 1970, pp. 110-148.

Mack, Gerstle. *Gustave Courbet.* London, 1951.

Marx, Karl. *Economic and Philosophical Manuscripts of 1844.* Ed. D. J. Struik. New York, 1964.

————. *The Poverty of Philosophy.* London and Moscow, 1956.

Nicolson, Benedict. *Courbet: The Studio of the Painter.* London and New York, 1973.

Nochlin, Linda. "Gustave Courbet's *Meeting*: A Portrait of the Artist as a Wandering Jew," *Art Bulletin,* 49(1967), pp. 209-222.

————. "The Invention of the Avant-Garde," *Art News Annual,* 34 (1968), pp. 11-19.

————. *Realism.* Baltimore and London, 1971.

Proudhon, Pierre-Joseph. *De la création de l'ordre dans l'humanité, ou principes d'organisation politique.* Paris, 1843.

————. *Idée générale de la révolution au XIXe siècle.* Paris, 1851.

————. *De la justice dans la révolution et dans l'Eglise.* Paris, 1858.

————. *Philosophie du progrès.* Paris, 1853.

————. *Du principe de l'art et de sa destination sociale.* Paris, 1865.

————. *Solution du problème social.* Paris, 1848.

————. *Système des contradictions économiques, ou philosophie de la misère.* Paris, 1846.

Riat, Georges. *Gustave Courbet, peintre.* Paris, 1906.

Sabatier-Ungher, François. *Salon de 1851.* Paris, 1851.

Schapiro, Meyer. "Courbet and Popular Imagery: An Essay on Realism and Naiveté," *Journal of the Warburg and Courtauld Institutes,* 4(1941), pp. 164-191.

Silvestre, Théophile. *Histoire des artistes vivants, français et étrangers: études d'après nature.* Paris, 1856.

Toussaint, Hélène. *Gustave Courbet.* Paris, Grand Palais, exh. cat., 1977.

Woodcock, George. *Pierre-Joseph Proudhon: A Biography.* London, 1956.

Zeldin, Theodore. *The Political System of Napoleon III.* New York, 1971.

Zola, Emile. "Courbet et Proudhon," *Mes Haines.* Paris, 1928, pp. 21-34.

INDEX

ILLUSTRATIONS

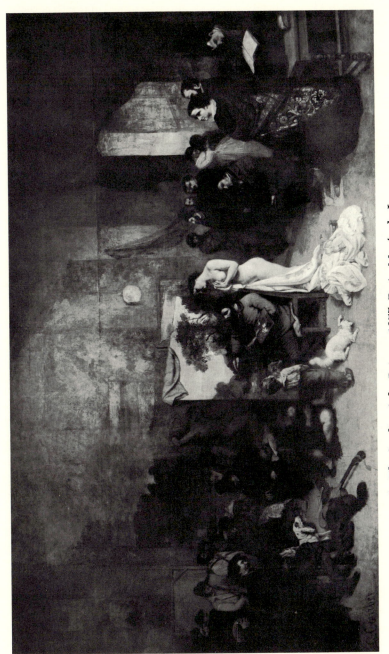

1. *The Studio of the Painter*, 1855. Paris, Musée du Louvre.

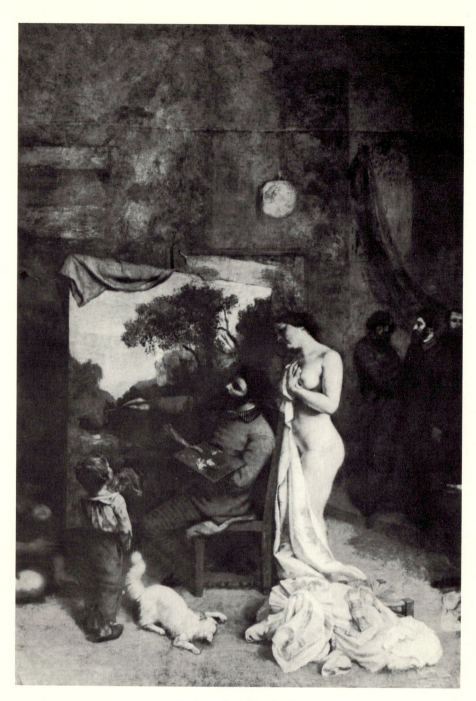

2. Detail of *The Studio*.

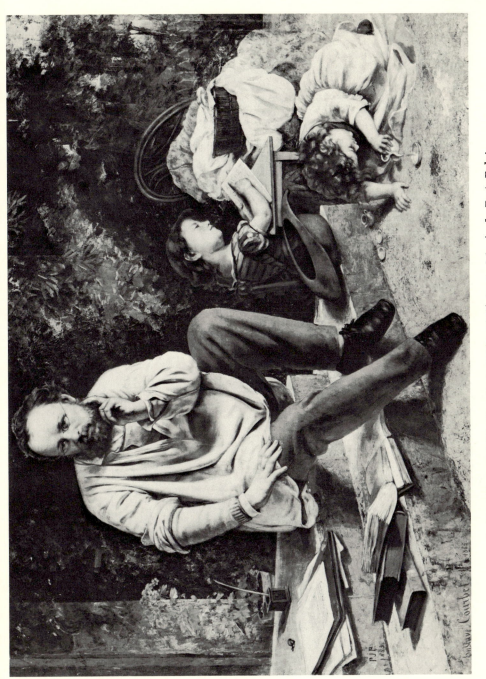

3. *Proudhon and His Family in 1853*, 1865. Paris, Musée du Petit Palais.

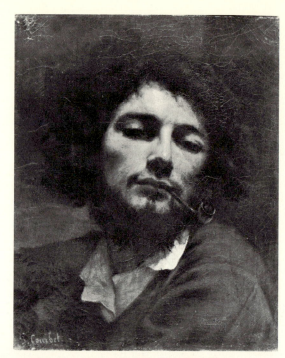

4. *Man with Pipe*, ca. 1847-1849. Montpellier, Musée Fabre.

5. *The Violoncellist*, ca. 1847. Stockholm, Nationalmuseum.

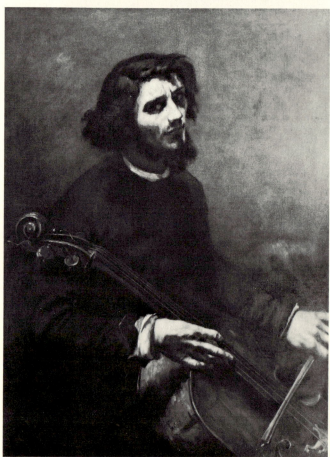

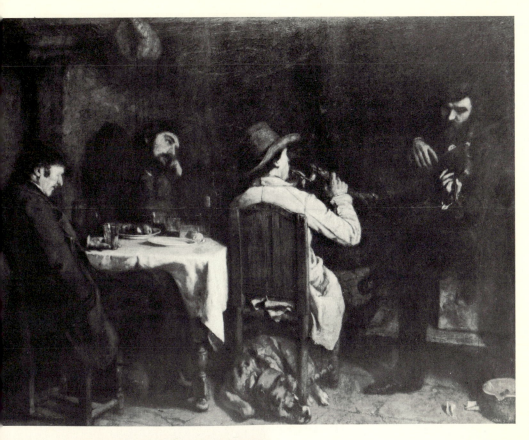

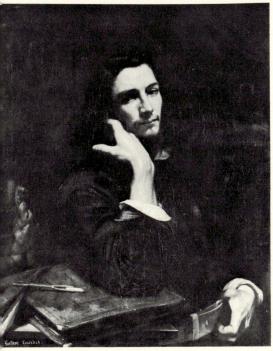

7. *After-Dinner at Ornans*, 1848-1849. Lille, Musée des Beaux-Arts.

6. *Man with Leather Belt*, ca. 1847. Paris, Musée du Louvre.

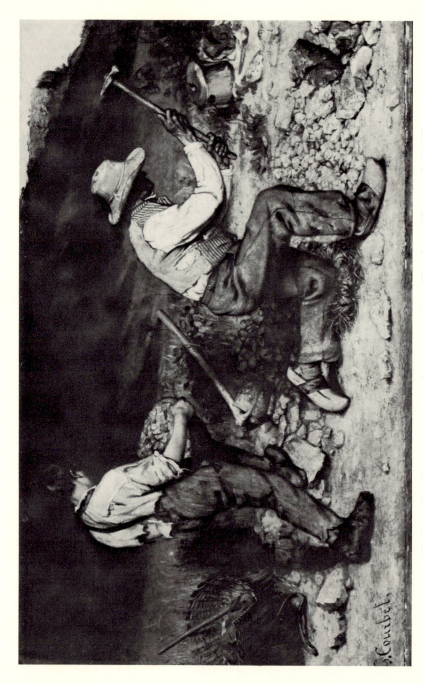

8. *The Stonebreakers*, 1849. Formerly Dresden, Gemäldegalerie (destroyed, 1945).

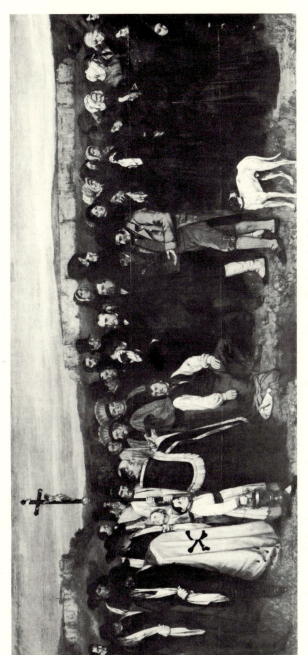

9. *The Burial at Ornans*, 1850. Paris, Musée du Louvre.

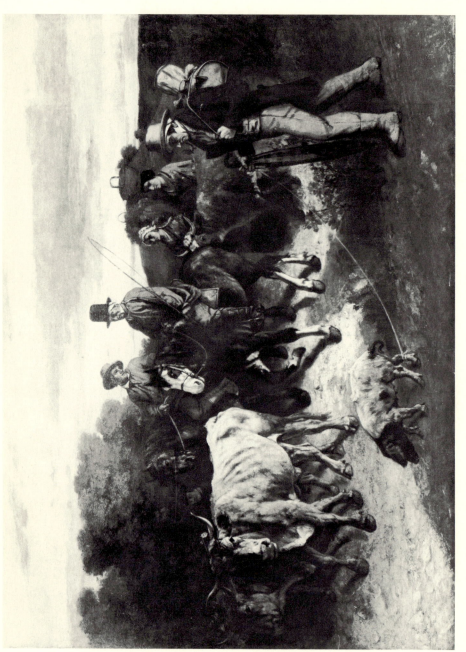

10. *The Peasants of Flagey Returning from the Fair*, 1850. Besançon, Musée des Beaux-Arts.

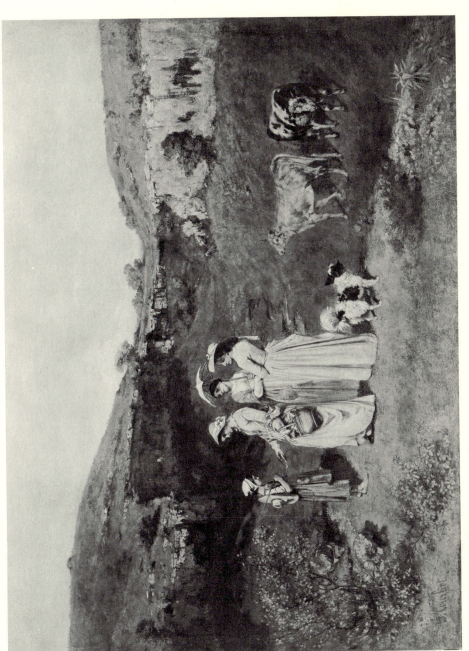

11. *The Village Maidens*, 1851. New York, The Metropolitan Museum of Art, Gift of Harry Payne Bingham, 1940.

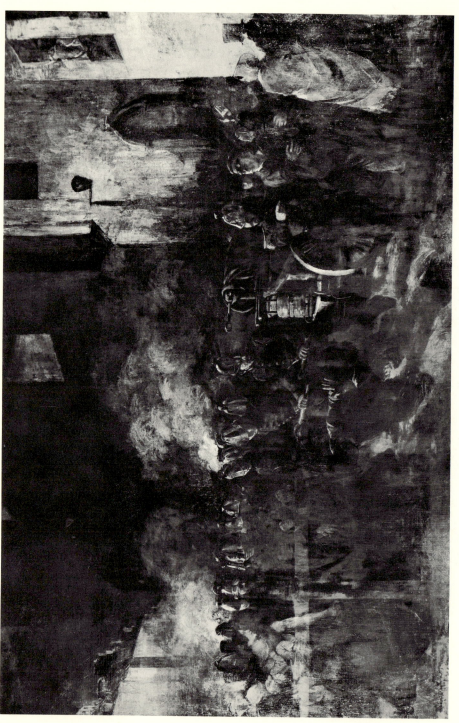

12. *Firemen Running to a Fire*, 1850-1851. Paris, Musée du Petit Palais.

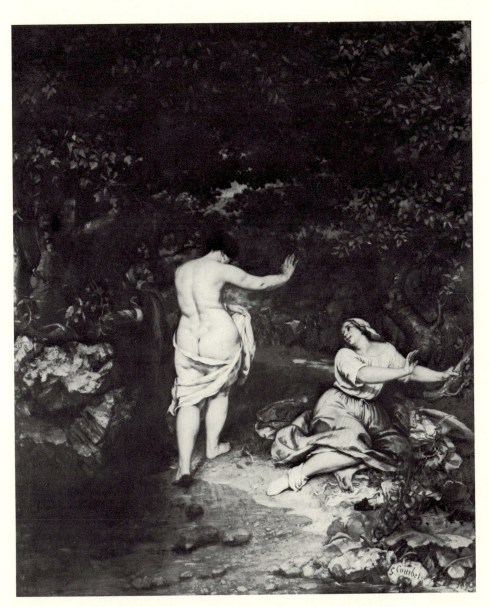

13. *The Bathers*, 1853. Montpellier, Musée Fabre.

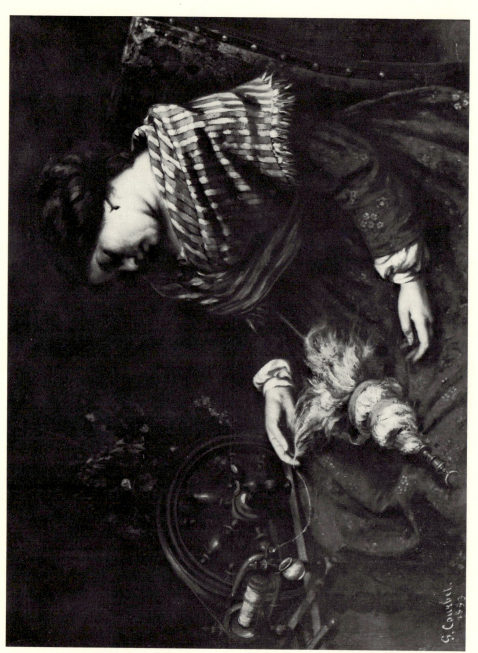

14. *The Sleeping Spinner*, 1853. Montpellier, Musée Fabre.

16. *Portrait of François Sabatier*, drawing, 1857? Montpellier, Musée Fabre.

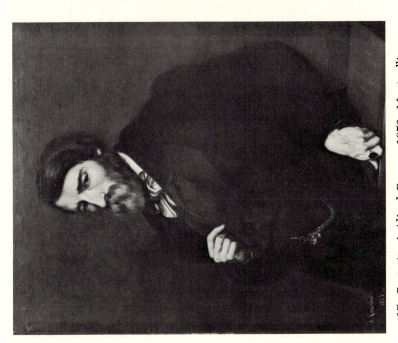

15. *Portrait of Alfred Bruyas*, 1853. Montpellier, Musée Fabre.

17. *The Meeting (Bonjour Monsieur Courbet)*, 1854. Montpellier, Musée Fabre.

18. Anonymous, Popular Print of the Wandering Jew, woodcut.

19. *The Apostle Jean Journet*, lithograph, 1850. Paris, Bibliothèque Nationale, Cabinet des Estampes.

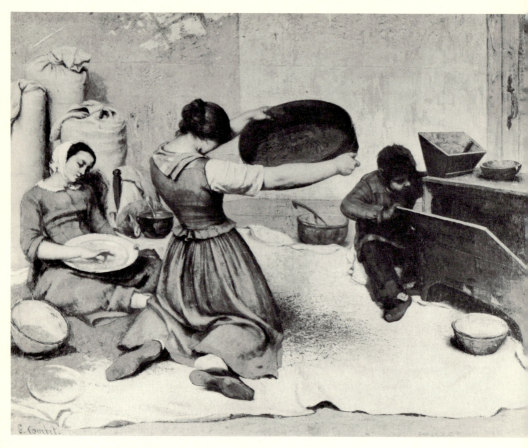

20. *The Grain Sifters*, 1854. Nantes, Musée des Beaux-Arts.

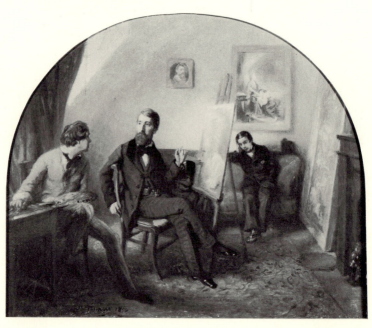

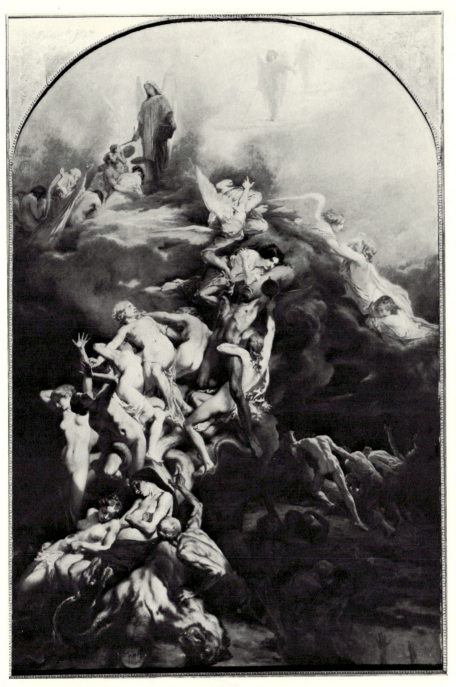

21. Octave Tassaert, *France Hesitating between Good and Evil Sentiments*, 1850. Montpellier, Musée Fabre.

Opposite page bottom:
22. Octave Tassaert, *The Artist's Studio*, 1853. Montpellier, Musée Fabre.

PHASE D'UNE ÉDUCATION D'ARTISTE DE LA GRANDE FAMILLE.

(**Cabinet BRUYAS.**)

MONTPELLIER. — 1834.

LA PEINTURE

AU XIXᵉ SIÈCLE.

AMOUR. *TRAVAIL.*

DÉBUT.	RELIGION.	SOLUTION.
AU JEUNE ARTISTE	**CONVICTION.**	L'HUMBLE ATELIER
Les beautés de la Nature!		Au grand Artiste
A. CABANEL.		O. TASSAERT.
Rome, 1845.		Paris, 1852.

LIBERTÉ (1)

G. COURBET. — 1853.

Sujets de Tableaux, pour plafond, destinés au salon Velleda, par A. B.

ÉTUDES DE MAITRES,

ou

Souvenirs de Voyage (principalement l'Italie et Paris), appuyées par quelques
Morceaux anciens et par des Tableaux modernes.

(1) La preuve que la liberté est l'idéal divin de l'homme, c'est
qu'elle est le premier rêve de la jeunesse, et qu'elle ne s'évanouit
dans notre âme que quand le cœur se flétrit et que l'esprit s'avilit
ou se décourage.

LAMARTINE.

23. Title page from Bruyas, *Explication*, 1854.

Opposite page:

Top: 24. Quillenbois, Caricature of Courbet,
The Studio, 1855.

Bottom: 25. Cham, Caricature of Courbet
and Proudhon, 1855.

M. Courbet dans toute la gloire de sa propre individualité, allégorie réelle déterminant une phase de sa vie artistique. (Voir le programme, où il prouve victorieusement qu'il n'a jamais eu de maître... de perspective.

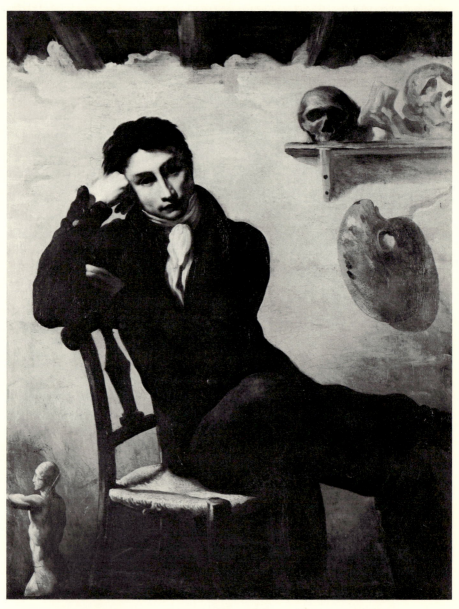

26. Théodore Géricault, *An Artist in His Studio*, ca. 1818-1819.
Paris, Musée du Louvre.

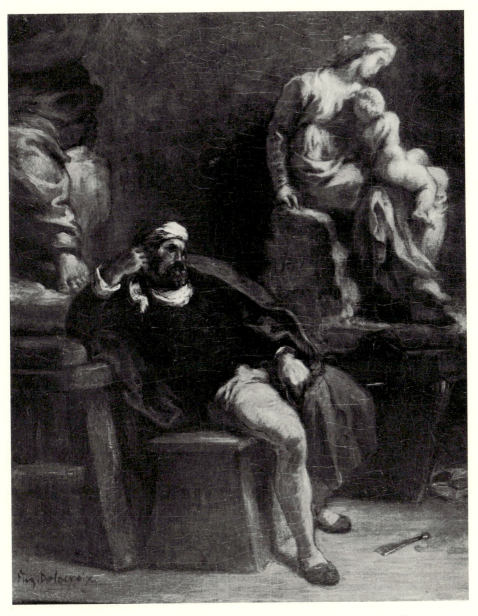

27. Eugène Delacroix, *Michelangelo in His Studio*, 1853. Montpellier,
Musée Fabre.

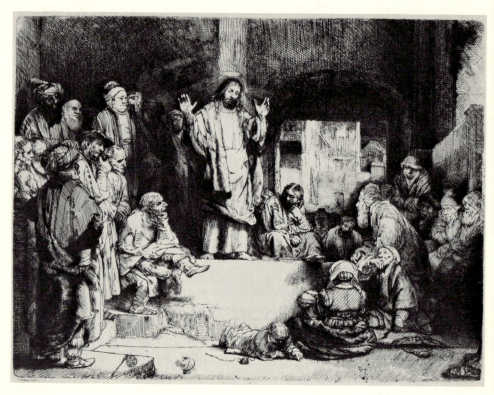

28. Rembrandt, *Christ Preaching the Remission of Sins*, called
La Petite Tombe, etching. London, British Museum.

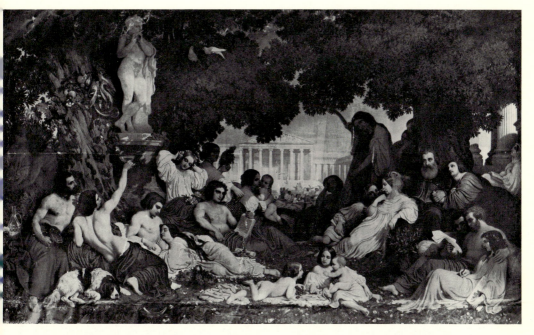

29. Dominique Papety, *The Dream of Happiness*, 1843. Compiègne, Musée Vivenel.

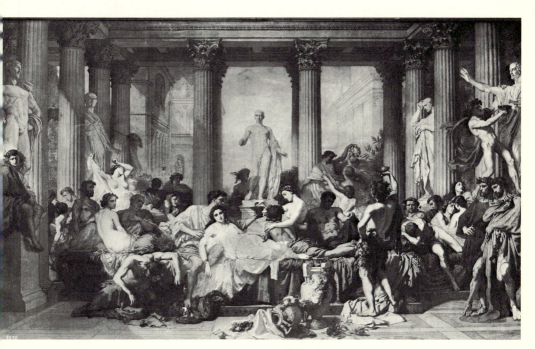

30. Thomas Couture, *The Romans of the Decadence*, 1847. Paris, Musée du Louvre.

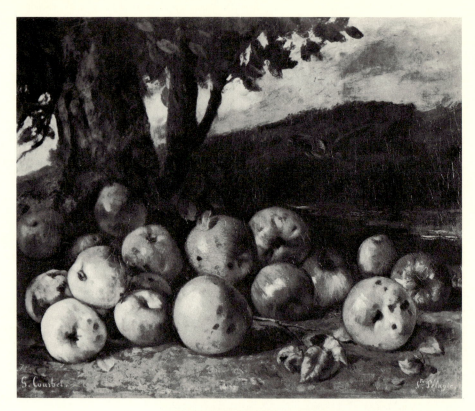

31. *Still-Life with Apples*,
ca. 1871-1872. The Hague,
Mesdag Museum.

32. *Three Trouts*, 1872.
Bern, Kunstmuseum

Opposite page top:
33. *The Wave*, 1870. Berlin
(West), Nationalgalerie,
Staatliche Museen
Preussischer Kulturbesitz.

Opposite page bottom:
34. *The Brook of Le
Puits-Noir*, 1868. Chicago,
The Art Institute.

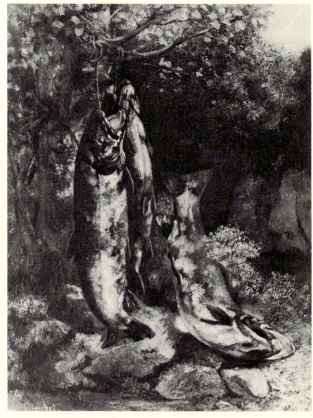

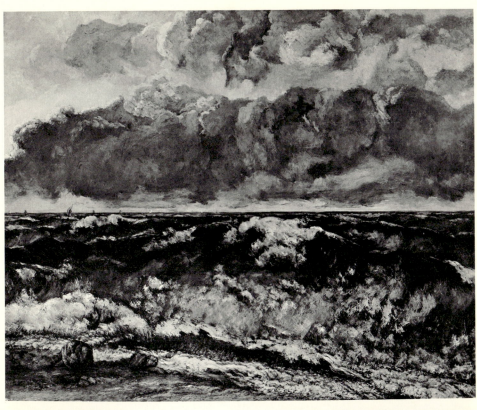

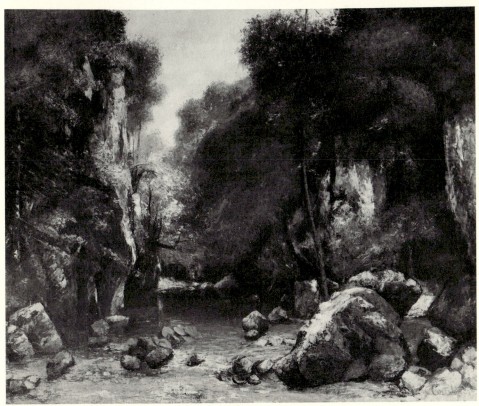

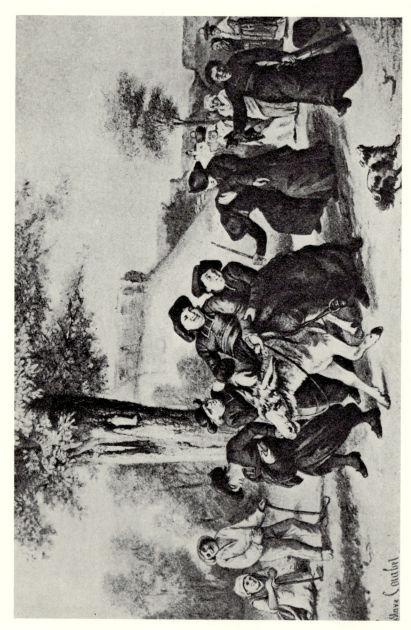

35. *The Priests, or The Return from the Conference*, 1862-1863. Destroyed.

Color plate: